S0-BNU-413

DRAWING & CARTOONING FOR LAUGHS

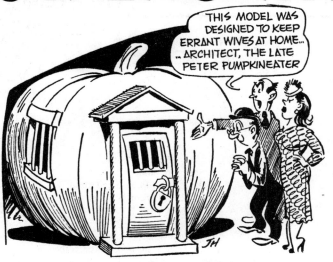

THIS MODEL WAS DESIGNED TO KEEP ERRANT WIVES AT HOME... ...ARCHITECT, THE LATE PETER PUMPKINEATER

JACK HAMM

A PERIGEE BOOK

OTHER BOOKS BY JACK HAMM:

Cartooning the Head & Figure
Drawing Scenery
Drawing the Head & Figure
First Lessons in Drawing and Painting
How to Draw Animals

DEDICATED TO

ADIE MARKS AND HARRY PROVENCE

THESE MEN HAVE BEEN VERY HELPFUL TO ME OVER THE YEARS.

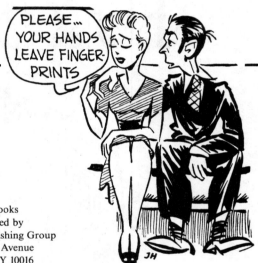

Perigee Books
are published by
The Putnam Publishing Group
200 Madison Avenue
New York, NY 10016

Copyright © 1990 by Jack Hamm
All rights reserved. This book, or parts thereof,
may not be reproduced in any form without permission.
Published simultaneously in Canada

Library of Congress Cataloging-in-Publication Data
Hamm, Jack.
 Drawing and cartooning for laughs / by Jack Hamm.
 p. cm.
 Includes index.
 ISBN 0-399-51634-4
 1. Cartooning. I. Title.
NC1320.H27 1990 90-36196 CIP
741.5—dc20

Printed in the United States of America
1 2 3 4 5 6 7 8 9 10

This book is printed on acid-free paper.

CONTENTS

"LAUGH

and the world laughs with you,
Weep, and you weep alone;
For this brave old earth must
borrow its mirth,
But has trouble enough of its own. "
— Ella Wheeler Wilcox
(American Poet)

PREFACE

I once knew a man who I could hear laughing long before I went into the room where he was. He was not a rich man money-wise. But he was wise in counseling people. His advice was free. His laughter was free.

William Mathews, the American author who lived over a hundred years age, said of laughter, "It is the cheapest luxury man enjoys, "and as Charles Lamb says, 'It is worth a hundred groans in any state of the market,' it stirs up the blood, expands the chest, electrifies the nerves, clears away the cobwebs from the brain, and gives the whole system a shock to which the voltaic-pile is as nothing. Nay, its delicious alchemy converts even tears into the quintessence of merriment, and makes wrinkles themselves expressive of youth and frolic."

Indeed, when one hears the laughter of little children it does something for us who have problems that at times seem unsolvable. We say, "Look at those kids. They haven't a care in the world." True, they don't seem to be burdened with too much yet. Band-Aids are available and their wounds are usually minor and get well quickly. Getting this book together involved hours of work, but by-in large it was fun. Fun things don't have to be costly.

For some four years it was my privilege to illustrate the late Dr. Albert Edward Wiggam's column "Let's Explore Your Mind." He was a good friend and scholar. Occasionally you may see a drawing extracted from the Wiggam series.

For three and a half years I worked at formulating actual television programs intended to entertain. Since the chalk artist has to stand at one side while performing so that the TV camera can zero in, it's necessary to have signal lines pre-drawn in light fall-out blue pencil on the paper. The original concept would be enlarged by means of an opaque projector. This way the resultant routines look right to the viewer.

It takes, on the average, an hour or so preparation for every TV minute before the camera. However, the picture is still the entire work of the one holding the chalk. These are "trade secrets" revealed in this book. It wouldn't be fair to the reader to withhold this information from him. This method was not bandied about when the show was on the weekly TV screen. Many cartoons developed for TV are in this book.

Other books by the author tell how to do the actual drawing step-by-step. An example of this is the A-B-C-D-E of the bear cub on page 89. For several years the author cartooned a "Week-in-Review" strip in a newspaper. Many of these spots are contained in this volume.

Years ago when comics first began, they were few and far between. A single strip was as wide as the newspaper page itself. Now they are half as wide. This is the bane of the cartoonist's life. He cannot develop much in the way of a background setting. There's little room for balloon talk. But he must live with it. For teaching and learning purposes, and in the spirit of the way things are, I have crowded some pages—they look "busy" and the spots are minuscule. However, relief is afforded with some giant-size heads.

The "Stupe the Student" samplings were written and cut on linoleum blocks then printed in the university newspaper. The church humor samplings were from a syndicated series. The big emphasis in this book is to *do* something laughable. What is funny to one person may not be funny to another. Happy reading!

JACK HAMM

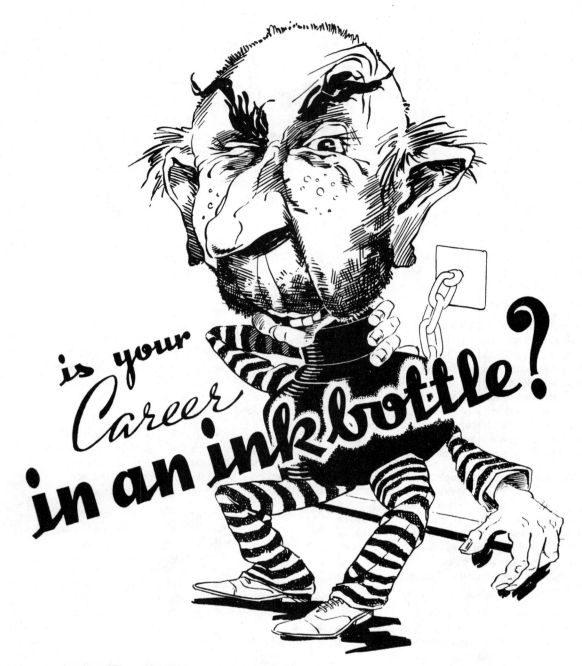

is your Career in an inkbottle?

This whimsical, unshorn character is confined and trapped. But the question is one which we might pose at the very start of the discussions which follow in this book. If you have a real interest in drawing and cartooning, let it escape! It just could be with spare-time practice you can develop a fascinating, fun-filled hobby or even a full-time career in some phase of funny drawing.

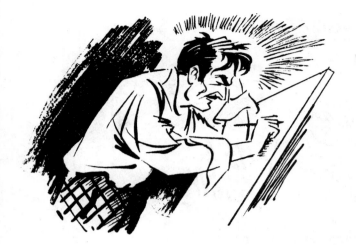

COPING WITH FRUSTRATION

What is the first thing a beginning artist or cartoonist must deal with? As an aspiring creator it has to be a certain feeling of frustration. Before him or her is a blank page. What will be done with it? Fortunately, there is an eraser handy. Often the eraser is as important as the pencil. Indeed, it should be thought of as a tool with which to work. Anyone can put an experimental line down, and anyone can erase it. Rather than grind in a line on the paper, be sure it's lightly done and subject to change.

Think of your pencil as a roving instrument. Lift it up — move it about. It's not very heavy. See how easy it is to touch it to the receiving surface. First off, this fellow at the left has a desk top or adjustable drawing board which is too steep. Of course, it is possible to work on a flat desk or drawing board, and some very successful cartoonists start out that way and end that way. The best way is to have the drawing board or table top slanted. How slanted? The answer: just so things don't slide off of it. When anything slides, it's too steep. So fix it permanently so it stays that way. It's easier on the eyes if it's slightly slanted. The eyes adjust themselves and grow less tired this way. If one is drawing or planning a large picture, a steep slant might be all right.

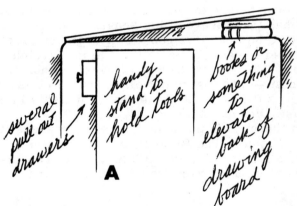

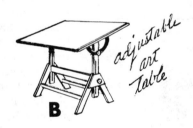

Fig. "A" above is a cross section of any kind of flat desk or table. Nearly everyone has that available. It may be necessary to purchase the drawing board. A couple of books are already close by. Now, prop them up for the proper slant and you're in business. By the newly improvised art table (in fig. A) is a cross section of a little stand of some kind to hold your tools and materials. If it has a drawer or two for accessories that's well and good. Later on you can purchase an adjustable art table such as diagram "B".

The little cartooned guy at the right is about to give birth to a new idea. The English economist and journalist Walter Bagehot said, "The keenest anguish known to human nature is the pain of a new idea." That is true. On the other hand, we've admitted to feeling "frustrated." Frustration is the first step in the right direction. Mixed in with that is being willing to laugh a little at one's self. And that drives away the "pain" of a new idea. It clears the way.

This book is full of new ideas. One idea begets another. Our minds rub off on each other. Ways and styles of cartooning were discussed in Cartooning the Head and Figure by this author. Even if you have never heard or seen this book, you can experiment on your own. With pencil and eraser put down something after you've been stimulated. Let your work be fun. Later you can ink your penciling. The following pages introduce you to "exaggeration" and "distortion."

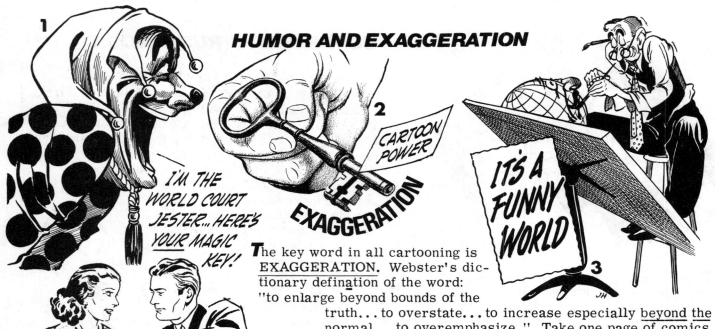

HUMOR AND EXAGGERATION

I'M THE WORLD COURT JESTER... HERE'S YOUR MAGIC KEY!

CARTOON POWER

EXAGGERATION

IT'S A FUNNY WORLD

The key word in all cartooning is EXAGGERATION. Webster's dictionary defination of the word: "to enlarge beyond bounds of the truth... to overstate... to increase especially beyond the normal... to overemphasize." Take one page of comics from most any metropolitan newspaper where there are 12 to 15 comic strips half a page wide and perhaps six to ten gag panels. Now, count every instance of obvious exaggeration. We'll come up with from 150 to 200 examples of exaggeration on that one page. These include exaggerations in the actual drawing and those in the story idea and the wording of it.

More than ever before in our history the reader thinks the cartoonist has taken leave of his senses. Whereas, he has gone way out, he may have gone a way, way out... and beyond that! There seems to be no limit to the stretch of his imagination. Call the cartoonist illogical, a fabricator, an extremist — and that may well be true, but usually that's what makes it funny. And the reader delights in escaping into this ludicrous buffoonery.

It serves a therapeutic purpose. To some readers it serves as a real tonic. The Bible says "A merry heart doeth good like a medicine" (Prov. 17: 22). One translation has it "A joyful heart worketh an excellent cure."

THE COMIC PAGE

SURELY THERE MUST BE ANOTHER WAY TO FIND OUT IF TH' GREASE IS HOT ENOUGH TO COOK FRENCH FRIES!

JACK HAMM

Abraham Lincoln said, "With the fearful strain that is on me night and day, if I did not laugh I should die." The English novelist Thackery wrote, "A good laugh is sunshine in a house." Sir Fulke Greville, English poet, observed, "Man is the only creature endowed with the power of laughter."

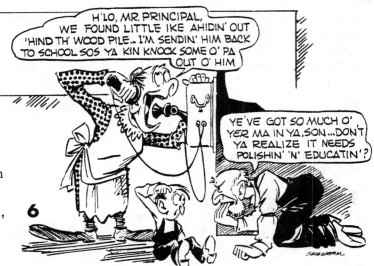

H'LO, MR. PRINCIPAL, WE FOUND LITTLE IKE A-HIDIN' OUT 'HIND TH' WOOD PILE... I'M SENDIN' HIM BACK TO SCHOOL SOS YA KIN KNOCK SOME O' PA OUT O' HIM

YE'VE GOT SO MUCH O' YER MA IN YA, SON... DON'T YA REALIZE IT NEEDS POLISHIN' 'N' EDUCATIN'?

JACK HAMM

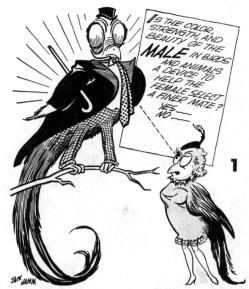

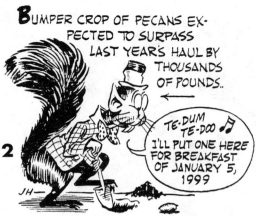

BIRD & ANIMAL EXAGGERATION

On future pages we will feature more birds and animals. Fig. 1 is a clip from Dr. Albert Edward Wiggam's column entitled "Let's Explore Your Mind." Each day there were three questions with the famous doctor's answers below. In the cartoon the two birds are dressed in human clothes. The

squirrel in fig. 2 is a clip from a local newspaper's week-in-review strip. The hat, coat and tie are fitted on the forgetful little creature who will bury many more nuts than he will ever return to dig up.

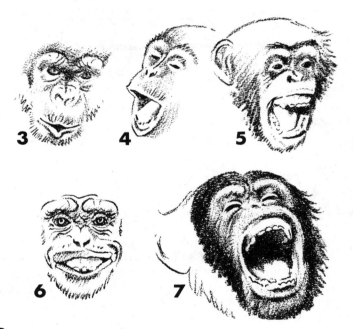

"I HARDLY THINK THAT'S WHAT WAS MEANT BY AN 'ADEQUATE FOLLOW-UP IN OUR FINANCIAL CAMPAIGN'"

Birds, squirrels and monkeys — there is no end — they all invite exaggeration. Figs. 3 to 7 are from How To Draw Animals by this author and are true to life. They were born to exaggerate themselves and they love it. Fig. 8 is an example of using animals with people. This particular situation is not so likely to happen.

The world is replete with bits of delightful exaggeration. Jokes we read and jokes we hear and laugh at are usually tinged with stretching a point. From the moment we get up in the morning we encourage pleasantries and that's all right. There should be an allowance made to engage in some playfulness. When we become serious, and we should, we are better fitted to take on the responsibilities of the day.

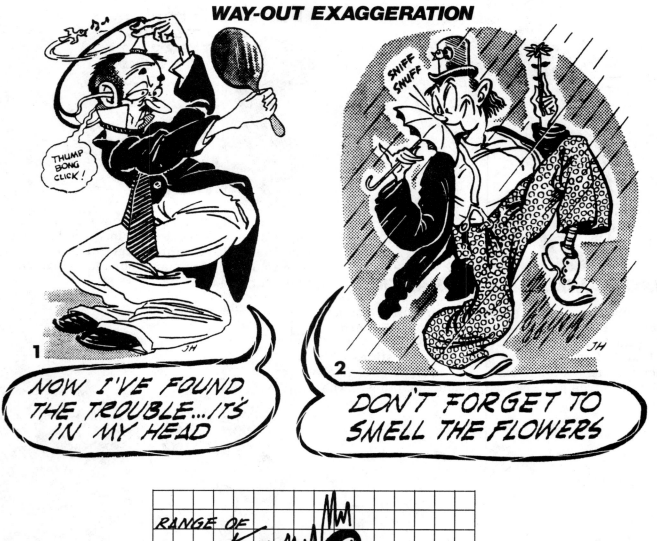

1. NOW I'VE FOUND THE TROUBLE....IT'S IN MY HEAD

2. DON'T FORGET TO SMELL THE FLOWERS

3. RANGE OF *Cartoon* EXAGGERATION

Figs. 1 & 2 are preposterous characters somewhat on the demented side. Little cuckoo birds reside close to their brains. Chart No. 3 suggests the ludicrous ups and downs found in these zany people. They are obvious kooks. Whoever heard of using a stethoscope on top one's head? Or the sounds inside one's head going "thump, bong, click?" But the one on the left admits he's found the trouble: it's in his head. Perhaps the hand mirror reflects something gone wrong.

Fig. 2 is a guy in the rain smelling the umbrella with a "sniff-snuff" sound rather than the flower. Albeit, the flower sheds no water at all. A cuckoo bird lives in his hat. Notice the misfit attire of each person. When one is cartooning craziness, he may portray boisterous bursts of buffoonery along with bits of subtle drollery. If you have fun in the doing, others will have fun in the viewing.

Remember, as we go along, violations of the normal must become the rule. Even before your sketch is finalized, see that there are significant differences. These early pages contain what may appear to be complicated examples of drawing. There will be a swing back to more simple rendering. Right now we need to look at, to consider, to explore the rewards of <u>way-out</u> EXAGGERATION.

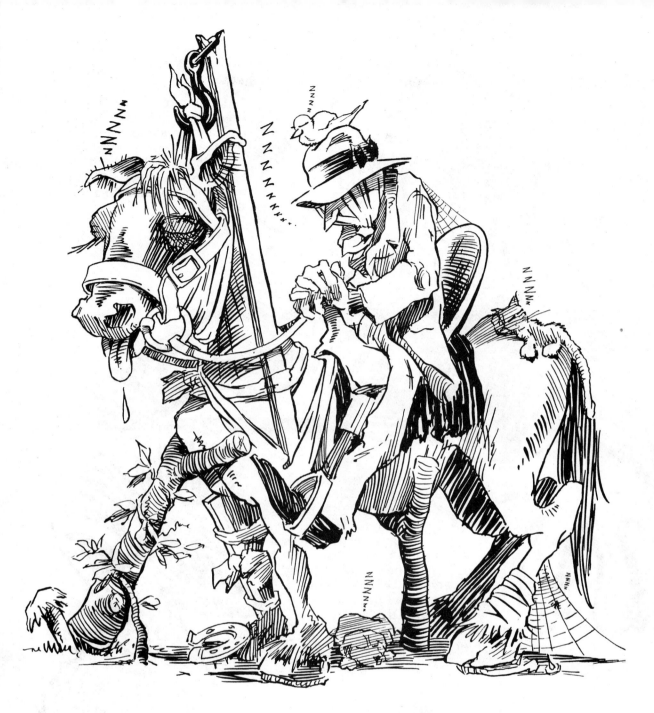

Now that we have the magic key, let's give ourselves an assignment. We want (1) A lazy, good-for-nothing nag of a horse; (2) A sleepy Rip van Winkle-type of rider that propped him up so he wouldn't fall over; and (3) Four list-less companions asleep with him. All of them are quietly snoring ZZZ-zzz-zz--z dove, cat, dog and spider.

The immediate problem is to stay awake long enough to get it all on paper. We've just had a little nap so we're ready to begin. We plan it with a drop-out-blue pencil (possibly a Berol Verithin Sky Blue No. 740 1/2) which re-quires no erasing...the camera won't pick it up). We'll ink it with a flexible pen point (preferably a Gillott No. 170 or a Hunt No. 99). After we're finished, if we have enough strength to crawl up on the bed, we'll take another little nap. We'll entitle our sketch "Stopped for a Rest Zz-z."

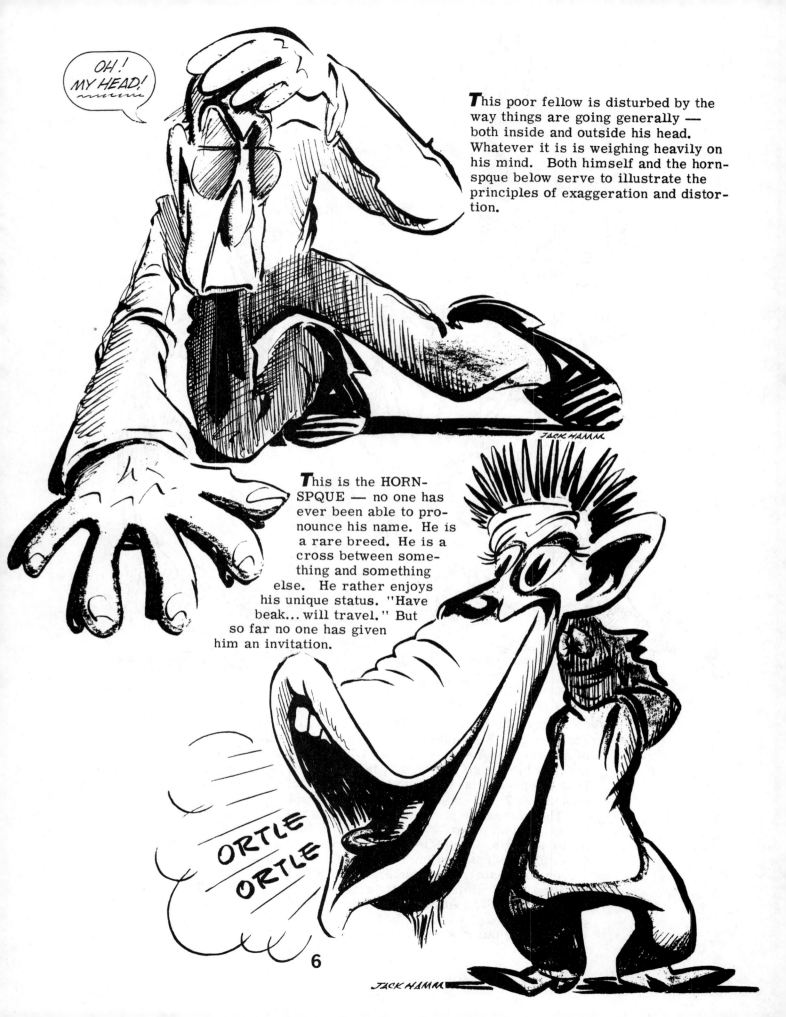

OH! MY HEAD!

This poor fellow is disturbed by the way things are going generally — both inside and outside his head. Whatever it is is weighing heavily on his mind. Both himself and the horn-spque below serve to illustrate the principles of exaggeration and distortion.

This is the HORN-SPQUE — no one has ever been able to pronounce his name. He is a rare breed. He is a cross between something and something else. He rather enjoys his unique status. "Have beak... will travel." But so far no one has given him an invitation.

ORTLE ORTLE

6

7

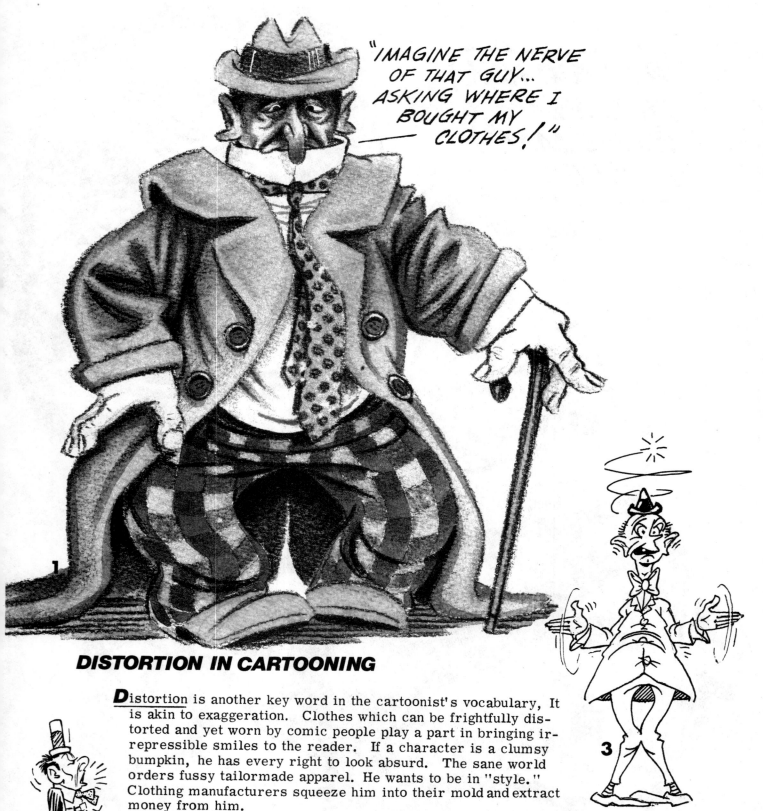

"IMAGINE THE NERVE OF THAT GUY... ASKING WHERE I BOUGHT MY —— CLOTHES!"

DISTORTION IN CARTOONING

Distortion is another key word in the cartoonist's vocabulary, It is akin to exaggeration. Clothes which can be frightfully distorted and yet worn by comic people play a part in bringing irrepressible smiles to the reader. If a character is a clumsy bumpkin, he has every right to look absurd. The sane world orders fussy tailormade apparel. He wants to be in "style." Clothing manufacturers squeeze him into their mold and extract money from him.

Fig. 1 above is highly offended that his taste in clothing is questioned. Fig. 2 openly defends his choice and fig. 3 couldn't care less. Open your daily newspaper to the comic page and count the pieces of clothing which don't fit. Hats sometimes come down over their eyes; some of them eat and sleep in their hats. Trousers are seldom pressed. Very often pants are too short or too long. Belts are left off or drawn too tightly. Neckties and collars are too big or too small. Sleeves on shirts and coats often cover the hands.

Why are circus clowns loved by children of all ages? One reason is their crazy,

(cont'd next page)

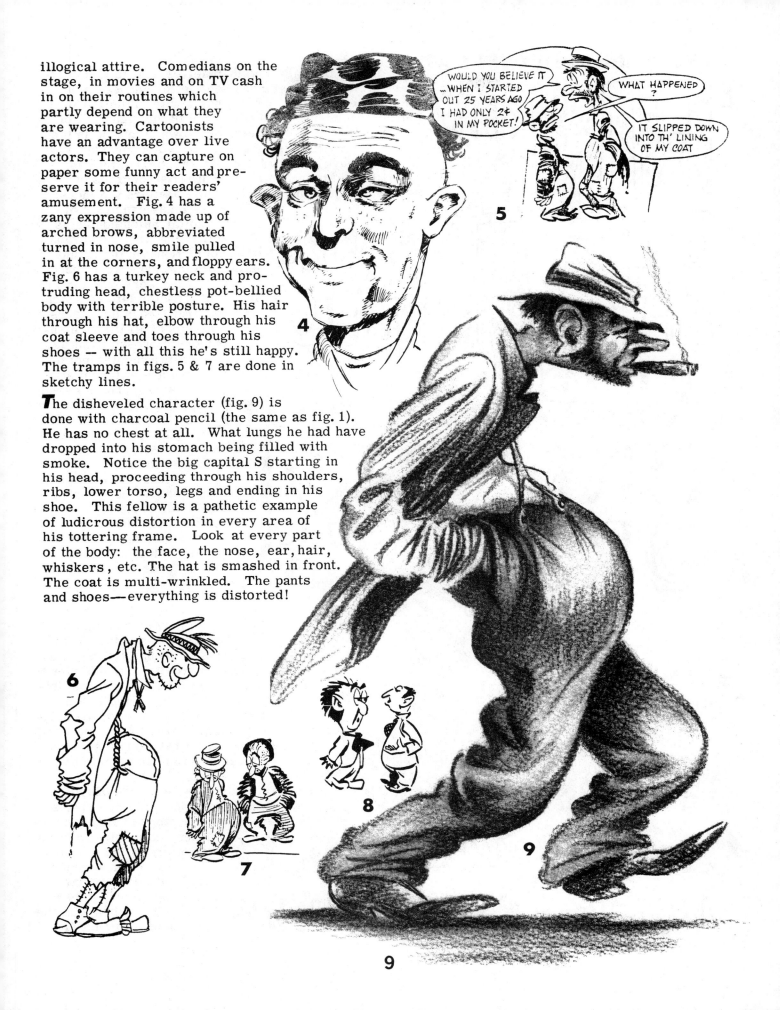

illogical attire. Comedians on the
stage, in movies and on TV cash
in on their routines which
partly depend on what they
are wearing. Cartoonists
have an advantage over live
actors. They can capture on
paper some funny act and pre-
serve it for their readers'
amusement. Fig. 4 has a
zany expression made up of
arched brows, abbreviated
turned in nose, smile pulled
in at the corners, and floppy ears.
Fig. 6 has a turkey neck and pro-
truding head, chestless pot-bellied
body with terrible posture. His hair
through his hat, elbow through his
coat sleeve and toes through his
shoes -- with all this he's still happy.
The tramps in figs. 5 & 7 are done in
sketchy lines.

The disheveled character (fig. 9) is
done with charcoal pencil (the same as fig. 1).
He has no chest at all. What lungs he had have
dropped into his stomach being filled with
smoke. Notice the big capital S starting in
his head, proceeding through his shoulders,
ribs, lower torso, legs and ending in his
shoe. This fellow is a pathetic example
of ludicrous distortion in every area of
his tottering frame. Look at every part
of the body: the face, the nose, ear, hair,
whiskers, etc. The hat is smashed in front.
The coat is multi-wrinkled. The pants
and shoes—everything is distorted!

WOULD YOU BELIEVE IT
...WHEN I STARTED
OUT 25 YEARS AGO
I HAD ONLY 2¢
IN MY POCKET!

WHAT HAPPENED
?

IT SLIPPED DOWN
INTO TH' LINING
OF MY COAT

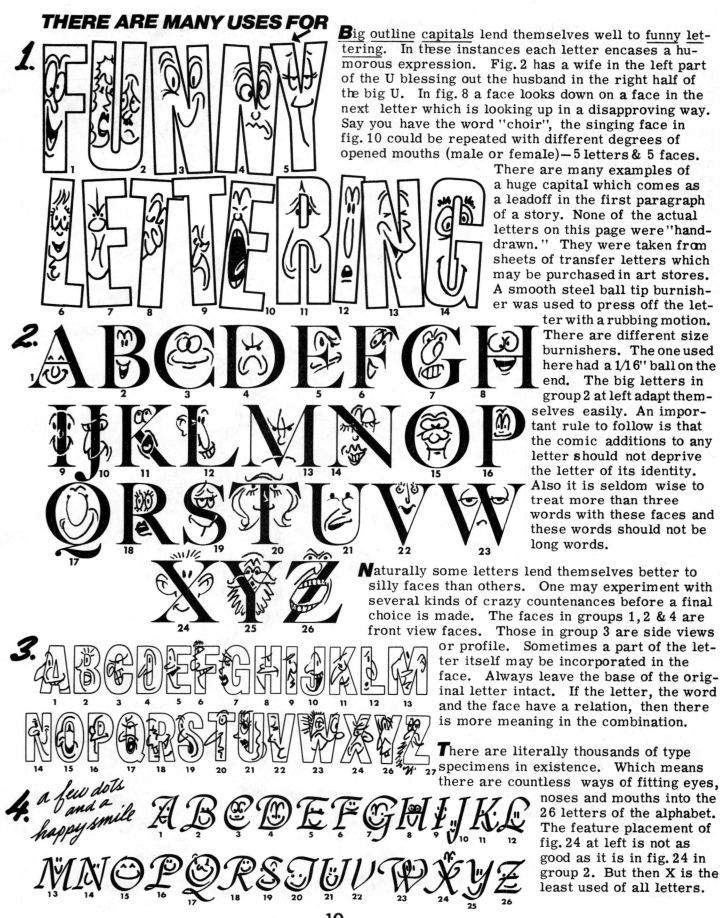

THERE ARE MANY USES FOR

1. FUNNY LETTERING

Big outline capitals lend themselves well to funny lettering. In these instances each letter encases a humorous expression. Fig. 2 has a wife in the left part of the U blessing out the husband in the right half of the big U. In fig. 8 a face looks down on a face in the next letter which is looking up in a disapproving way. Say you have the word "choir", the singing face in fig. 10 could be repeated with different degrees of opened mouths (male or female)—5 letters & 5 faces.

There are many examples of a huge capital which comes as a leadoff in the first paragraph of a story. None of the actual letters on this page were "hand-drawn." They were taken from sheets of transfer letters which may be purchased in art stores. A smooth steel ball tip burnisher was used to press off the letter with a rubbing motion. There are different size burnishers. The one used here had a 1/16" ball on the end. The big letters in group 2 at left adapt themselves easily. An important rule to follow is that the comic additions to any letter should not deprive the letter of its identity. Also it is seldom wise to treat more than three words with these faces and these words should not be long words.

Naturally some letters lend themselves better to silly faces than others. One may experiment with several kinds of crazy countenances before a final choice is made. The faces in groups 1, 2 & 4 are front view faces. Those in group 3 are side views or profile. Sometimes a part of the letter itself may be incorporated in the face. Always leave the base of the original letter intact. If the letter, the word and the face have a relation, then there is more meaning in the combination.

There are literally thousands of type specimens in existence. Which means there are countless ways of fitting eyes, noses and mouths into the 26 letters of the alphabet. The feature placement of fig. 24 at left is not as good as it is in fig. 24 in group 2. But then X is the least used of all letters.

10

A GOOD CARTOON STRIP OR A GOOD
TITLE DESERVES GOOD LETTERING

The first law of all lettering is to contain the meaning of what's said. Good lettering should have an instantaneous quality about it. Today the competition is so great in printed matter that even in the funny papers it's a good idea to make it read quickly. Some people automatically pass up reading if it takes work to read it. If a standing caption or title or a brand name is to compete, then it should be uniquely different in appearance. Of course, the product should be good at the start. If it's supposed to be laughable, it should emit more than a whimper.

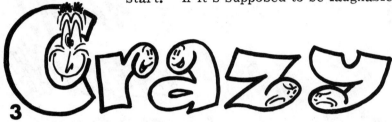

Since the surface of paper is flat and two dimensional, it lelps to <u>lift</u> lettering off the page optically. One way of doing that is to put a shadow behind it

as in example No. 1. Just bold outline is all right as in example No. 2 if there is a special uniqueness about the design itself. But the outline should be <u>bold</u>. If color is involved then the inside of each letter may have this added help. Example No. 3 has comic faces within ovals which are integral parts of the five letters in the word Crazy. Example No. 4 has the captial "C" as false teeth chomping down on the next letter which is none too happy about being bitten. False teeth in comics often have a hinge onto which the upper and lower plates are attached. Example No. 5 has five little people peeking over and through the letters. The letters are of the balloon type with the lower portion of each shaded to create the illusion of thickness.

In example No. 6 Crazy is spelled crazily with a capital "K" and "ie" instead of the "y" ending. The word Krazie (though there be no such word) is on a long light-lined rectangle with a shadow beneath it. The pair above the made-up word make an off-the-cuff observation.

Lastly, the two words CARTOON LETTERING are of the outline variety and are often used in comic strips and gag panels. On the following pages cartoon "sounds" are explored. They contribute to this business of laughing, the primary emphasis of this book.

The hand lettering on this page has been designed to give us an idea of what can be done to enhance your comics. First let's consider a few basic letter styles as set forth in examples from fig. 1 through fig. 13. Actually the most commonly used capitals are figs. 1 through 8.

No. 1 OVERLAP is just what it says. The outline letters overlap each other in an informal way. No. 2 BALLOON has many variances in thickness. There may be overlap in these letters also. No. 3 CONNECT has letters which appear to grow into and out of each other. No. 4 SHADOW has letters which seem to be lifted up from the page leaving shadows underneath. These too may overlap. No. 5 OUTLINE has a continuous line going around informal capitals. No. 6 FAT is in contrast with No. 7 SKINNY. No. 8 SOLID consists of thick, bold letters filled in. Nos. 9 to 13 are less often used.

Be inventive!! This funny business has no hard and fast rules. Now we're ready to discuss CARTOON SOUNDS.

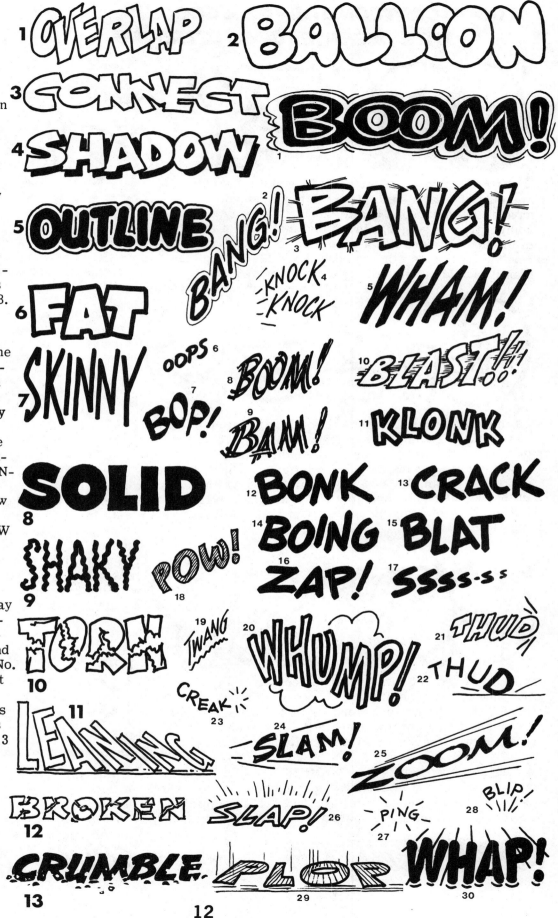

SOUNDS THAT BRING LIFE TO COMIC PAGES

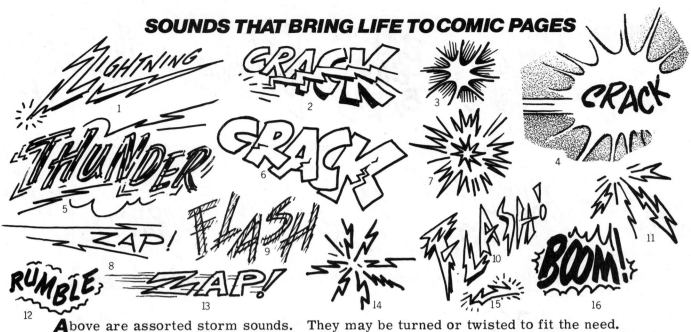

Above are assorted storm sounds. They may be turned or twisted to fit the need. Too many at one time may lessen the effect desired. They may be simplified, enlarged or reduced to fit the occasion. Some may be used along with fireworks.

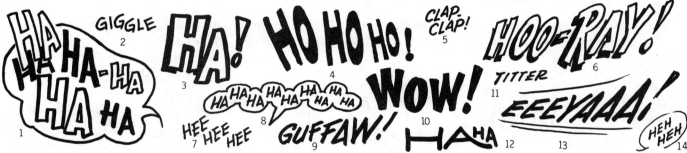

Sounds of laughter can be easily adapted: a series of HA's or just one HA, knee-slapping laughter or a quiet little chuckle. Facial expressions on cartoon people and their bodily positions are important. Be sure to relate the laughter sound with the person sounding off.

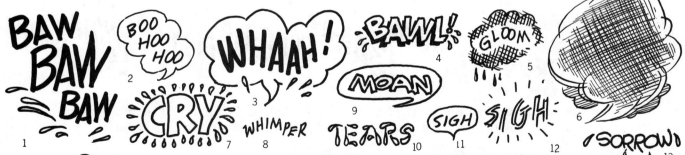

Sounds of crying are at opposites with those of laughter. From the expected BOO-HOO to the silent gloom cloud where there is just nothing but grey hovering overhead. From little babies to big grown-ups, when a tear flows the noise grows.

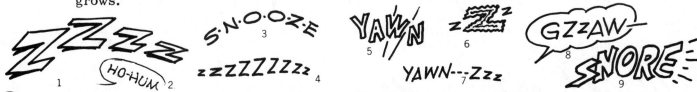

Sleeping sounds near a cartooned head denote sleep. Just one Z can get the job done. The depth of sleep may call for many Z's. Loud snores may require bigger letters. Funny people do sleep lots.

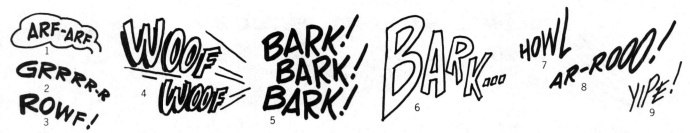

Here are some sounds dogs make. The size and intensity of the lettering is important.

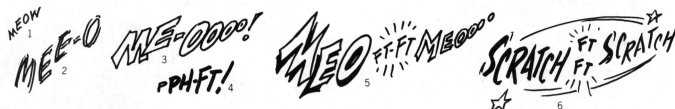

Cat sounds can be quiet like fig. 1 or they can be loud like 2 & 3. Figs. 4, 5 & 6 would be for two or more cats getting in a fight.

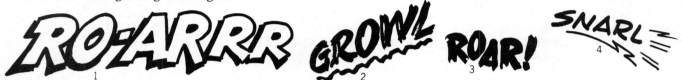

Noises of the jungle or zoos grow louder still. Comic animals can talk in some gag panels or strips expressing themselves in English or the language of the readers.

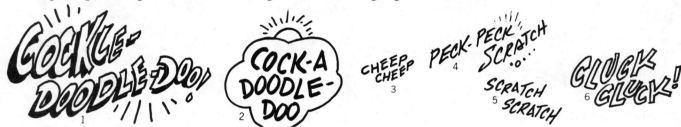

Turning to the backyard or out on the farm, we hear the rooster or baby chicks or hens.

OINK-OINK-OINK GRUNT GRUNT MOOOO-OO-OO BAA-A-A-AA HEE-HAW NAY-Y-Y-Y-Y-AA WHN-NIE WHN-NIE

Continuing sounds from farm animals: (1)pig, (2)cow, (3)sheep, (4)donkey, (5)horse. Notice possible outline treatment in fig. 1. Figs. 2, 3, 4 & 5 begin with shadowed initial letter. Surely there are other ways too.

KAW KAW! POLY WANTS A CRACKER— ARK ARK CHIRP CHIRP HOOT HOOT HOOT HOOT

Bird sounds are sometimes needed. Fig. 1 is the crow; fig. 2 is the parrot; fig. 3 a bird, of course there are many bird calls, but the "chirp" for cartoonists is usually enough; figs. 4 & 5 the hoot owl.

WHOA.!! STOP.!! HALT.!! WAIT.!!

At left are four different words meant to hold up. They are italicized for emphasis. Exclamation points are a further help.

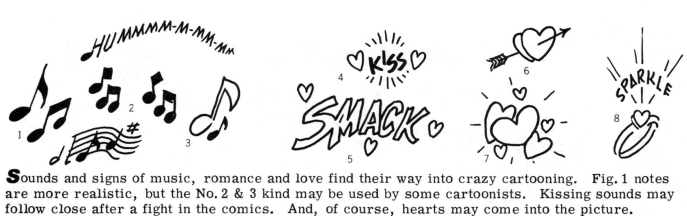

Sounds and signs of music, romance and love find their way into crazy cartooning. Fig. 1 notes are more realistic, but the No. 2 & 3 kind may be used by some cartoonists. Kissing sounds may follow close after a fight in the comics. And, of course, hearts may come into the picture.

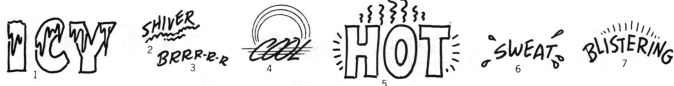

Cold sounds and shivering are in contrast to hot sounds and sweltering.

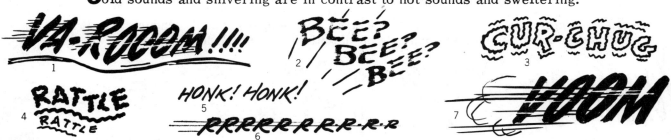

Sounds of automobiles, motorcycles and speedboats. They can come from the motor, the horn or the condition of the machine itself.

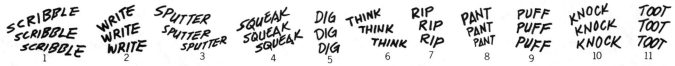

Sounds that can be expressed in triplicate. Such words are usually one beneath the other. They could be graduated in larger letters as they come down. In some cases like example 6 there could be no actual sounds at all — the THINKS should be close to the head. Exclamation points could follow each word. There are many other word sounds than are presented here.

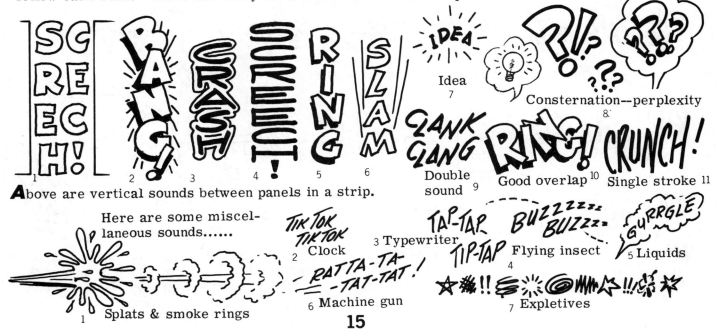

Above are vertical sounds between panels in a strip.

Here are some miscellaneous sounds......

Idea 7

Consternation--perplexity 8

Double sound 9 Good overlap 10 Single stroke 11

2 Clock 3 Typewriter 4 Flying insect 5 Liquids

6 Machine gun 7 Expletives

1 Splats & smoke rings

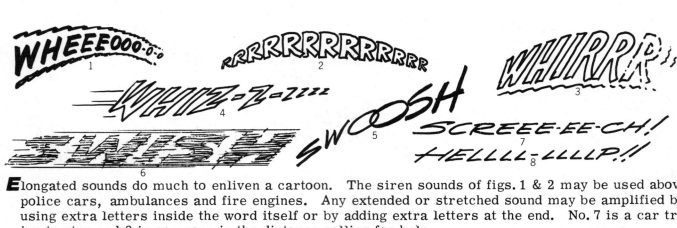

Elongated sounds do much to enliven a cartoon. The siren sounds of figs. 1 & 2 may be used above police cars, ambulances and fire engines. Any extended or stretched sound may be amplified by using extra letters inside the word itself or by adding extra letters at the end. No. 7 is a car trying to stop and 8 is someone in the distance calling for help.

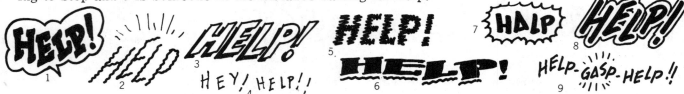

In the comics calls for help are often from a wide-open mouth — though not always. The degree of desperation depends on the situation and the idea behind it.

Whether it's sitting on a tack or being run over by a train it can be funny in the funny papers. The sound may be the same in either case. Since it's not real life it's not to be taken seriously.

A sound or two when one is under the weather.

Some cartoon characters are noisy eaters and drinkers.

Here are some overhead cartoon sounds that may be used when people engage in swatting matches or fisticuffs. The spontaneous disagreements which funny neighbors have or which bosses have with members of their office force...comic characters can get steamed up over about anything.

"WE'RE GOING TO TURN THIS PLACE INTO A
POORTRAIT STUPIDIO.

YOU GIVE ME THE TRAITS. I'LL DO THE POOR PART.
AND THE RESULTS WILL PROBABLY BE STUPID!

Doubtless this place has never been a stupidio—and, after today (by majority consent), may never be again."

IF YOU'RE BEHIND A POST WHERE YOU CAN'T SEE, HOLD ON TO YOUR SEAT...LATER IN THE PROGRAM IT WILL BE WORTH TWICE WHAT YOU PAID FOR IT!

"**F**irst, let's divide the audience into five sections. The first on my right will be our <u>nose department</u>. There are many kinds of noses: Roman nose, pug nose, long nose, beak nose, broken nose, big round nose, etc. I'll be back for your choice in a moment — help me keep those noses running!

Next is our <u>mouth department</u>. Think it through: laughing mouth,

*(continued top left),

*(cont'd from center column this page)

sad mouth, bucktooth mouth, angry mouth, yelling mouth, etc. The mouth is a great emotion setter and we eat with it too.

Next we have the <u>eye department</u>. Could be one derives inspiration by looking into the eyes of the party next to you. There are sleepy eyes, crying eyes, bespectacled eyes, surprised eyes, squinting eyes, etc.

Next come the chins. Since the mouth and chin work together, we draw them with each in mind. In the <u>chin department</u>: double and triple chins, receding chins, protruding chins, pointed chins, long whiskers, etc.

Last of all is the <u>hair department</u>. Oftentimes the sex of the character is determined by the hair or lack thereof. Any comic face can be feminized by a woman's comic hairdo. This POORTRAIT STUPIDIO routine has been presented to groups ranging in size from a few dozen in school classrooms to large audiences in public auditoriums. It is an audience-participation "game" for all ages. For additional facial features see the next page in this book entitled FACIAL FEATURE FUN WHEELS.

17

FACIAL FEATURE FUN WHEELS

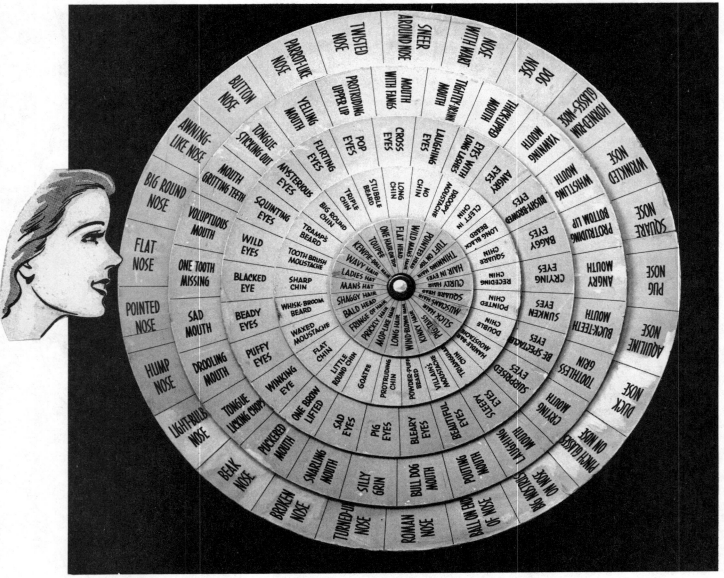

TWIRLED BEFORE MILLIONS OF TELEVISION VIEWERS

Above are five different wheels which may be revolved independently of each other. They are mounted on a sturdy tripod and spun by hand. The outer wheel is 32 inches in diameter. The center spindle is five feet off the floor to accommodate a young lady's profile. Her nose serves as a pointer. When all wheels have stopped, the five features in line serve as a guide for a crazy face. The face is drawn on a large pad of paper before the TV camera. There are over 48 million possibilities by actual count. Here are 18 examples:

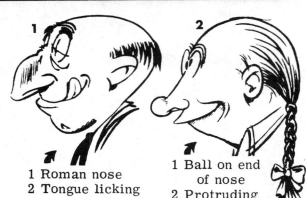

1
1 Roman nose
2 Tongue licking chops
3 Bleary eyes
4 Cleft in chin
5 Fringe of hair

2
1 Ball on end of nose
2 Protruding upper lip
3 Cross eyes
4 No chin
5 Pigtails

18

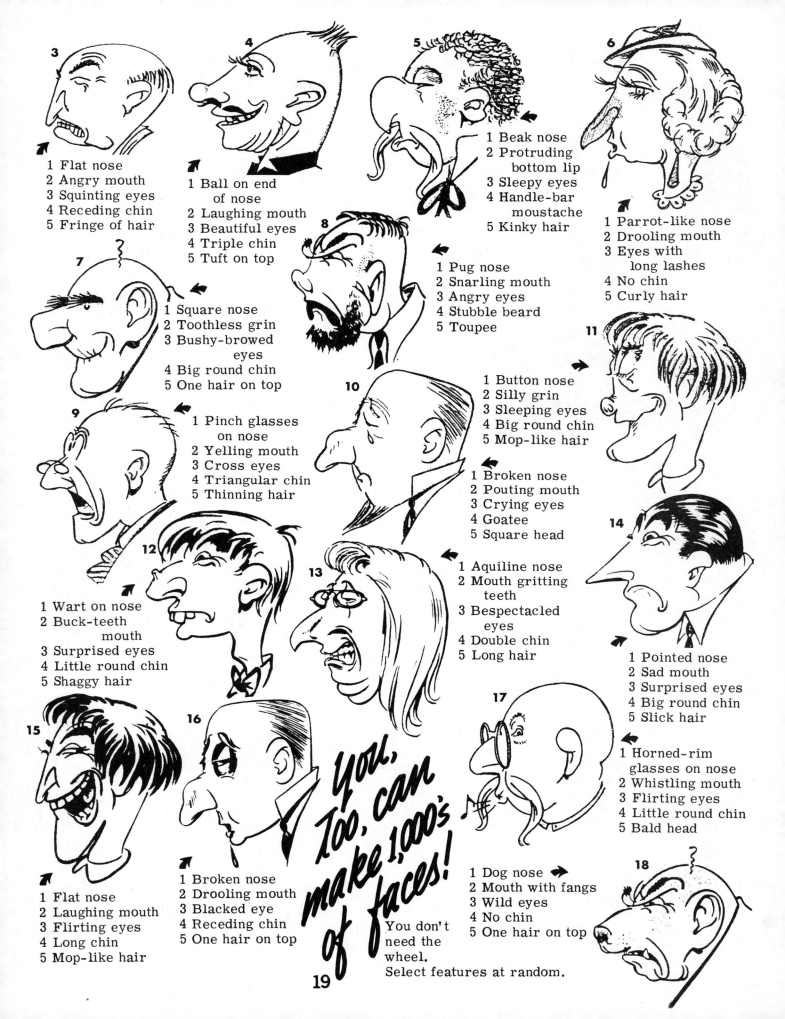

3
1 Flat nose
2 Angry mouth
3 Squinting eyes
4 Receding chin
5 Fringe of hair

4
1 Ball on end
 of nose
2 Laughing mouth
3 Beautiful eyes
4 Triple chin
5 Tuft on top

5
1 Beak nose
2 Protruding
 bottom lip
3 Sleepy eyes
4 Handle-bar
 moustache
5 Kinky hair

6
1 Parrot-like nose
2 Drooling mouth
3 Eyes with
 long lashes
4 No chin
5 Curly hair

7
1 Square nose
2 Toothless grin
3 Bushy-browed
 eyes
4 Big round chin
5 One hair on top

8
1 Pug nose
2 Snarling mouth
3 Angry eyes
4 Stubble beard
5 Toupee

9
1 Pinch glasses
 on nose
2 Yelling mouth
3 Cross eyes
4 Triangular chin
5 Thinning hair

10
1 Broken nose
2 Pouting mouth
3 Crying eyes
4 Goatee
5 Square head

11
1 Button nose
2 Silly grin
3 Sleeping eyes
4 Big round chin
5 Mop-like hair

12
1 Wart on nose
2 Buck-teeth
 mouth
3 Surprised eyes
4 Little round chin
5 Shaggy hair

13
1 Aquiline nose
2 Mouth gritting
 teeth
3 Bespectacled
 eyes
4 Double chin
5 Long hair

14
1 Pointed nose
2 Sad mouth
3 Surprised eyes
4 Big round chin
5 Slick hair

15
1 Flat nose
2 Laughing mouth
3 Flirting eyes
4 Long chin
5 Mop-like hair

16
1 Broken nose
2 Drooling mouth
3 Blacked eye
4 Receding chin
5 One hair on top

17
1 Horned-rim
 glasses on nose
2 Whistling mouth
3 Flirting eyes
4 Little round chin
5 Bald head

18

19
1 Dog nose
2 Mouth with fangs
3 Wild eyes
4 No chin
5 One hair on top

You, Too, can make 1,000's of faces!

You don't
need the
wheel.
Select features at random.

FUNNY FACES BY THE NUMBER

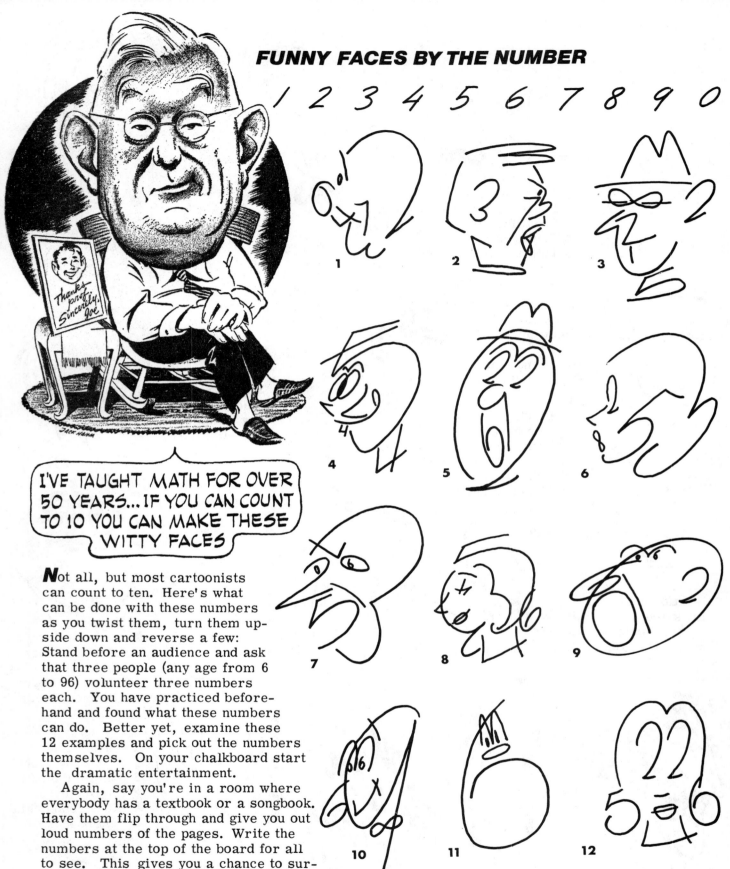

1 2 3 4 5 6 7 8 9 0

I'VE TAUGHT MATH FOR OVER 50 YEARS... IF YOU CAN COUNT TO 10 YOU CAN MAKE THESE WITTY FACES

Not all, but most cartoonists can count to ten. Here's what can be done with these numbers as you twist them, turn them upside down and reverse a few: Stand before an audience and ask that three people (any age from 6 to 96) volunteer three numbers each. You have practiced beforehand and found what these numbers can do. Better yet, examine these 12 examples and pick out the numbers themselves. On your chalkboard start the dramatic entertainment.

Again, say you're in a room where everybody has a textbook or a songbook. Have them flip through and give you out loud numbers of the pages. Write the numbers at the top of the board for all to see. This gives you a chance to survey what you've got to work with. Then engage in the fun. Or let's say you're at a party. You have Xerox copies of these 12 examples ready to hand out after the guests arrive. This gives everybody an idea of what to do on the blank pages with the pencils you've afforded them. If you are the sole performer there are lots of ways the numbers can be arrived at: people's ages, birthdays, number of children times three, or number of grandchildren, etc.

20

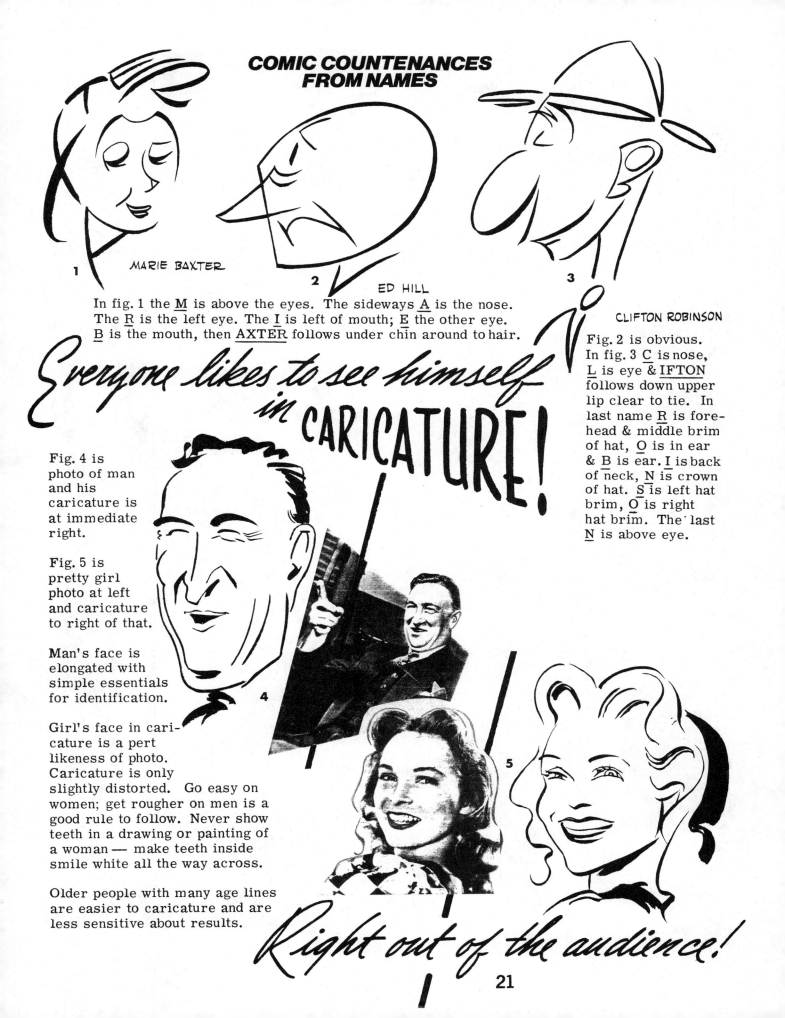

COMIC COUNTENANCES FROM NAMES

1

MARIE BAXTER

2

ED HILL

3

CLIFTON ROBINSON

In fig. 1 the <u>M</u> is above the eyes. The sideways <u>A</u> is the nose. The <u>R</u> is the left eye. The <u>I</u> is left of mouth; <u>E</u> the other eye. <u>B</u> is the mouth, then <u>AXTER</u> follows under chin around to hair.

Fig. 2 is obvious. In fig. 3 <u>C</u> is nose, <u>L</u> is eye & <u>IFTON</u> follows down upper lip clear to tie. In last name <u>R</u> is forehead & middle brim of hat, <u>O</u> is in ear & <u>B</u> is ear. <u>I</u> is back of neck, <u>N</u> is crown of hat. <u>S</u> is left hat brim, <u>O</u> is right hat brim. The last <u>N</u> is above eye.

Everyone likes to see himself in CARICATURE!

Fig. 4 is photo of man and his caricature is at immediate right.

Fig. 5 is pretty girl photo at left and caricature to right of that.

Man's face is elongated with simple essentials for identification.

Girl's face in caricature is a pert likeness of photo. Caricature is only slightly distorted. Go easy on women; get rougher on men is a good rule to follow. Never show teeth in a drawing or painting of a woman — make teeth inside smile white all the way across.

Older people with many age lines are easier to caricature and are less sensitive about results.

4

5

Right out of the audience!

21

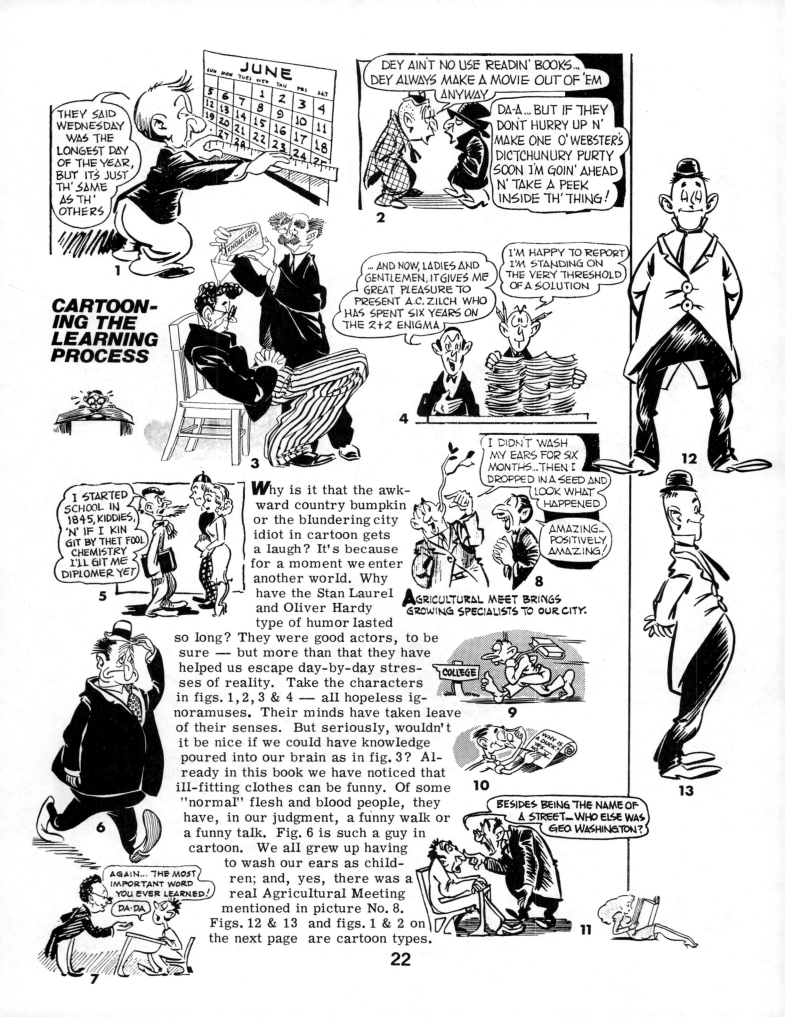

CARTOONING THE LEARNING PROCESS

Why is it that the awkward country bumpkin or the blundering city idiot in cartoon gets a laugh? It's because for a moment we enter another world. Why have the Stan Laurel and Oliver Hardy type of humor lasted so long? They were good actors, to be sure — but more than that they have helped us escape day-by-day stresses of reality. Take the characters in figs. 1, 2, 3 & 4 — all hopeless ignoramuses. Their minds have taken leave of their senses. But seriously, wouldn't it be nice if we could have knowledge poured into our brain as in fig. 3? Already in this book we have noticed that ill-fitting clothes can be funny. Of some "normal" flesh and blood people, they have, in our judgment, a funny walk or a funny talk. Fig. 6 is such a guy in cartoon. We all grew up having to wash our ears as children; and, yes, there was a real Agricultural Meeting mentioned in picture No. 8. Figs. 12 & 13 and figs. 1 & 2 on the next page are cartoon types.

CARTOONING SCHOOL KIDS

Random spots from the scrap book

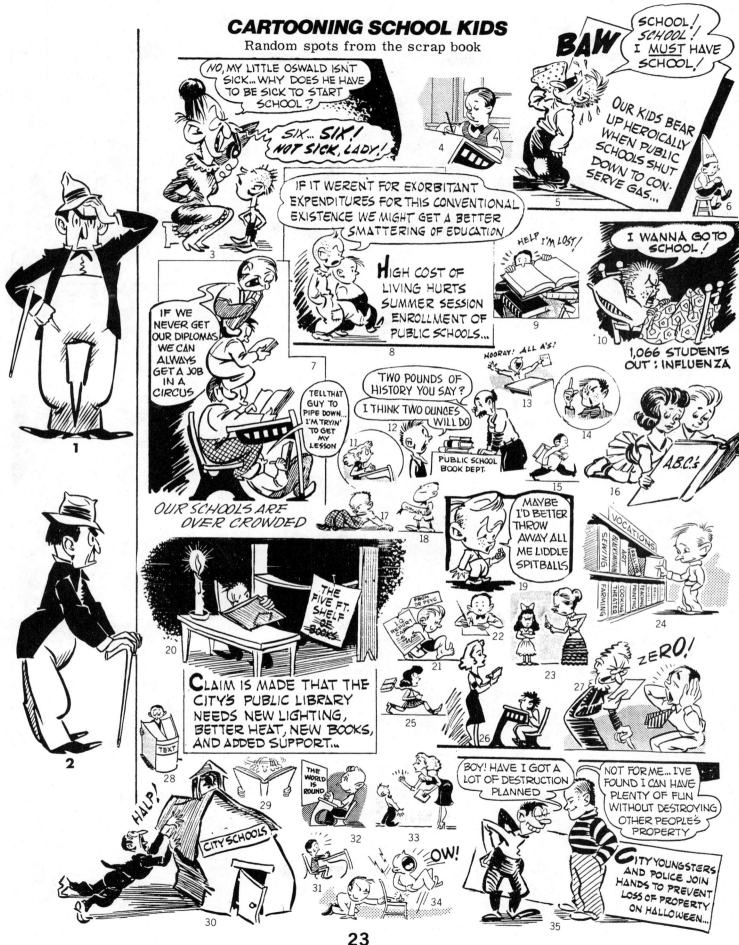

CARTOONING COLLEGE STUDENTS

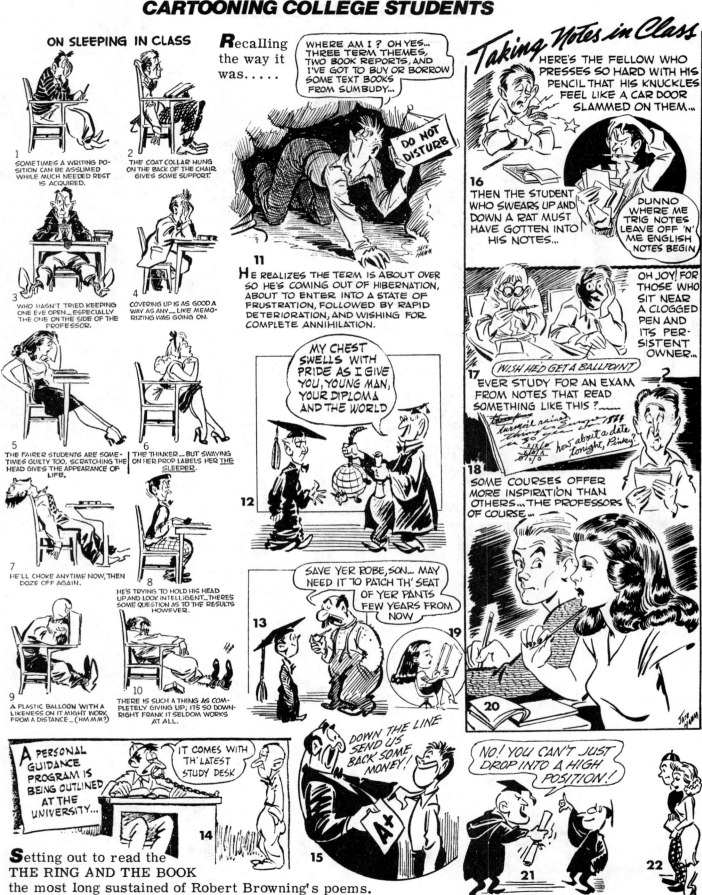

ON SLEEPING IN CLASS

1 SOMETIMES A WRITING POSITION CAN BE ASSUMED WHILE MUCH NEEDED REST IS ACQUIRED.

2 THE COAT COLLAR HUNG ON THE BACK OF THE CHAIR GIVES SOME SUPPORT.

3 WHO HASN'T TRIED KEEPING ONE EYE OPEN—ESPECIALLY THE ONE ON THE SIDE OF THE PROFESSOR.

4 COVERING UP IS AS GOOD A WAY AS ANY—LIKE MEMORIZING WAS GOING ON.

5 THE FAIRER STUDENTS ARE SOMETIMES GUILTY TOO. SCRATCHING THE HEAD GIVES THE APPEARANCE OF LIFE.

6 THE THINKER—BUT SWAYING ON HER PROP LABELS HER THE SLEEPER.

7 HE'LL CHOKE ANYTIME NOW, THEN DOZE OFF AGAIN.

8 HE'S TRYING TO HOLD HIS HEAD UP AND LOOK INTELLIGENT—THERE'S SOME QUESTION AS TO THE RESULTS HOWEVER.

9 A PLASTIC BALLOON WITH A LIKENESS ON IT MIGHT WORK FROM A DISTANCE— (HMMM?)

10 THERE IS SUCH A THING AS COMPLETELY GIVING UP; IT'S SO DOWNRIGHT FRANK IT SELDOM WORKS AT ALL.

Recalling the way it was.....

WHERE AM I? OH YES... THREE TERM THEMES, TWO BOOK REPORTS, AND I'VE GOT TO BUY OR BORROW SOME TEXT BOOKS FROM SUMBUDY...

DO NOT DISTURB

11 **H**E REALIZES THE TERM IS ABOUT OVER SO HE'S COMING OUT OF HIBERNATION, ABOUT TO ENTER INTO A STATE OF FRUSTRATION, FOLLOWED BY RAPID DETERIORATION, AND WISHING FOR COMPLETE ANNIHILATION.

MY CHEST SWELLS WITH PRIDE AS I GIVE YOU, YOUNG MAN, YOUR DIPLOMA AND THE WORLD

12

SAVE YER ROBE, SON... MAY NEED IT TO PATCH TH' SEAT OF YER PANTS FEW YEARS FROM NOW

13

A PERSONAL GUIDANCE PROGRAM IS BEING OUTLINED AT THE UNIVERSITY...

IT COMES WITH TH' LATEST STUDY DESK

14

Setting out to read the THE RING AND THE BOOK the most long sustained of Robert Browning's poems.

DOWN THE LINE SEND US BACK SOME MONEY!

A+

15

Taking Notes in Class

HERE'S THE FELLOW WHO PRESSES SO HARD WITH HIS PENCIL THAT HIS KNUCKLES FEEL LIKE A CAR DOOR SLAMMED ON THEM...

16 THEN THE STUDENT WHO SWEARS UP AND DOWN A RAT MUST HAVE GOTTEN INTO HIS NOTES...

DUNNO WHERE ME TRIG NOTES LEAVE OFF 'N' ME ENGLISH NOTES BEGIN

17 OH JOY! FOR THOSE WHO SIT NEAR A CLOGGED PEN AND ITS PERSISTENT OWNER...

WISH HED GET A BALLPOINT

18 EVER STUDY FOR AN EXAM FROM NOTES THAT READ SOMETHING LIKE THIS?

how about a date tonight, Pinky?

19 SOME COURSES OFFER MORE INSPIRATION THAN OTHERS...THE PROFESSORS OF COURSE...

20

NO! YOU CAN'T JUST DROP INTO A HIGH POSITION!

21

22

24

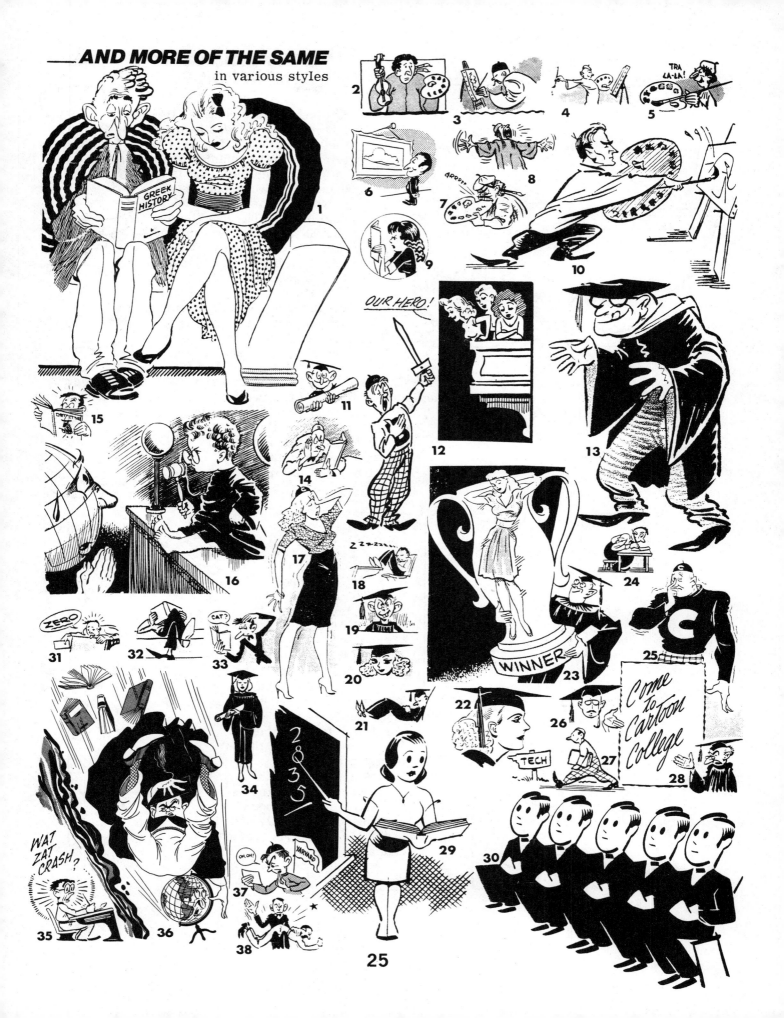

___ *AND MORE OF THE SAME*
in various styles

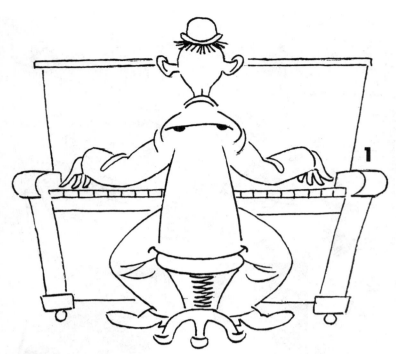

FUNNY MUSICIAN BREAKDOWS

During this TV routine, tin-pan piano music was heard in the background. The first thing drawn for pianist No. 1 is fig. 2 at the right. It is a huge face with droopy eyes, a furrowed brow and a thick underlip grin. The head below (fig. 3) was not drawn immediately. Later, when it was added, it showed the backside as it appears at the left. As a final punch line, his smiling face was twisted around beneath his derby hat. His handlebar ears are in keeping with musicians of this type.

Routine No. 2 is made up of six different faces. It is well to present these one at a time in their proper place on the revolving board. The long face (fig. 1) is drawn first. His smiling compatriot (fig. 2) is drawn below this to the right. The board is then turned so the fig. 3 face (on the arm) can be added. Face (fig. 4) with his tongue hanging out is next in line. For this the entire board is turned upside down.

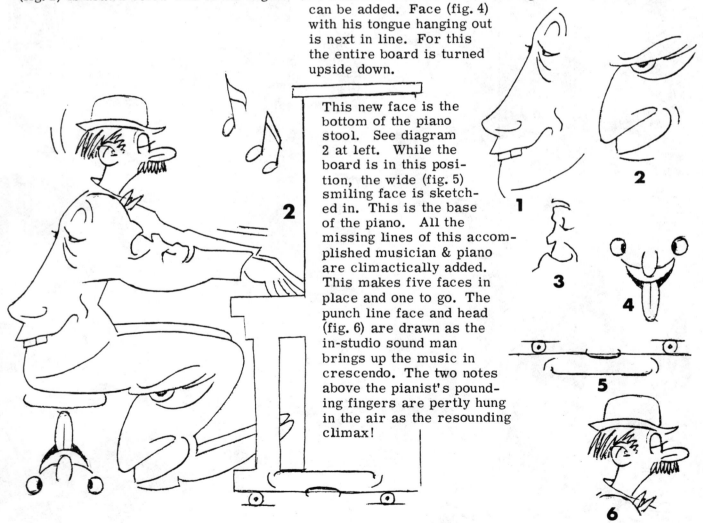

This new face is the bottom of the piano stool. See diagram 2 at left. While the board is in this position, the wide (fig. 5) smiling face is sketched in. This is the base of the piano. All the missing lines of this accomplished musician & piano are climactically added. This makes five faces in place and one to go. The punch line face and head (fig. 6) are drawn as the in-studio sound man brings up the music in crescendo. The two notes above the pianist's pounding fingers are pertly hung in the air as the resounding climax!

26

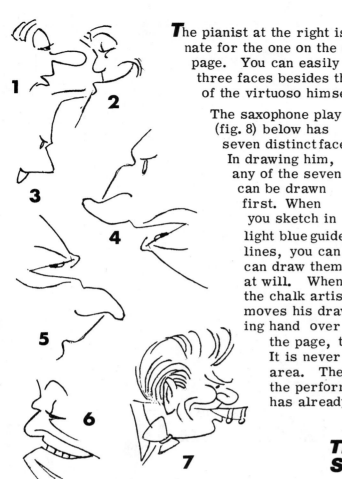

The pianist at the right is an alternate for the one on the opposite page. You can easily locate three faces besides the one of the virtuoso himself.

The saxophone player (fig. 8) below has seven distinct faces. In drawing him, any of the seven can be drawn first. When you sketch in light blue guide lines, you can can draw them at will. When the chalk artist moves his drawing hand over the page, the viewer is kept awake wondering what is going on. It is never wise to confine too much minute activity in a small area. The whole operation has more of a "flare" about it when the performer wastes no time. The careful exacting planning has already been done beforetime.

THE 7-HEADED SAXOPHONIST

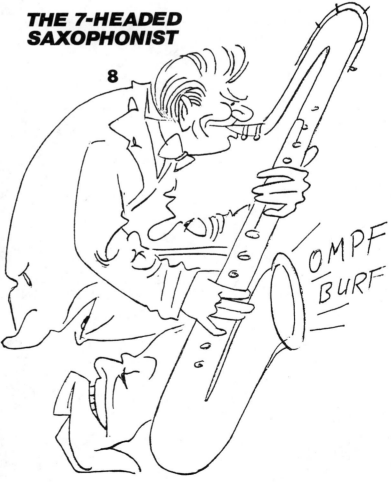

THE MUSICAL FOOTBALL SQUAD CHOIR

"THE CENTER, GUARDS, TACKLES AND ENDS ARE SINGING WELL ... NOW, CONCERNING THE BACKFIELD..."

27

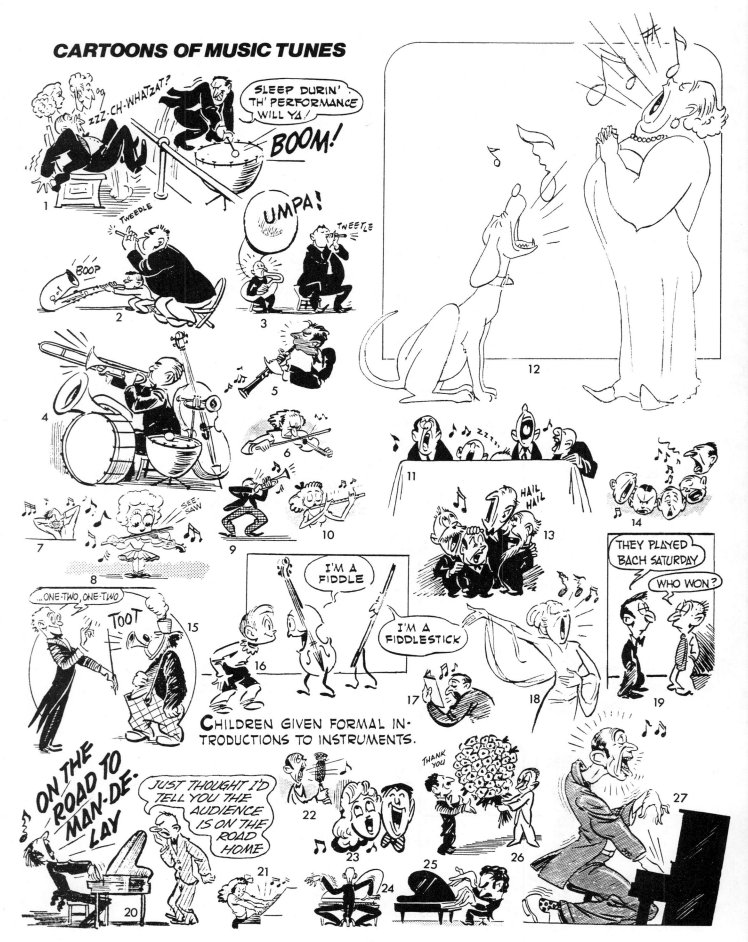

CARTOONS OF MUSIC TUNES

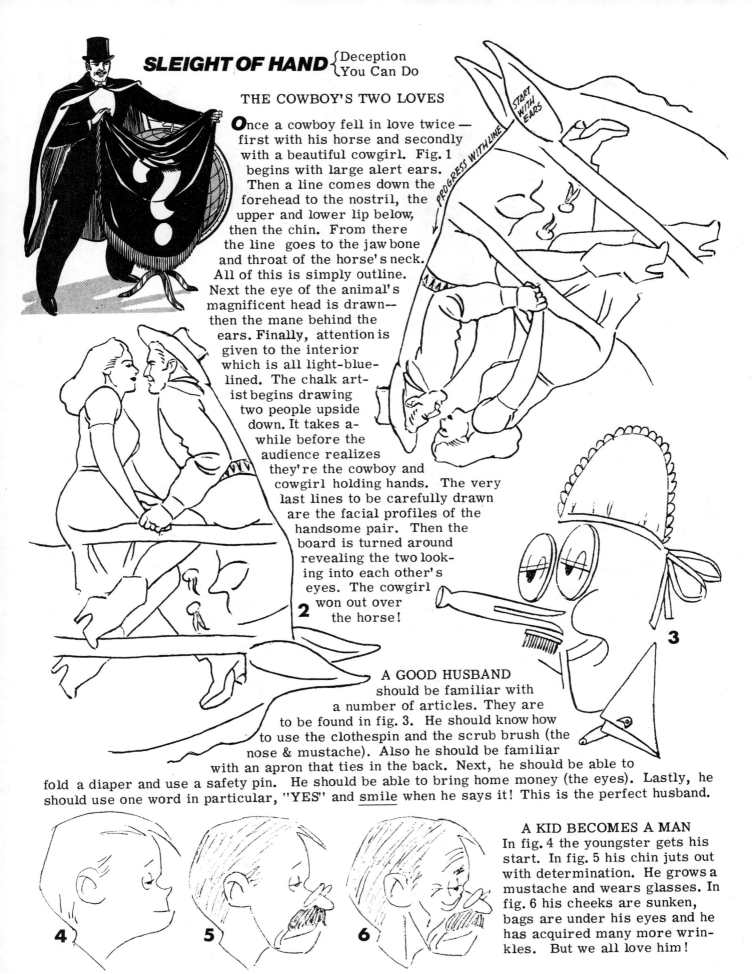

SLEIGHT OF HAND {Deception You Can Do

THE COWBOY'S TWO LOVES

Once a cowboy fell in love twice — first with his horse and secondly with a beautiful cowgirl. Fig. 1 begins with large alert ears. Then a line comes down the forehead to the nostril, the upper and lower lip below, then the chin. From there the line goes to the jaw bone and throat of the horse's neck. All of this is simply outline. Next the eye of the animal's magnificent head is drawn— then the mane behind the ears. Finally, attention is given to the interior which is all light-blue-lined. The chalk art-ist begins drawing two people upside down. It takes a-while before the audience realizes they're the cowboy and cowgirl holding hands. The very last lines to be carefully drawn are the facial profiles of the handsome pair. Then the board is turned around revealing the two look-ing into each other's eyes. The cowgirl won out over the horse!

START WITH EARS

PROGRESS WITH LINE

2

3

A GOOD HUSBAND
should be familiar with a number of articles. They are to be found in fig. 3. He should know how to use the clothespin and the scrub brush (the nose & mustache). Also he should be familiar with an apron that ties in the back. Next, he should be able to fold a diaper and use a safety pin. He should be able to bring home money (the eyes). Lastly, he should use one word in particular, "YES" and <u>smile</u> when he says it! This is the perfect husband.

4 **5** **6**

A KID BECOMES A MAN
In fig. 4 the youngster gets his start. In fig. 5 his chin juts out with determination. He grows a mustache and wears glasses. In fig. 6 his cheeks are sunken, bags are under his eyes and he has acquired many more wrin-kles. But we all love him!

STORY OF THE CAST-OFF PANTS

Once upon a time there was a pair of pants outgrown by my brother. When I got into them I found the hole in the left knee was just perfect for me to see out of (fig. 1).

Time went by and I realized I was becoming stoop shouldered, so I pulled out and sought another peek out place. There was a hole in the right pocket. By stretching a bit I could see out there (fig. 2). It was a proud day for me. The family called me the "8" ball in the side pocket. There was a hole in the seat, but the kids laughed when I looked out there. All the while I was still growing.

Finally I could see over the belt line (fig. 3). I had cause to smile. When it rained I crouched and drew the belt up to the last notch.

I had grown into my older brother's shoes and could walk as never before. They were roomy and didn't cut off circulation.

I inherited his shirt (fig. 4). The neck was a little too big, but thank goodness my shoulders didn't slip through. I never wore a tie because it cut off my hearing.

Fig. 4 shows the record of my rise. At last my fingers came through the shirt sleeves and I could do things to help earn the family living. With my left hand I could hold up the pants quite well. As time went by I gave the pants to my little brother for he could see out the knee.

30

THE BACHELOR AND THE BABE

This is the story of an old sailor (kind of like "Popeye The Sailor Man") who fell in love with a nifty babe. Of course, when this story is told and drawn in sequence, it has more interest. As it is, the various steps are necessarily revealed for one cannot help but see the ending before it's supposed to come. Anyway, the chalk cartoonist

begins by drawing the big nose in fig. 1 (including the nostril). Next, the eyes are drawn — one open and the other squinting with a frown. After that, the turned down mouth and chin are portrayed with "The bachelor wasn't very happy. He had a scowl on his face most of the time."

Next, his pointed head is added with "But one day this ole codger met a nifty babe who was to change his whole life." This prompted him to be more careful about his appearance. He didn't have much hair, but he combed the several strands which he had (now add lines in fig. 3 which were not in fig. 1). He wanted to make a good impression on his new interest in life. He grew sideburns in front of his ear — again not much to work with. As he walked along he nervously grabbed a straw and chewed it (as in fig. 2). Then he got out his old corncob pipe shaped something like a little foot and puffed a line or two of smoke — all shown in fig. 2 but drawn in place as in fig. 3. Next, he started to wear a tie, but he knew nothing about tying the knot. See how rumpled it is in fig. 4. The knot became huge. Now turn the board to reveal the babe to the audience (fig. 5). "You see she is lying on

her back playing with her toes and she has a cute smile on her face." The old sailor bachelor did all he could to help the parents for he, too, was quite taken with his new friend.

Concerning the preparation for this routine: The babe should be enlarged on the paper by means of an opaque projector. While the image is on the paper light-blue-line it so only the chalk artist can see what's there. Think it through and decide on the process as explained above. Mentally combine the patter with the movement of the hand. Fig. 2 and the upside down face of the baby in fig. 4 are the most complicated. The width of the chalk line should be strong enough to be seen by viewers in the back of the room.

BACK IN THE HILLS

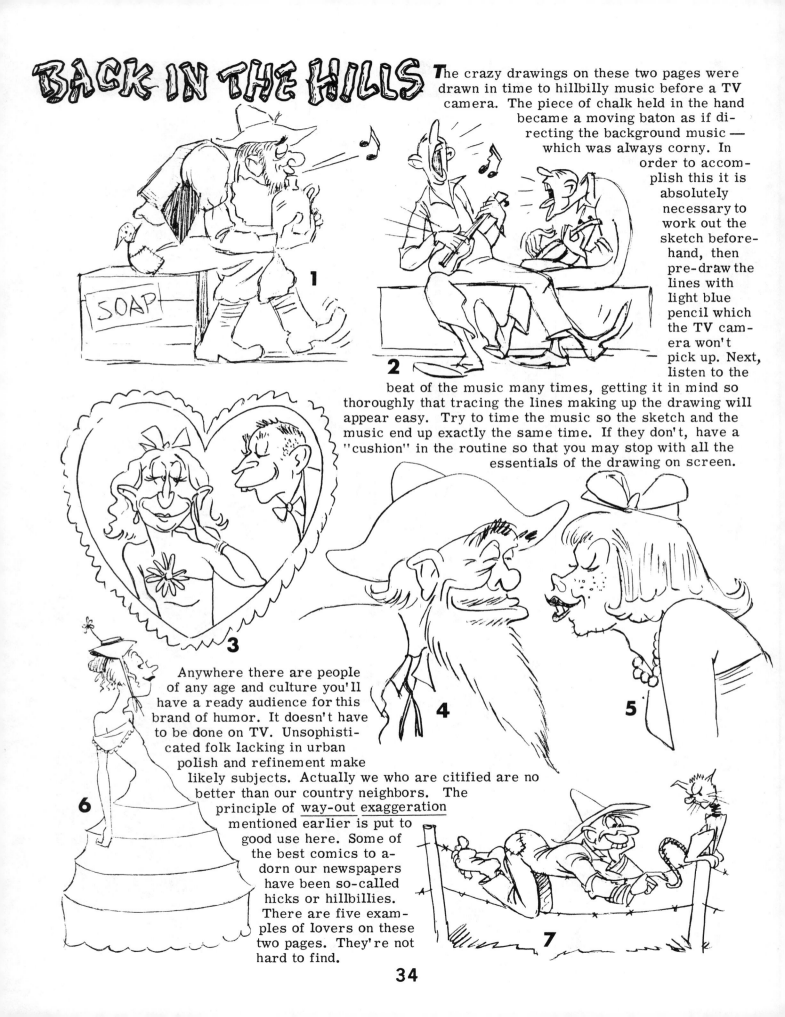

The crazy drawings on these two pages were drawn in time to hillbilly music before a TV camera. The piece of chalk held in the hand became a moving baton as if directing the background music — which was always corny. In order to accomplish this it is absolutely necessary to work out the sketch beforehand, then pre-draw the lines with light blue pencil which the TV camera won't pick up. Next, listen to the beat of the music many times, getting it in mind so thoroughly that tracing the lines making up the drawing will appear easy. Try to time the music so the sketch and the music end up exactly the same time. If they don't, have a "cushion" in the routine so that you may stop with all the essentials of the drawing on screen.

Anywhere there are people of any age and culture you'll have a ready audience for this brand of humor. It doesn't have to be done on TV. Unsophisticated folk lacking in urban polish and refinement make likely subjects. Actually we who are citified are no better than our country neighbors. The principle of way-out exaggeration mentioned earlier is put to good use here. Some of the best comics to adorn our newspapers have been so-called hicks or hillbillies. There are five examples of lovers on these two pages. They're not hard to find.

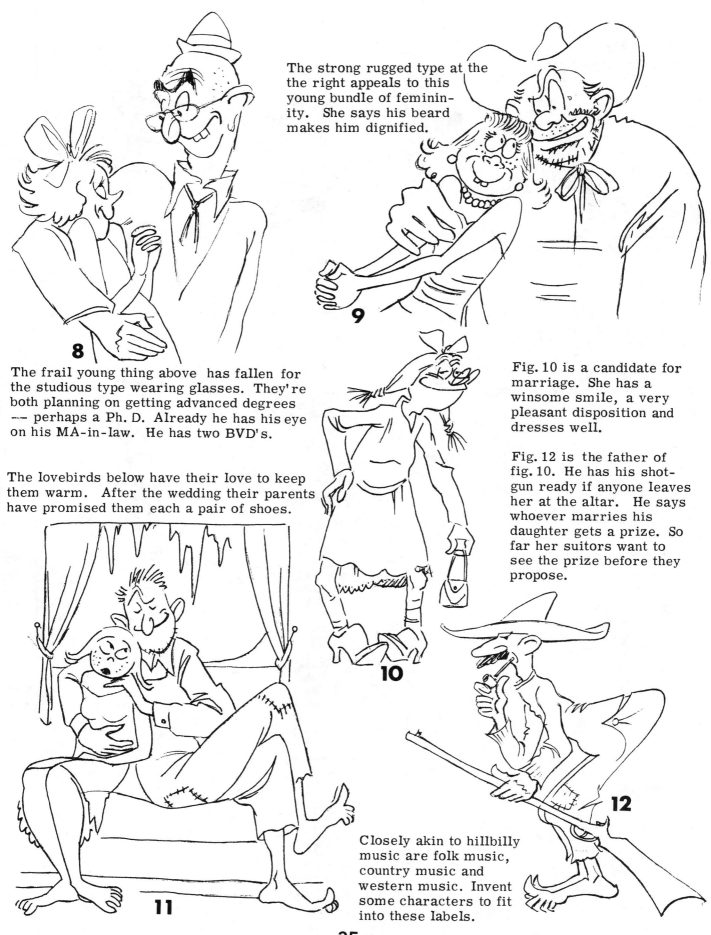

The strong rugged type at the the right appeals to this young bundle of feminin- ity. She says his beard makes him dignified.

The frail young thing above has fallen for the studious type wearing glasses. They're both planning on getting advanced degrees — perhaps a Ph. D. Already he has his eye on his MA-in-law. He has two BVD's.

The lovebirds below have their love to keep them warm. After the wedding their parents have promised them each a pair of shoes.

Fig. 10 is a candidate for marriage. She has a winsome smile, a very pleasant disposition and dresses well.

Fig. 12 is the father of fig. 10. He has his shot- gun ready if anyone leaves her at the altar. He says whoever marries his daughter gets a prize. So far her suitors want to see the prize before they propose.

Closely akin to hillbilly music are folk music, country music and western music. Invent some characters to fit into these labels.

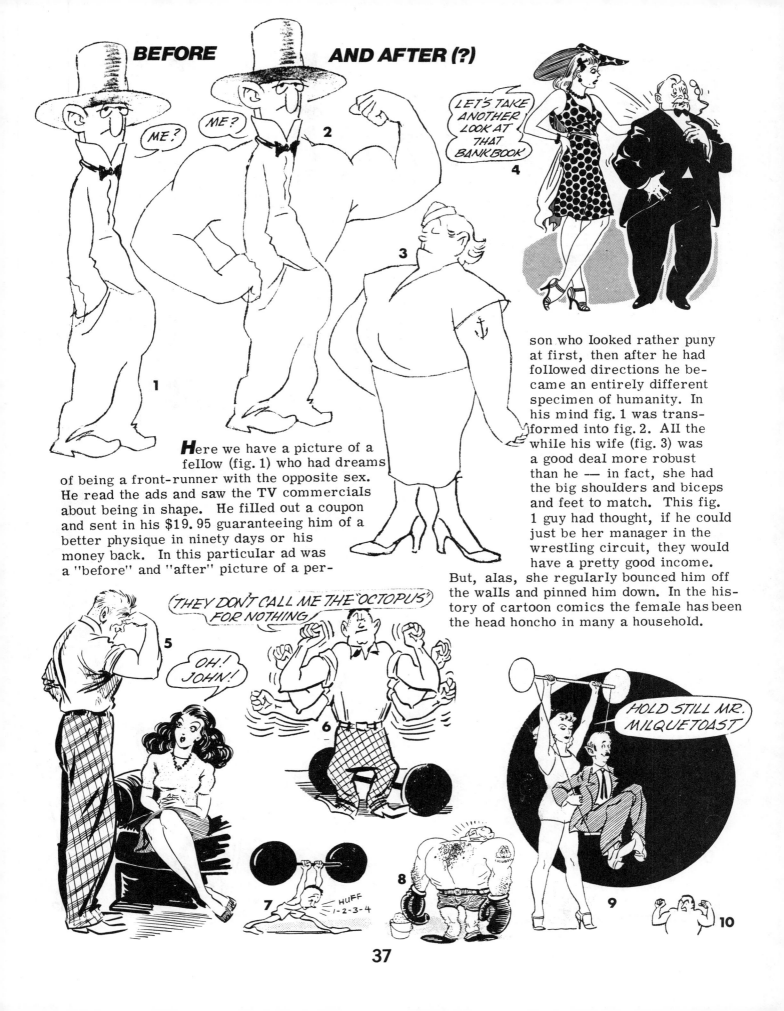

BEFORE AND AFTER (?)

Here we have a picture of a fellow (fig. 1) who had dreams of being a front-runner with the opposite sex. He read the ads and saw the **TV** commercials about being in shape. He filled out a coupon and sent in his $19.95 guaranteeing him of a better physique in ninety days or his money back. In this particular ad was a "before" and "after" picture of a person who looked rather puny at first, then after he had followed directions he became an entirely different specimen of humanity. In his mind fig. 1 was transformed into fig. 2. All the while his wife (fig. 3) was a good deal more robust than he — in fact, she had the big shoulders and biceps and feet to match. This fig. 1 guy had thought, if he could just be her manager in the wrestling circuit, they would have a pretty good income. But, alas, she regularly bounced him off the walls and pinned him down. In the history of cartoon comics the female has been the head honcho in many a household.

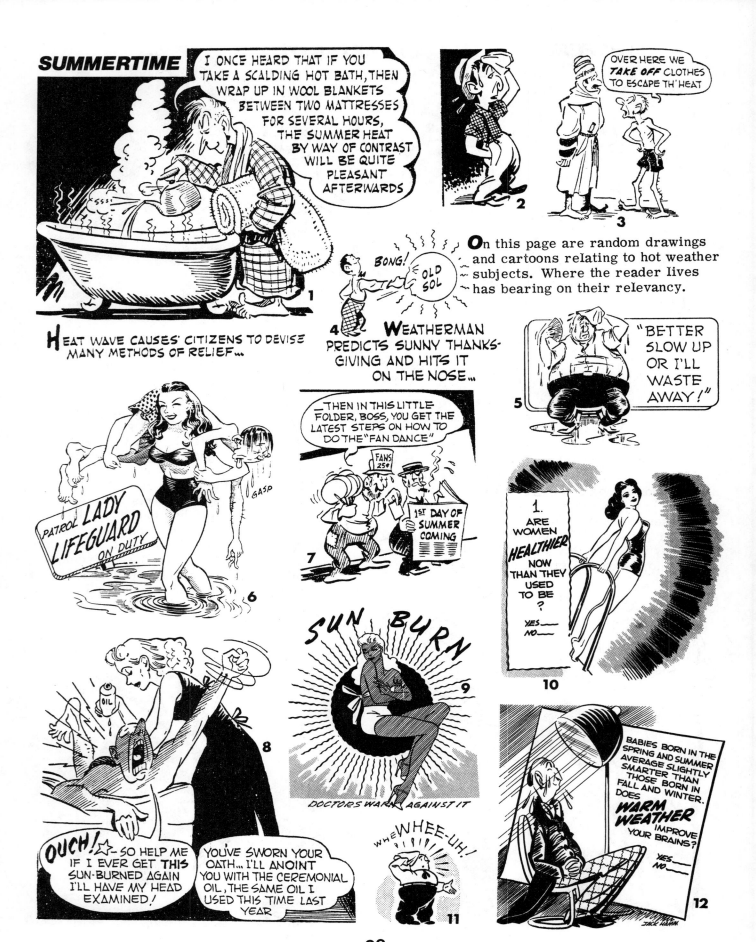

SUMMERTIME

1 I ONCE HEARD THAT IF YOU TAKE A SCALDING HOT BATH, THEN WRAP UP IN WOOL BLANKETS BETWEEN TWO MATTRESSES FOR SEVERAL HOURS, THE SUMMER HEAT BY WAY OF CONTRAST WILL BE QUITE PLEASANT AFTERWARDS

HEAT WAVE CAUSES' CITIZENS TO DEVISE MANY METHODS OF RELIEF...

2

3 OVER HERE WE *TAKE OFF* CLOTHES TO ESCAPE TH' HEAT

On this page are random drawings and cartoons relating to hot weather subjects. Where the reader lives has bearing on their relevancy.

4 BONG! OLD SOL

WEATHERMAN PREDICTS SUNNY THANKSGIVING AND HITS IT ON THE NOSE...

5 "BETTER SLOW UP OR I'LL WASTE AWAY!"

6 PATROL LADY LIFEGUARD ON DUTY — GASP

7 —THEN IN THIS LITTLE FOLDER, BOSS, YOU GET THE LATEST STEPS ON HOW TO DO THE "FAN DANCE" — FANS 25¢ — 1ST DAY OF SUMMER COMING

8 OIL — OUCH! ☆ — SO HELP ME IF I EVER GET *THIS* SUN-BURNED AGAIN I'LL HAVE MY HEAD EXAMINED! — YOU'VE SWORN YOUR OATH... I'LL ANOINT YOU WITH THE CEREMONIAL OIL, THE SAME OIL I USED THIS TIME LAST YEAR

9 SUN BURN — DOCTORS WARN AGAINST IT

10 1. ARE WOMEN *HEALTHIER* NOW THAN THEY USED TO BE ? YES___ NO___

11 WHEWHEE-UH!

12 BABIES BORN IN THE SPRING AND SUMMER AVERAGE SLIGHTLY SMARTER THAN THOSE BORN IN FALL AND WINTER. DOES *WARM WEATHER* IMPROVE YOUR BRAINS? YES___ NO___

JACK HAMM

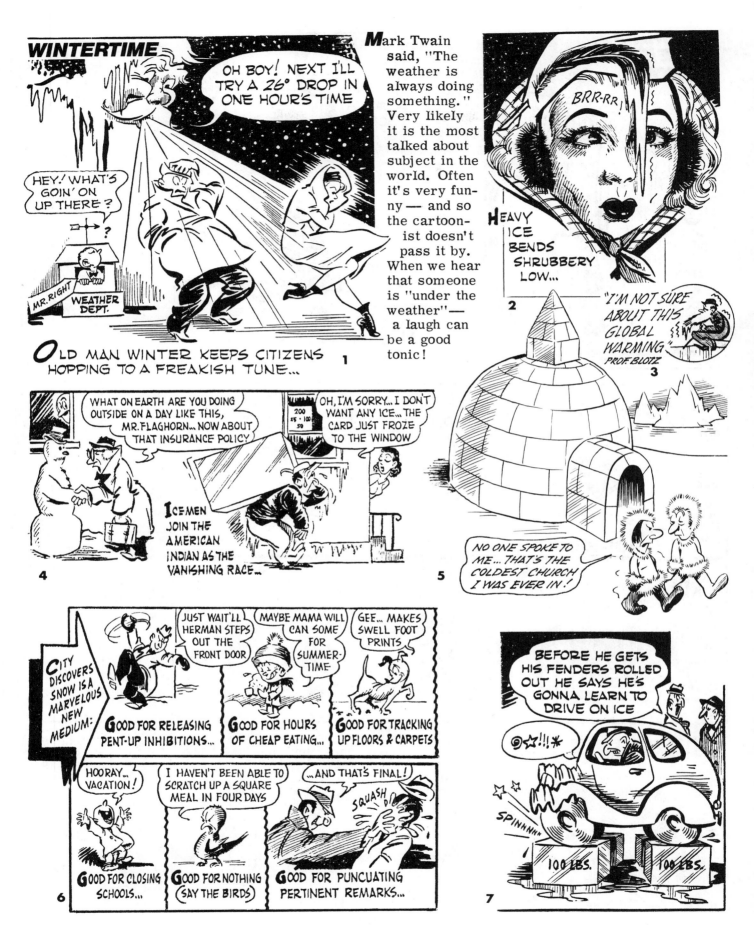

WINTERTIME

Mark Twain said, "The weather is always doing something." Very likely it is the most talked about subject in the world. Often it's very funny — and so the cartoonist doesn't pass it by. When we hear that someone is "under the weather"— a laugh can be a good tonic!

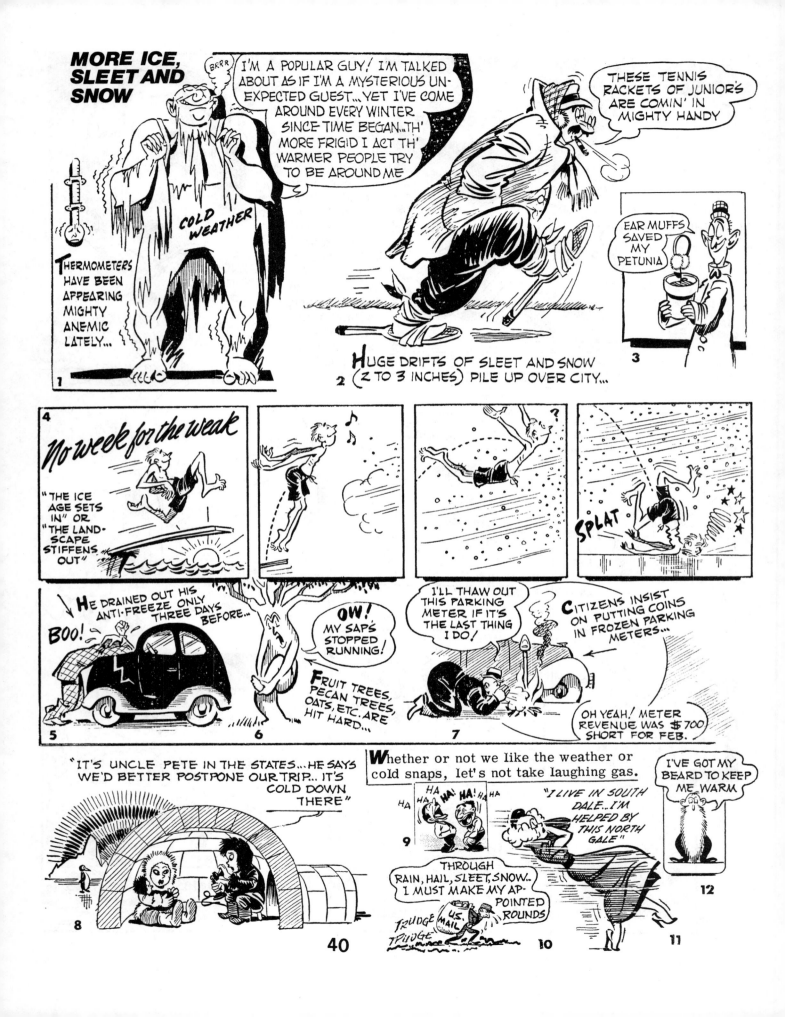

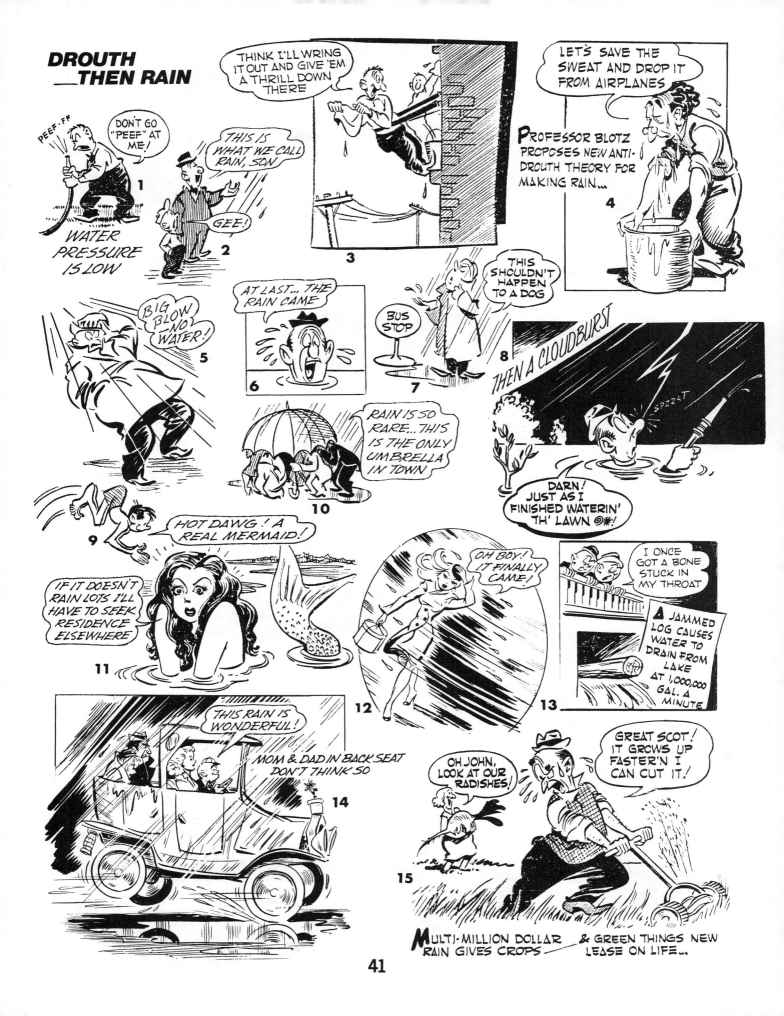

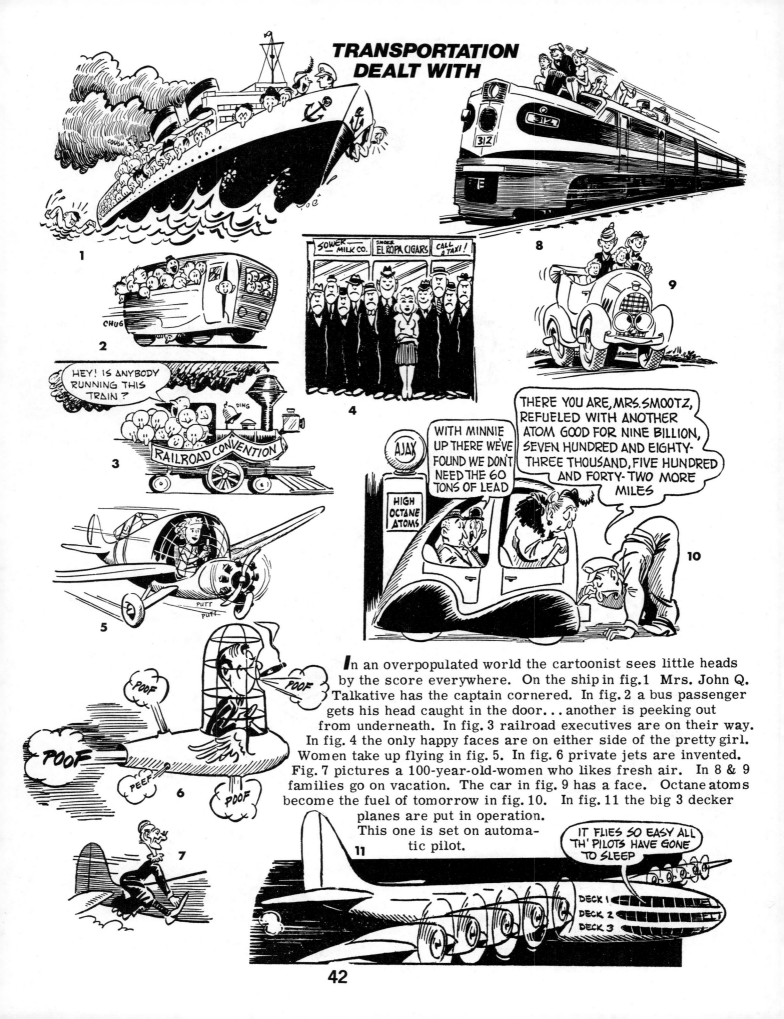

TRANSPORTATION DEALT WITH

In an overpopulated world the cartoonist sees little heads by the score everywhere. On the ship in fig. 1 Mrs. John Q. Talkative has the captain cornered. In fig. 2 a bus passenger gets his head caught in the door... another is peeking out from underneath. In fig. 3 railroad executives are on their way. In fig. 4 the only happy faces are on either side of the pretty girl. Women take up flying in fig. 5. In fig. 6 private jets are invented. Fig. 7 pictures a 100-year-old-women who likes fresh air. In 8 & 9 families go on vacation. The car in fig. 9 has a face. Octane atoms become the fuel of tomorrow in fig. 10. In fig. 11 the big 3 decker planes are put in operation. This one is set on automatic pilot.

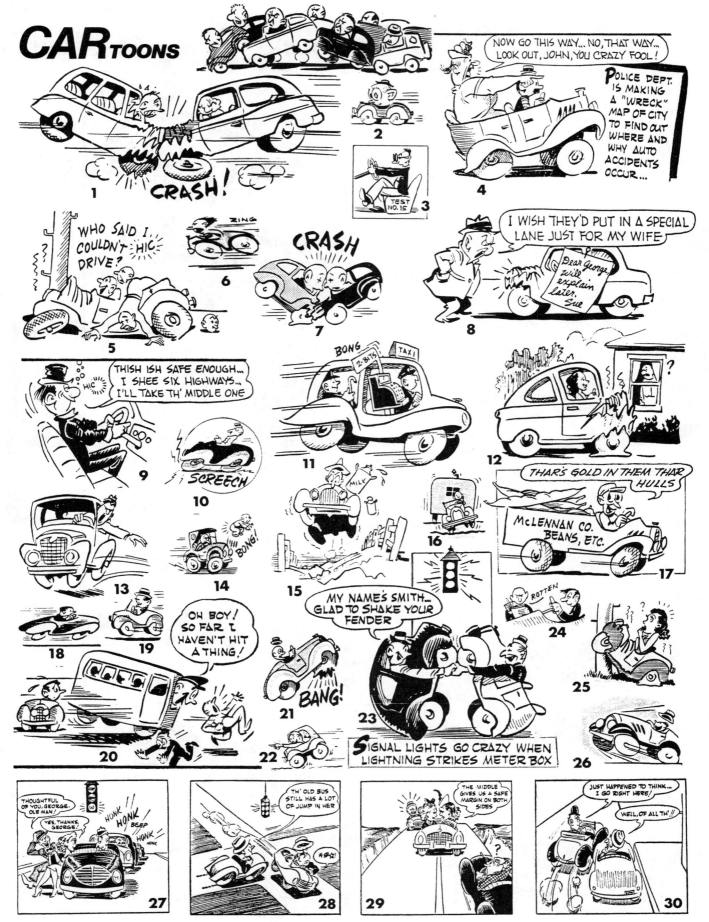

CARtoons

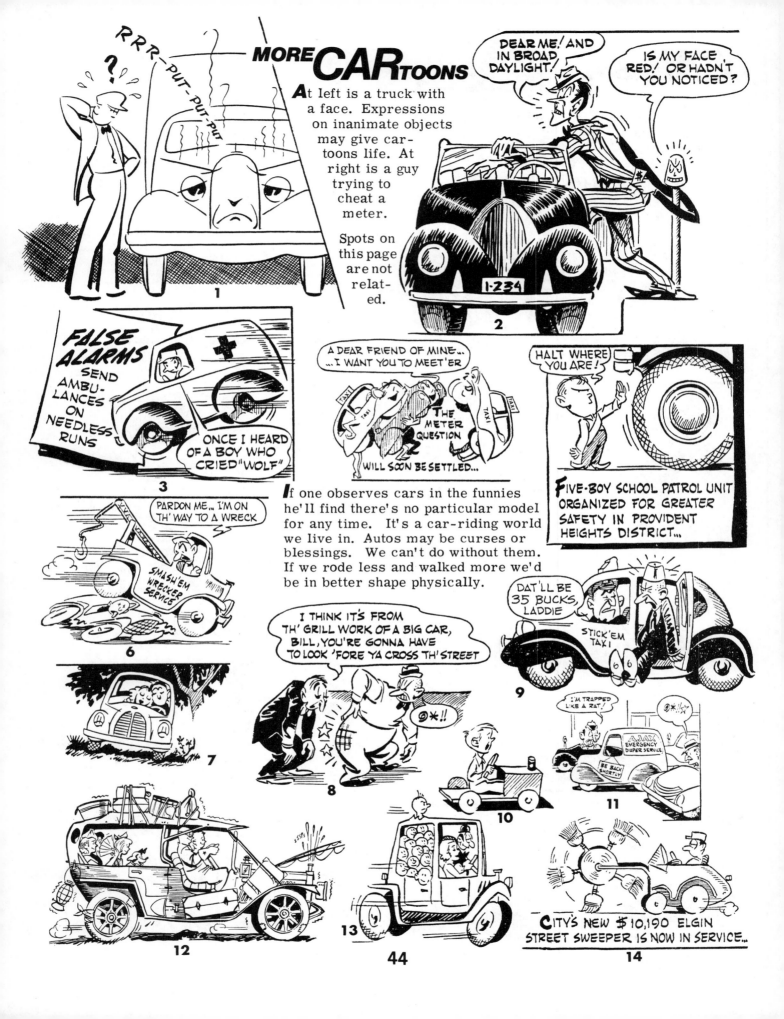

MORE CARtoons

At left is a truck with a face. Expressions on inanimate objects may give cartoons life. At right is a guy trying to cheat a meter.

Spots on this page are not related.

If one observes cars in the funnies he'll find there's no particular model for any time. It's a car-riding world we live in. Autos may be curses or blessings. We can't do without them. If we rode less and walked more we'd be in better shape physically.

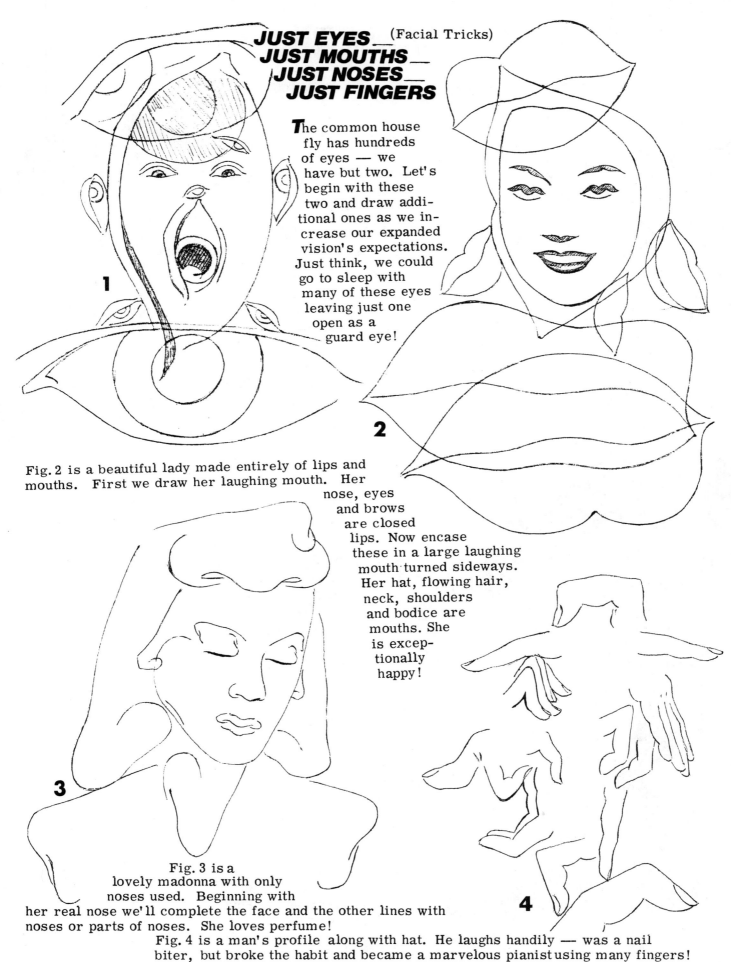

JUST EYES — (Facial Tricks)
JUST MOUTHS —
JUST NOSES —
JUST FINGERS

*T*he common house fly has hundreds of eyes — we have but two. Let's begin with these two and draw additional ones as we increase our expanded vision's expectations. Just think, we could go to sleep with many of these eyes leaving just one open as a guard eye!

1

2

Fig. 2 is a beautiful lady made entirely of lips and mouths. First we draw her laughing mouth. Her nose, eyes and brows are closed lips. Now encase these in a large laughing mouth turned sideways. Her hat, flowing hair, neck, shoulders and bodice are mouths. She is exceptionally happy!

3

Fig. 3 is a lovely madonna with only noses used. Beginning with her real nose we'll complete the face and the other lines with noses or parts of noses. She loves perfume!

4

Fig. 4 is a man's profile along with hat. He laughs handily — was a nail biter, but broke the habit and became a marvelous pianist using many fingers!

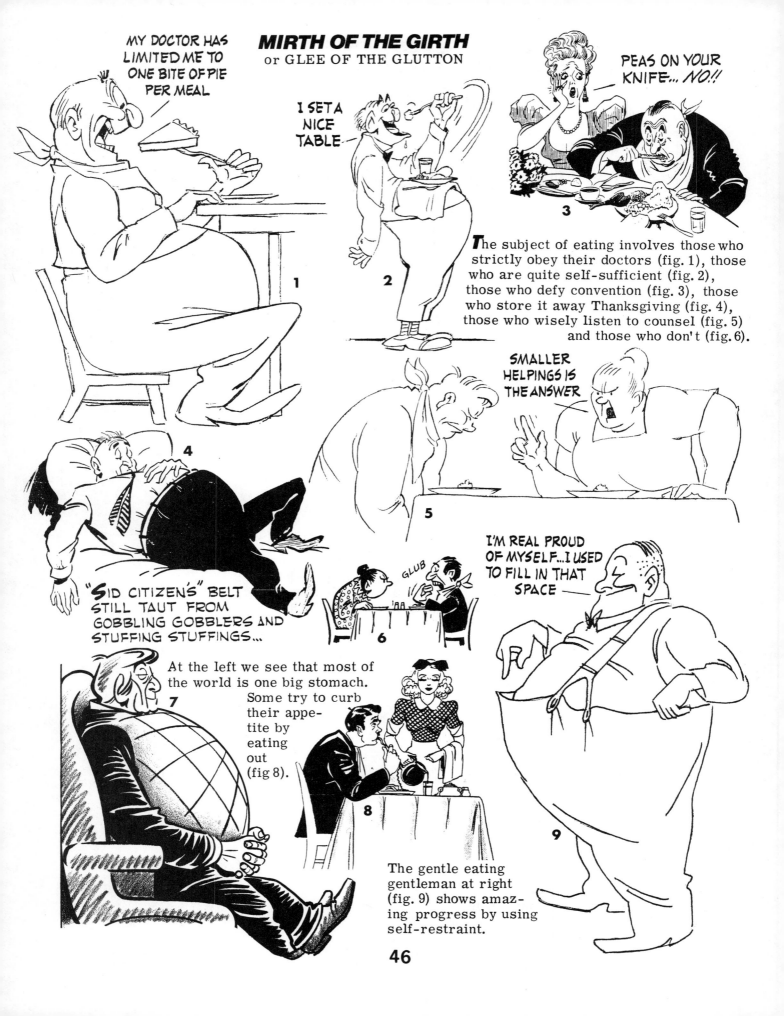

MIRTH OF THE GIRTH
or GLEE OF THE GLUTTON

MY DOCTOR HAS LIMITED ME TO ONE BITE OF PIE PER MEAL

I SET A NICE TABLE

PEAS ON YOUR KNIFE... NO!!

The subject of eating involves those who strictly obey their doctors (fig. 1), those who are quite self-sufficient (fig. 2), those who defy convention (fig. 3), those who store it away Thanksgiving (fig. 4), those who wisely listen to counsel (fig. 5) and those who don't (fig. 6).

SMALLER HELPINGS IS THE ANSWER

"SID CITIZEN'S" BELT STILL TAUT FROM GOBBLING GOBBLERS AND STUFFING STUFFINGS...

GLUB

I'M REAL PROUD OF MYSELF...I USED TO FILL IN THAT SPACE

At the left we see that most of the world is one big stomach. Some try to curb their appetite by eating out (fig 8).

The gentle eating gentleman at right (fig. 9) shows amazing progress by using self-restraint.

46

COOKING, EATING, DRINKING

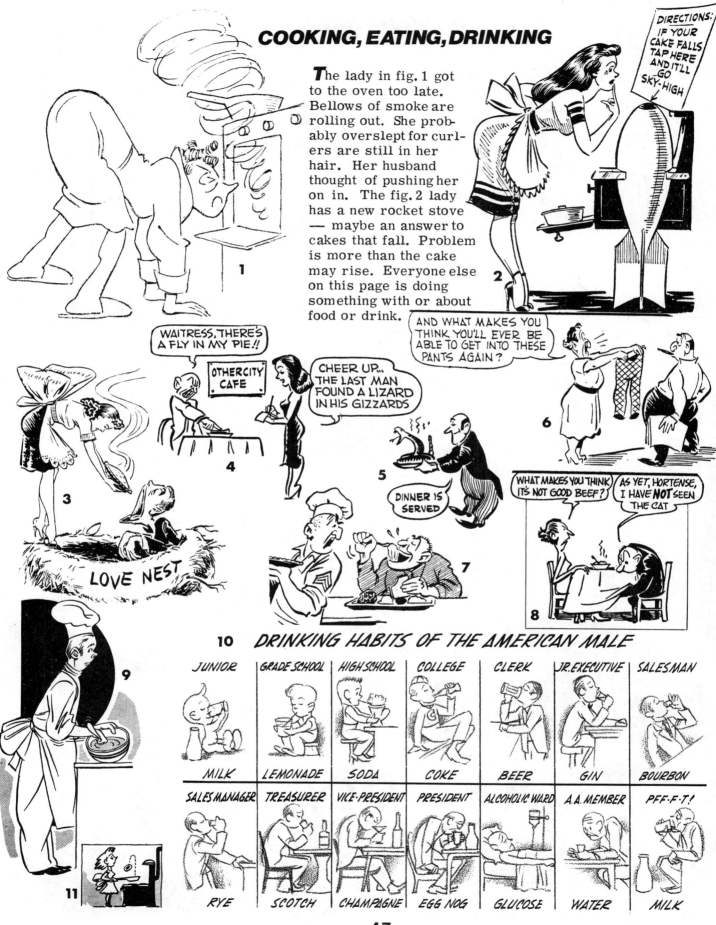

The lady in fig. 1 got to the oven too late. Bellows of smoke are rolling out. She probably overslept for curlers are still in her hair. Her husband thought of pushing her on in. The fig. 2 lady has a new rocket stove — maybe an answer to cakes that fall. Problem is more than the cake may rise. Everyone else on this page is doing something with or about food or drink.

DIRECTIONS: IF YOUR CAKE FALLS TAP HERE AND IT'LL GO SKY-HIGH

WAITRESS, THERE'S A FLY IN MY PIE!!

OTHERCITY CAFE

CHEER UP... THE LAST MAN FOUND A LIZARD IN HIS GIZZARDS

AND WHAT MAKES YOU THINK YOU'LL EVER BE ABLE TO GET INTO THESE PANTS AGAIN?

LOVE NEST

DINNER IS SERVED

WHAT MAKES YOU THINK IT'S NOT GOOD BEEF?

AS YET, HORTENSE, I HAVE **NOT** SEEN THE CAT

DRINKING HABITS OF THE AMERICAN MALE

JUNIOR	GRADE SCHOOL	HIGH SCHOOL	COLLEGE	CLERK	JR. EXECUTIVE	SALESMAN
MILK	LEMONADE	SODA	COKE	BEER	GIN	BOURBON
SALES MANAGER	TREASURER	VICE-PRESIDENT	PRESIDENT	ALCOHOLIC WARD	A.A. MEMBER	PFF-F-T!
RYE	SCOTCH	CHAMPAGNE	EGG NOG	GLUCOSE	WATER	MILK

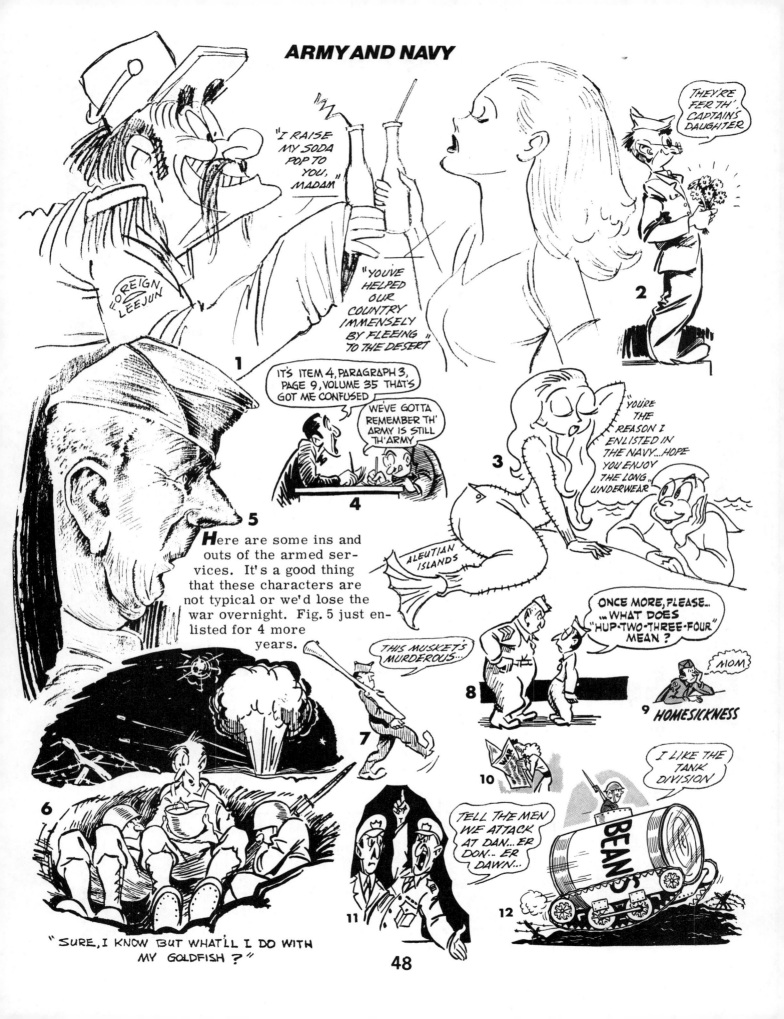

ARMY AND NAVY

Here are some ins and outs of the armed services. It's a good thing that these characters are not typical or we'd lose the war overnight. Fig. 5 just enlisted for 4 more years.

HUNTING AND FISHING

49

CARTOON SPOTS ASSIST POLICE AND FIREMEN

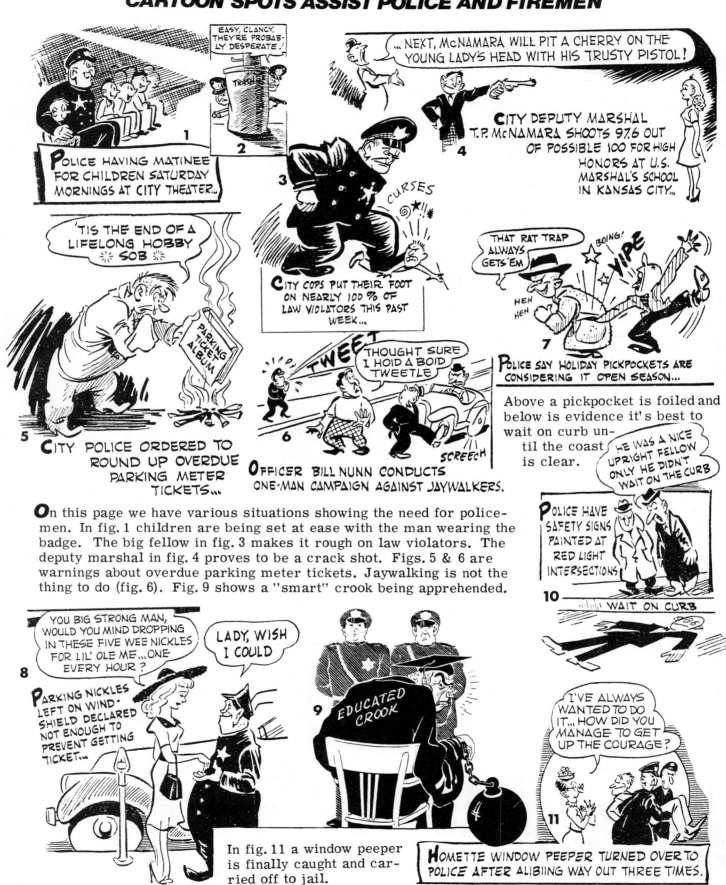

1 POLICE HAVING MATINEE FOR CHILDREN SATURDAY MORNINGS AT CITY THEATER...

EASY, CLANCY, THEY'RE PROBABLY DESPERATE! **2**

3 CITY COPS PUT THEIR FOOT ON NEARLY 100% OF LAW VIOLATORS THIS PAST WEEK...

...NEXT, McNAMARA WILL PIT A CHERRY ON THE YOUNG LADY'S HEAD WITH HIS TRUSTY PISTOL!

4 CITY DEPUTY MARSHAL T.P. McNAMARA SHOOTS 97.6 OUT OF POSSIBLE 100 FOR HIGH HONORS AT U.S. MARSHAL'S SCHOOL IN KANSAS CITY...

'TIS THE END OF A LIFELONG HOBBY SOB

5 CITY POLICE ORDERED TO ROUND UP OVERDUE PARKING METER TICKETS...

THOUGHT SURE I HOID A BOID TWEETLE

6 OFFICER BILL NUNN CONDUCTS ONE-MAN CAMPAIGN AGAINST JAYWALKERS.

THAT RAT TRAP ALWAYS GETS 'EM

7 POLICE SAY HOLIDAY PICKPOCKETS ARE CONSIDERING IT OPEN SEASON...

Above a pickpocket is foiled and below is evidence it's best to wait on curb until the coast is clear.

HE WAS A NICE UPRIGHT FELLOW ONLY HE DIDN'T WAIT ON THE CURB

10 POLICE HAVE SAFETY SIGNS PAINTED AT RED LIGHT INTERSECTIONS

WAIT ON CURB

On this page we have various situations showing the need for policemen. In fig. 1 children are being set at ease with the man wearing the badge. The big fellow in fig. 3 makes it rough on law violators. The deputy marshal in fig. 4 proves to be a crack shot. Figs. 5 & 6 are warnings about overdue parking meter tickets. Jaywalking is not the thing to do (fig. 6). Fig. 9 shows a "smart" crook being apprehended.

YOU BIG STRONG MAN, WOULD YOU MIND DROPPING IN THESE FIVE WEE NICKLES FOR LIL' OLE ME...ONE EVERY HOUR?

LADY, WISH I COULD

8 PARKING NICKLES LEFT ON WINDSHIELD DECLARED NOT ENOUGH TO PREVENT GETTING TICKET...

9 EDUCATED CROOK

I'VE ALWAYS WANTED TO DO IT... HOW DID YOU MANAGE TO GET UP THE COURAGE?

11

In fig. 11 a window peeper is finally caught and carried off to jail.

HOMETTE WINDOW PEEPER TURNED OVER TO POLICE AFTER ALIBIING WAY OUT THREE TIMES.

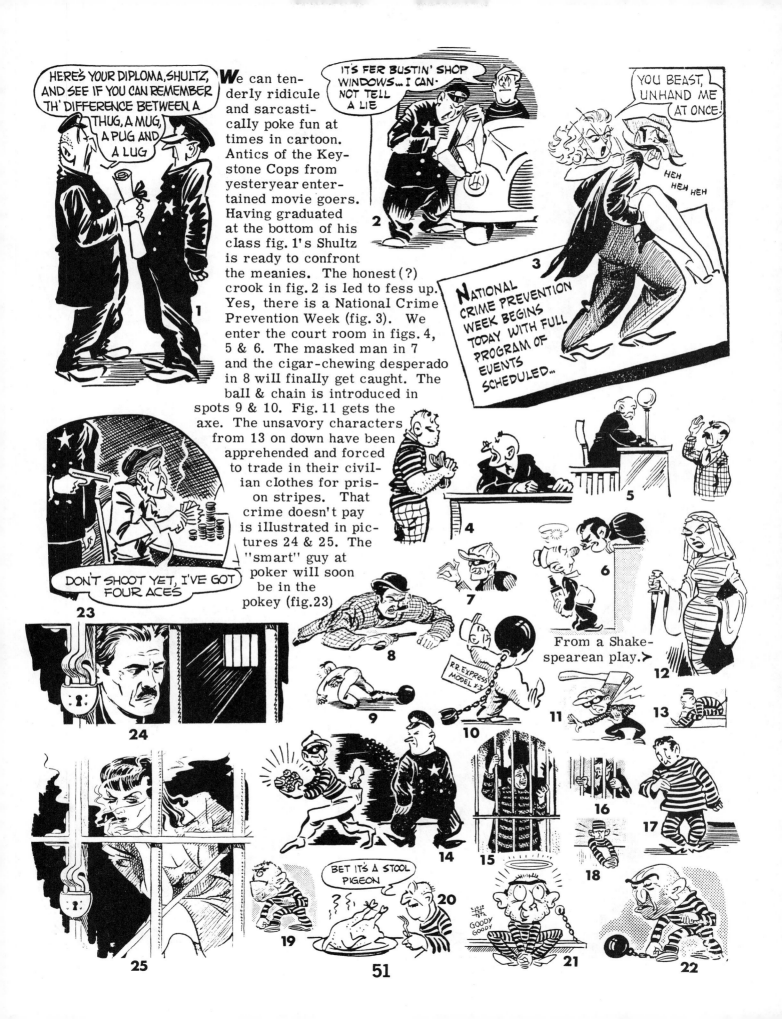

We can tenderly ridicule and sarcastically poke fun at times in cartoon. Antics of the Keystone Cops from yesteryear entertained movie goers. Having graduated at the bottom of his class fig. 1's Shultz is ready to confront the meanies. The honest (?) crook in fig. 2 is led to fess up. Yes, there is a National Crime Prevention Week (fig. 3). We enter the court room in figs. 4, 5 & 6. The masked man in 7 and the cigar-chewing desperado in 8 will finally get caught. The ball & chain is introduced in spots 9 & 10. Fig. 11 gets the axe. The unsavory characters from 13 on down have been apprehended and forced to trade in their civilian clothes for prison stripes. That crime doesn't pay is illustrated in pictures 24 & 25. The "smart" guy at poker will soon be in the pokey (fig. 23)

DRAWING & CARTOON SPOTS ON CRIME

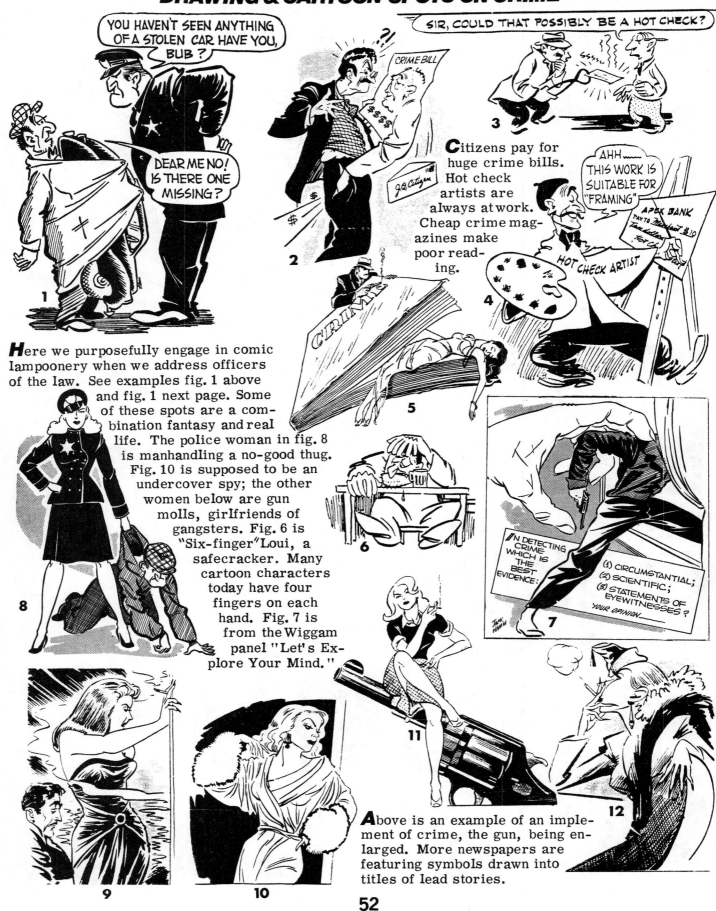

YOU HAVEN'T SEEN ANYTHING OF A STOLEN CAR HAVE YOU, BUB?

DEAR ME NO! IS THERE ONE MISSING?

SIR, COULD THAT POSSIBLY BE A HOT CHECK?

CRIME BILL

J.Q. Citizen

Citizens pay for huge crime bills. Hot check artists are always at work. Cheap crime magazines make poor reading.

AHH— THIS WORK IS SUITABLE FOR "FRAMING"

APEX BANK
PAY TO Merchant $10
Tom Collins
Hot Ch

HOT CHECK ARTIST

Here we purposefully engage in comic lampoonery when we address officers of the law. See examples fig. 1 above and fig. 1 next page. Some of these spots are a combination fantasy and real life. The police woman in fig. 8 is manhandling a no-good thug. Fig. 10 is supposed to be an undercover spy; the other women below are gun molls, girlfriends of gangsters. Fig. 6 is "Six-finger" Loui, a safecracker. Many cartoon characters today have four fingers on each hand. Fig. 7 is from the Wiggam panel "Let's Explore Your Mind."

IN DETECTING CRIME WHICH IS THE BEST EVIDENCE:

(1) CIRCUMSTANTIAL;
(2) SCIENTIFIC;
(3) STATEMENTS OF EYEWITNESSES?
YOUR OPINION_____

Above is an example of an implement of crime, the gun, being enlarged. More newspapers are featuring symbols drawn into titles of lead stories.

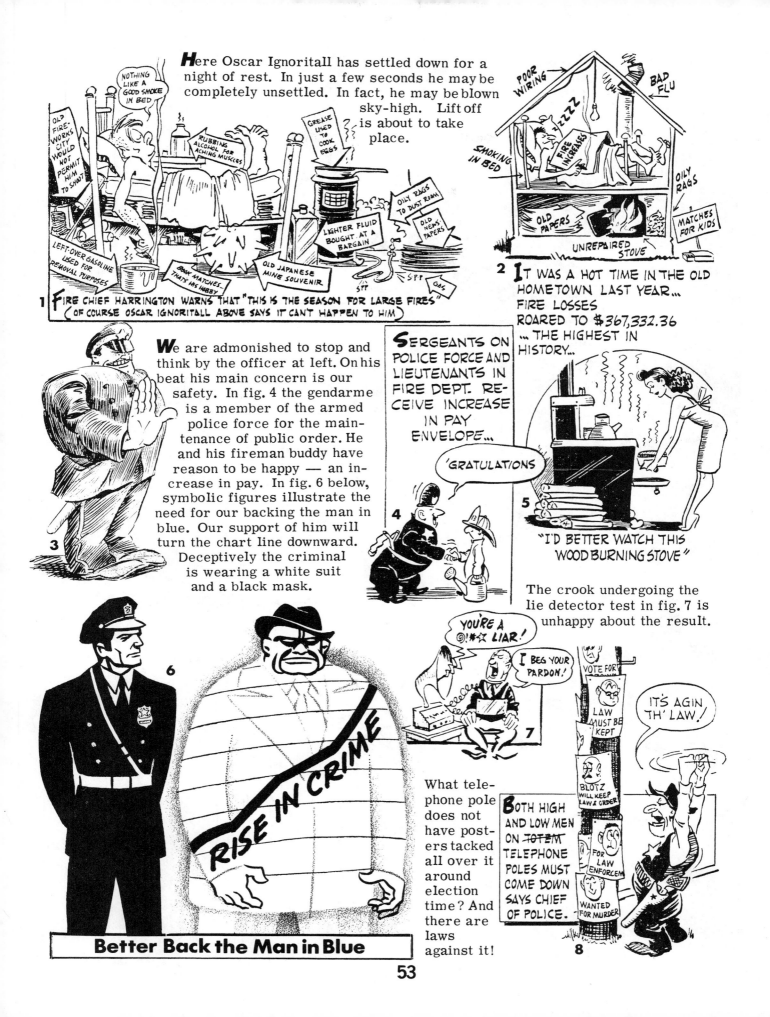

Here Oscar Ignoritall has settled down for a night of rest. In just a few seconds he may be completely unsettled. In fact, he may be blown sky-high. Lift off is about to take place.

NOTHING LIKE A GOOD SMOKE IN BED

OLD FIRE-WORKS CITY WOULD NOT PERMIT HIM TO SHOOT

RUBBING ALCOHOL FOR ACHING MUSCLES

GREASE USED TO COOK EGGS

LIGHTER FLUID BOUGHT AT A BARGAIN

OILY RAGS TO DUST ROOM

OLD NEWS PAPERS

LEFT-OVER GASOLINE USED FOR REMOVAL PURPOSES

BOMB MATCHES... THAT'S HIS HOBBY

OLD JAPANESE MINE SOUVENIR

GAS

1 FIRE CHIEF HARRINGTON WARNS THAT "THIS IS THE SEASON FOR LARGE FIRES" (OF COURSE OSCAR IGNORITALL ABOVE SAYS IT CAN'T HAPPEN TO HIM)

POOR WIRING

BAD FLU

ZZZZ

FIRE INCREASES

SMOKING IN BED

OILY RAGS

OLD PAPERS

MATCHES FOR KIDS

UNREPAIRED STOVE

2 **I**T WAS A HOT TIME IN THE OLD HOMETOWN LAST YEAR... FIRE LOSSES ROARED TO $367,332.36 ... THE HIGHEST IN HISTORY...

We are admonished to stop and think by the officer at left. On his beat his main concern is our safety. In fig. 4 the gendarme is a member of the armed police force for the maintenance of public order. He and his fireman buddy have reason to be happy — an increase in pay. In fig. 6 below, symbolic figures illustrate the need for our backing the man in blue. Our support of him will turn the chart line downward. Deceptively the criminal is wearing a white suit and a black mask.

SERGEANTS ON POLICE FORCE AND LIEUTENANTS IN FIRE DEPT. RECEIVE INCREASE IN PAY ENVELOPE...

'GRATULATIONS

4

"I'D BETTER WATCH THIS WOOD BURNING STOVE"

5

The crook undergoing the lie detector test in fig. 7 is unhappy about the result.

3

6

YOU'RE A @!*☆ LIAR!

I BEG YOUR PARDON!

7

VOTE FOR

LAW MUST BE KEPT

BLOTZ WILL KEEP LAW & ORDER

FOR LAW ENFORCEM

WANTED FOR MURDER

IT'S AGIN TH' LAW!

What telephone pole does not have posters tacked all over it around election time? And there are laws against it!

BOTH HIGH AND LOW MEN ON ~~TOTEM~~ TELEPHONE POLES MUST COME DOWN SAYS CHIEF OF POLICE.

8

Better Back the Man in Blue

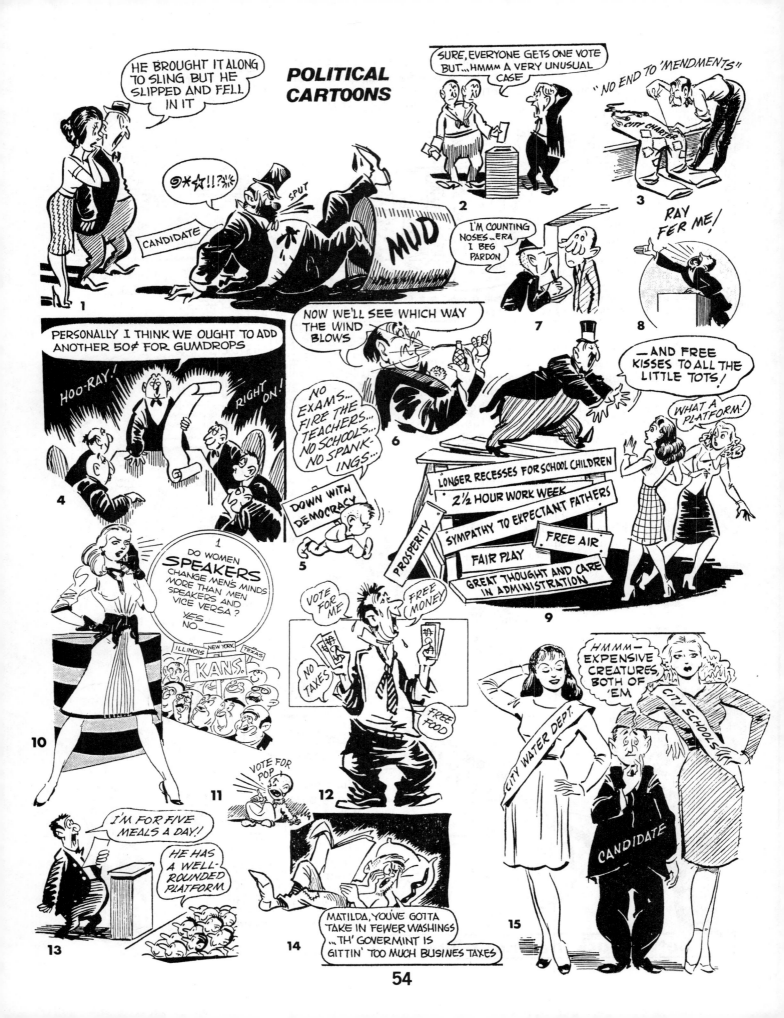

POLITICAL CARTOONS

CITY CARTOON COMMENT

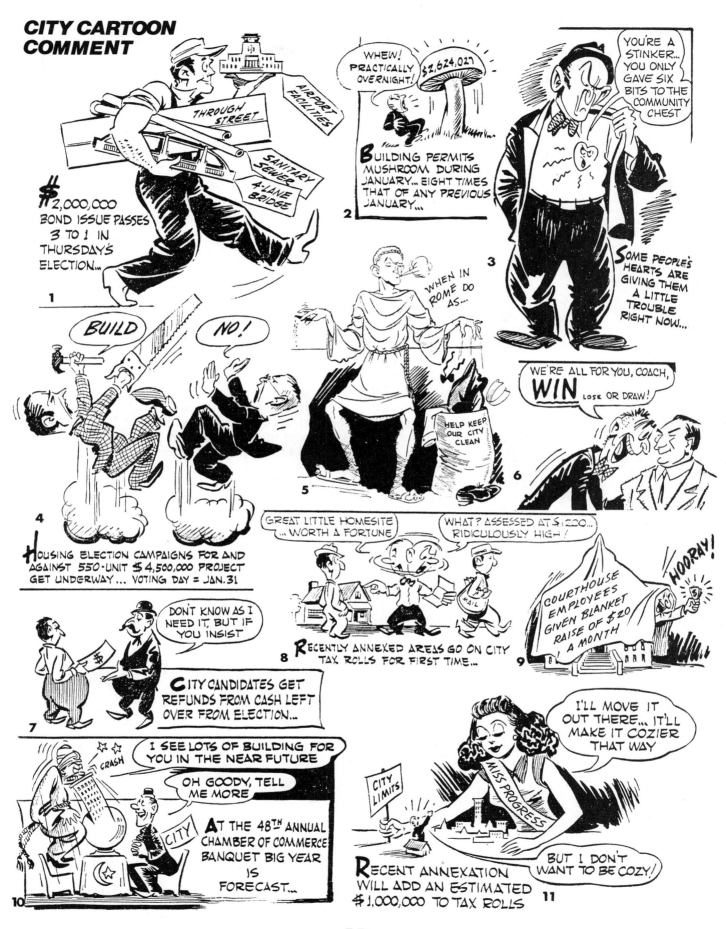

1 $2,000,000 BOND ISSUE PASSES 3 TO 1 IN THURSDAY'S ELECTION...

2 BUILDING PERMITS MUSHROOM DURING JANUARY... EIGHT TIMES THAT OF ANY PREVIOUS JANUARY...
WHEW! PRACTICALLY OVERNIGHT! $2,624,027

3 SOME PEOPLE'S HEARTS ARE GIVING THEM A LITTLE TROUBLE RIGHT NOW...
YOU'RE A STINKER... YOU ONLY GAVE SIX BITS TO THE COMMUNITY CHEST

4 HOUSING ELECTION CAMPAIGNS FOR AND AGAINST 550-UNIT $4,500,000 PROJECT GET UNDERWAY... VOTING DAY = JAN. 31
BUILD NO!

5 WHEN IN ROME DO AS...
HELP KEEP OUR CITY CLEAN

6 WE'RE ALL FOR YOU, COACH, WIN LOSE OR DRAW!

7 CITY CANDIDATES GET REFUNDS FROM CASH LEFT OVER FROM ELECTION...
DON'T KNOW AS I NEED IT, BUT IF YOU INSIST

8 RECENTLY ANNEXED AREAS GO ON CITY TAX ROLLS FOR FIRST TIME...
GREAT LITTLE HOMESITE ...WORTH A FORTUNE
WHAT? ASSESSED AT $1200... RIDICULOUSLY HIGH!

9 COURTHOUSE EMPLOYEES GIVEN BLANKET RAISE OF $20 A MONTH
HOORAY!

10 AT THE 48TH ANNUAL CHAMBER OF COMMERCE BANQUET BIG YEAR IS FORECAST...
CRASH
I SEE LOTS OF BUILDING FOR YOU IN THE NEAR FUTURE
OH GOODY, TELL ME MORE

11 RECENT ANNEXATION WILL ADD AN ESTIMATED $1,000,000 TO TAX ROLLS
I'LL MOVE IT OUT THERE... IT'LL MAKE IT COZIER THAT WAY
BUT I DON'T WANT TO BE COZY!
CITY LIMITS
MISS PROGRESS

THE "HOY-PALOY"

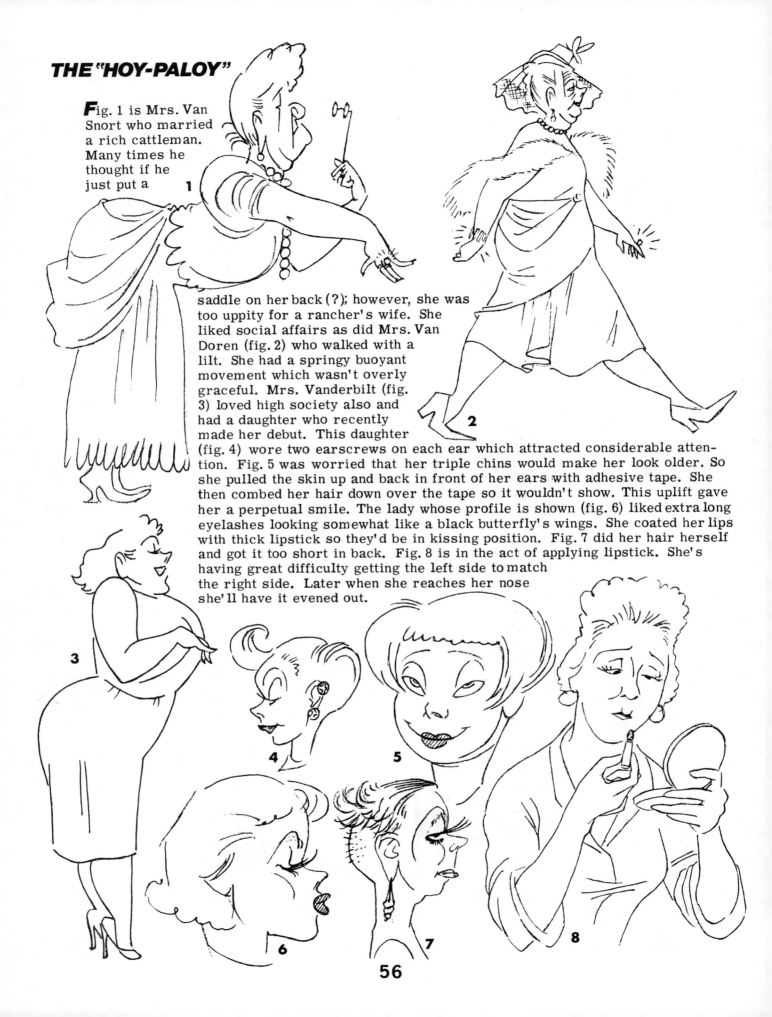

Fig. 1 is Mrs. Van Snort who married a rich cattleman. Many times he thought if he just put a saddle on her back (?); however, she was too uppity for a rancher's wife. She liked social affairs as did Mrs. Van Doren (fig. 2) who walked with a lilt. She had a springy buoyant movement which wasn't overly graceful. Mrs. Vanderbilt (fig. 3) loved high society also and had a daughter who recently made her debut. This daughter (fig. 4) wore two earscrews on each ear which attracted considerable attention. Fig. 5 was worried that her triple chins would make her look older. So she pulled the skin up and back in front of her ears with adhesive tape. She then combed her hair down over the tape so it wouldn't show. This uplift gave her a perpetual smile. The lady whose profile is shown (fig. 6) liked extra long eyelashes looking somewhat like a black butterfly's wings. She coated her lips with thick lipstick so they'd be in kissing position. Fig. 7 did her hair herself and got it too short in back. Fig. 8 is in the act of applying lipstick. She's having great difficulty getting the left side to match the right side. Later when she reaches her nose she'll have it evened out.

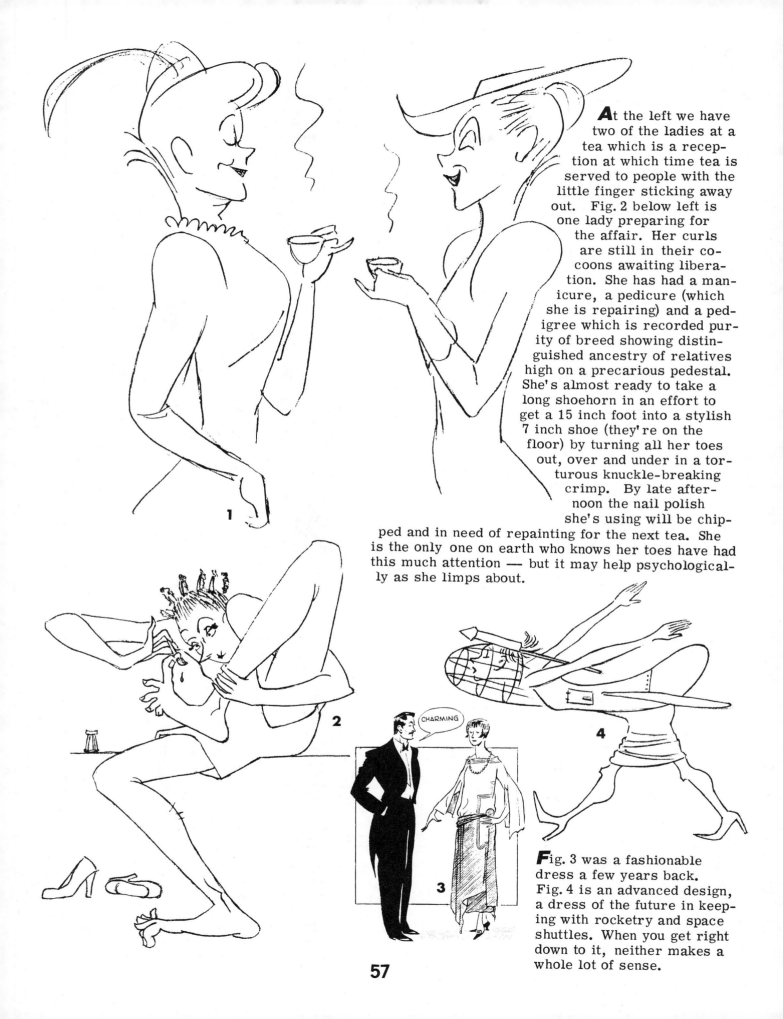

At the left we have two of the ladies at a tea which is a reception at which time tea is served to people with the little finger sticking away out. Fig. 2 below left is one lady preparing for the affair. Her curls are still in their cocoons awaiting liberation. She has had a manicure, a pedicure (which she is repairing) and a pedigree which is recorded purity of breed showing distinguished ancestry of relatives high on a precarious pedestal. She's almost ready to take a long shoehorn in an effort to get a 15 inch foot into a stylish 7 inch shoe (they're on the floor) by turning all her toes out, over and under in a torturous knuckle-breaking crimp. By late afternoon the nail polish she's using will be chipped and in need of repainting for the next tea. She is the only one on earth who knows her toes have had this much attention — but it may help psychologically as she limps about.

CHARMING

Fig. 3 was a fashionable dress a few years back. Fig. 4 is an advanced design, a dress of the future in keeping with rocketry and space shuttles. When you get right down to it, neither makes a whole lot of sense.

HUMOR IN CRYING

It's been said money doesn't buy happiness. The gentleman at the left is dressed in a cutaway coat, is wearing an expensive tie and has a silk stovepipe hat. He has decided to jump into the lake and end it all — his true love has turned him down. He had spent tons of money on her. Though he cannot swim, fortunately the air space in his hat is going to keep him from drowning.

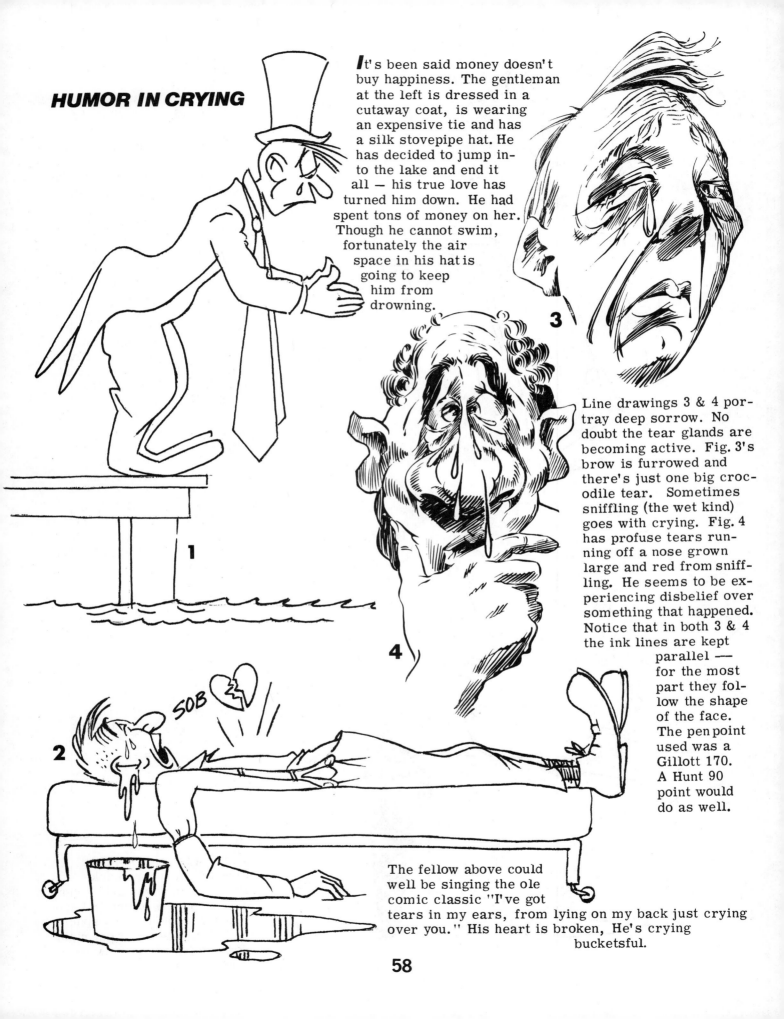

1

2

SOB

3

4

Line drawings 3 & 4 portray deep sorrow. No doubt the tear glands are becoming active. Fig. 3's brow is furrowed and there's just one big crocodile tear. Sometimes sniffling (the wet kind) goes with crying. Fig. 4 has profuse tears running off a nose grown large and red from sniffling. He seems to be experiencing disbelief over something that happened. Notice that in both 3 & 4 the ink lines are kept parallel — for the most part they follow the shape of the face. The pen point used was a Gillott 170. A Hunt 90 point would do as well.

The fellow above could well be singing the ole comic classic "I've got tears in my ears, from lying on my back just crying over you." His heart is broken, He's crying bucketsful.

58

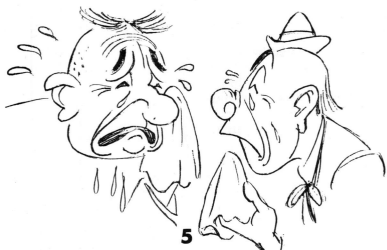

5

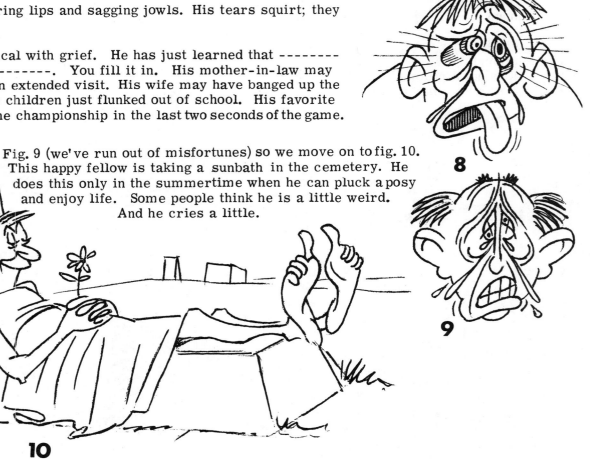

6

7

8

9

Misery likes company. The clown-like characters in fig. 5 may be consoling each other. Comic tears may fly off into the air. So much of comic humor is built on tragedy. If all the funny paper cases of tragedy occurred, the whole world would be in a terrible fix. One way we can avert real tragedy from hurting so much is to read about funny people who get it in wholesale quantities. Our funny bones are tickled in seeing make-believe folk get banged, bonked and whamed. It would be a sad world without comic pages in newspapers and magazines.

Fig. 6 at top right is completely choked up with great gushes of tears. What a taste he must have in his mouth -- tears are salty and the poor guy may swallow some of it.

Fig. 7 has quivering lips and sagging jowls. His tears squirt; they don't just fall.

Fig. 8 is hysterical with grief. He has just learned that -------- --------------------. You fill it in. His mother-in-law may be coming for an extended visit. His wife may have banged up the family car. His children just flunked out of school. His favorite team just lost the championship in the last two seconds of the game.

Fig. 9 (we've run out of misfortunes) so we move on to fig. 10. This happy fellow is taking a sunbath in the cemetery. He does this only in the summertime when he can pluck a posy and enjoy life. Some people think he is a little weird. And he cries a little.

10

DRAWING SILLY SLEEPERS

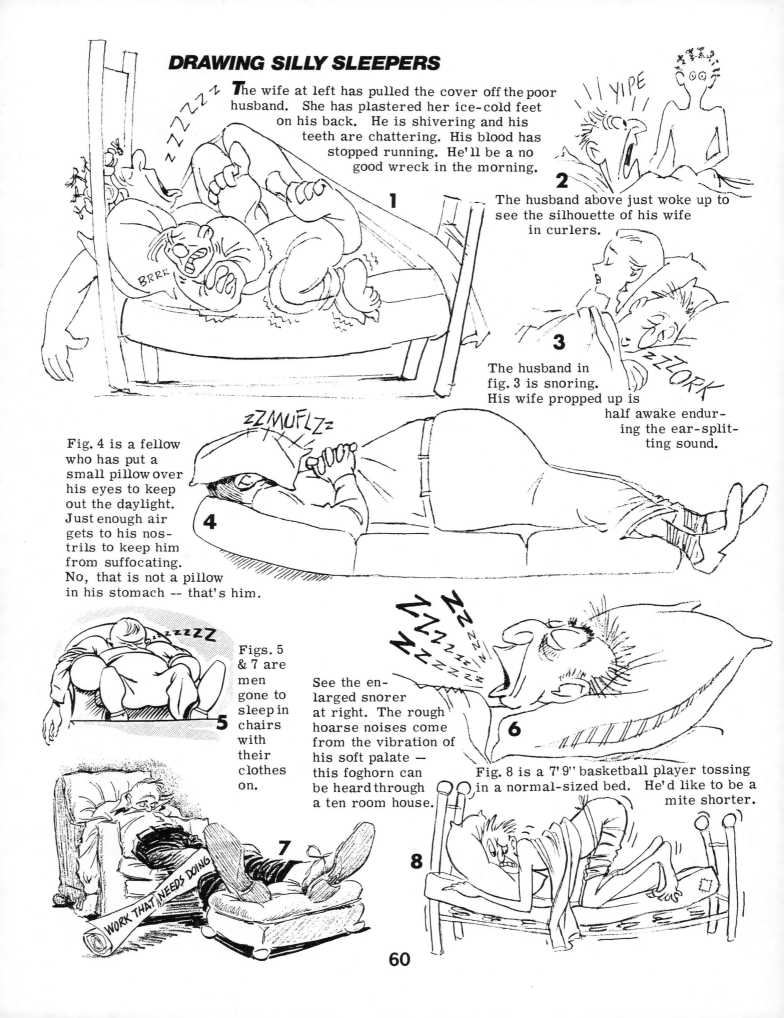

1 The wife at left has pulled the cover off the poor husband. She has plastered her ice-cold feet on his back. He is shivering and his teeth are chattering. His blood has stopped running. He'll be a no good wreck in the morning.

2 The husband above just woke up to see the silhouette of his wife in curlers.

3 The husband in fig. 3 is snoring. His wife propped up is half awake enduring the ear-splitting sound.

4 Fig. 4 is a fellow who has put a small pillow over his eyes to keep out the daylight. Just enough air gets to his nostrils to keep him from suffocating. No, that is not a pillow in his stomach -- that's him.

Figs. 5 & 7 are men gone to sleep in chairs with their clothes on.

See the enlarged snorer at right. The rough hoarse noises come from the vibration of his soft palate — this foghorn can be heard through a ten room house.

6

Fig. 8 is a 7' 9" basketball player tossing in a normal-sized bed. He'd like to be a mite shorter.

7 WORK THAT NEEDS DOING

8

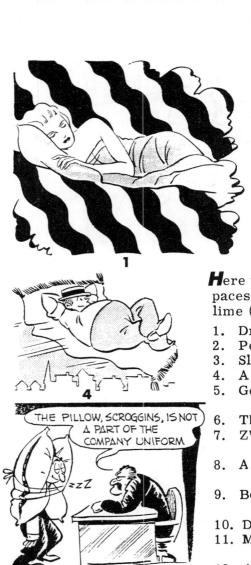

1

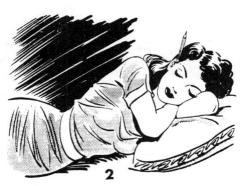

2

3

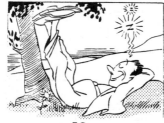

13

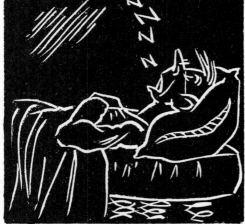

4

Here we have SLEEP put through its paces — from the ridiculous to the sublime (in reverse). A hasty rundown:

1. Dreaming in technicolor — do we do it?
2. Pencil still behind the ear while napping.
3. Sleeping beauty.
4. A fantasy trip on a flying carpet.
5. Getting into the laughably absurd — even the ridiculous.
6. The semi-absurd on a couch.
7. Z's for sleep vs. BUZ's from the bee about to land on this poor guy's nose.
8. A big Z, an insecurely tied hammock and a big tack directly beneath.
9. Bowed in bedposts and sagging mattress — good for cartoon.
10. Disturbed sleep — horrifying!
11. Mom gets breakfast in bed — a semi-cartoon.
12. A delightfull bit of dream fantasy — doing a ballet in his long underwear.
13. Preposterous position — feet propped up, head on a rock.
14. Resting in a hospital bed.
15. Good intentions down the Z drain.
16. Snores cut in a linoleum block -- he wears glasses to better recognize people he dreams about.
17. Man who has learned to sleep standing up.

THE PILLOW, SCROGGINS, IS NOT A PART OF THE COMPANY UNIFORM

zZZ

5

Zzz

6

14

BUZzz

ZZZZ

7

BEFORE I BEGIN DIGGING I'D BETTER PLAN THE GARDEN... OH HUM...zzzzzzzzz

SEEDS

15

Z

8

zzz

9

CRASH!

10

17

11

12

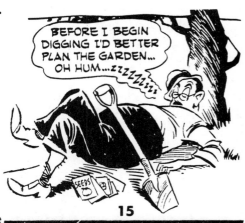

16

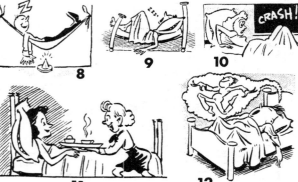

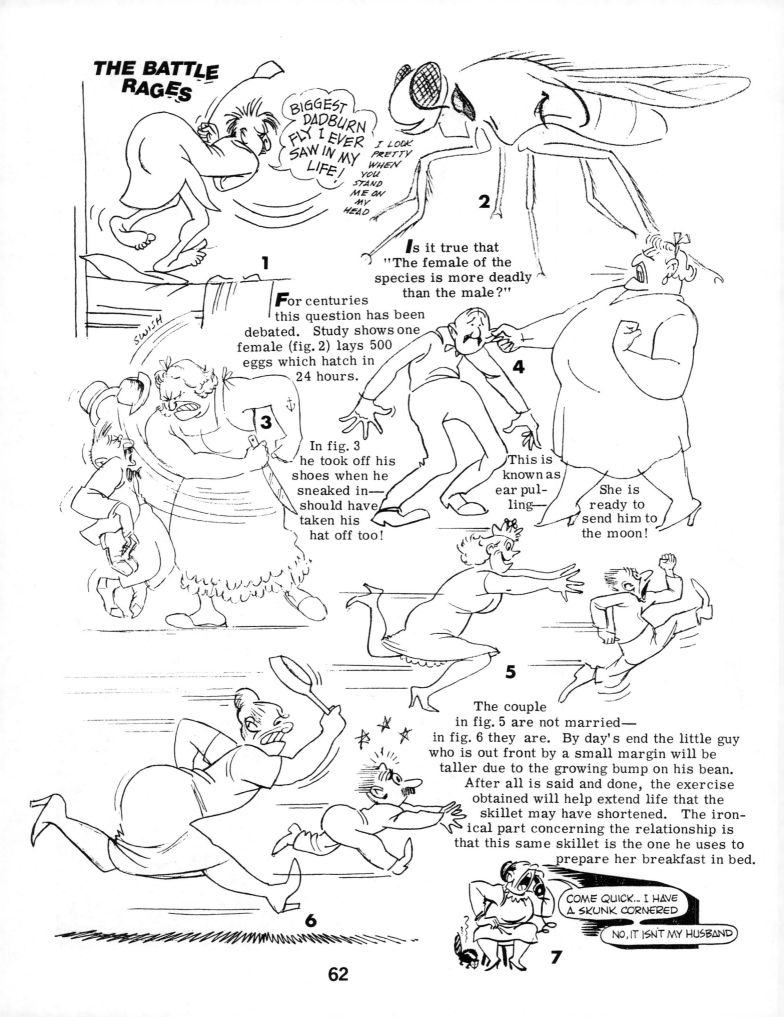

THE BATTLE RAGES

BIGGEST DADBURN FLY I EVER SAW IN MY LIFE!

I LOOK PRETTY WHEN YOU STAND ME ON MY HEAD

1

SWISH

2

Is it true that "The female of the species is more deadly than the male?"

For centuries this question has been debated. Study shows one female (fig. 2) lays 500 eggs which hatch in 24 hours.

3

In fig. 3 he took off his shoes when he sneaked in— should have taken his hat off too!

4

This is known as ear pulling—

She is ready to send him to the moon!

5

The couple in fig. 5 are not married— in fig. 6 they are. By day's end the little guy who is out front by a small margin will be taller due to the growing bump on his bean. After all is said and done, the exercise obtained will help extend life that the skillet may have shortened. The ironical part concerning the relationship is that this same skillet is the one he uses to prepare her breakfast in bed.

6

COME QUICK... I HAVE A SKUNK CORNERED

NO, IT ISN'T MY HUSBAND

7

ENGAGEMENT PROCEDURES

The way it used to be... stiff collar, string tie and spats. For her: nervous little fan, long gloves and bustle.

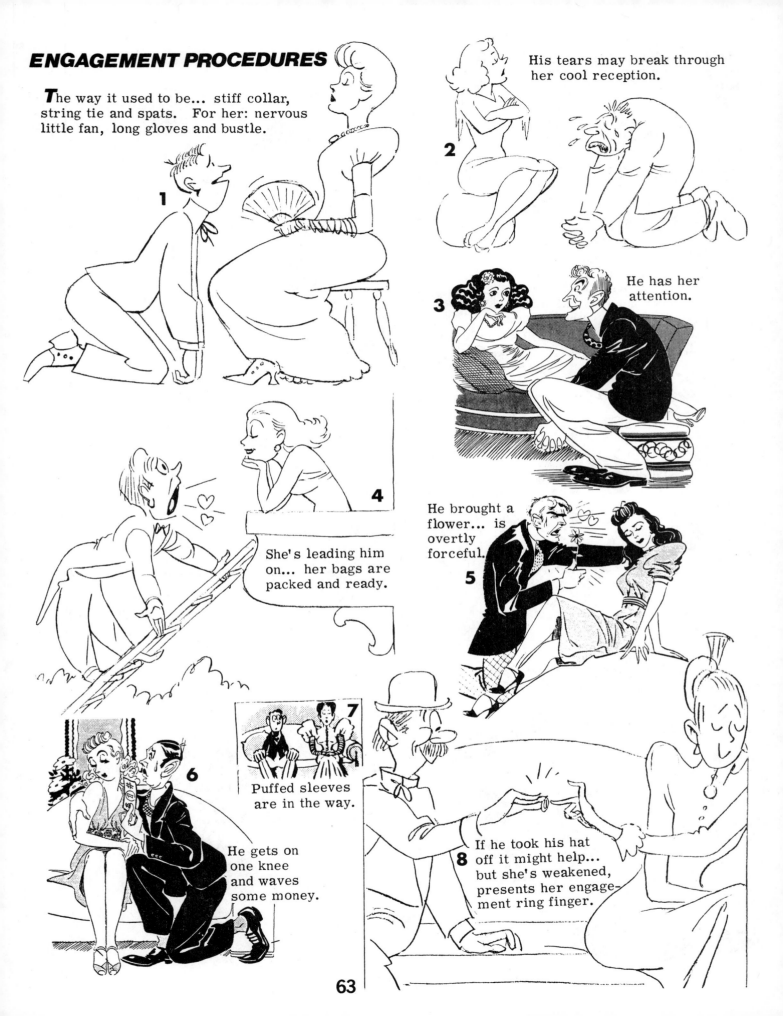

1

His tears may break through her cool reception.

2

He has her attention.

3

4

She's leading him on... her bags are packed and ready.

He brought a flower... is overtly forceful.

5

6

He gets on one knee and waves some money.

7

Puffed sleeves are in the way.

If he took his hat off it might help... but she's weakened, presents her engagement ring finger.

8

HUSBAND & WIFE SITUATIONS

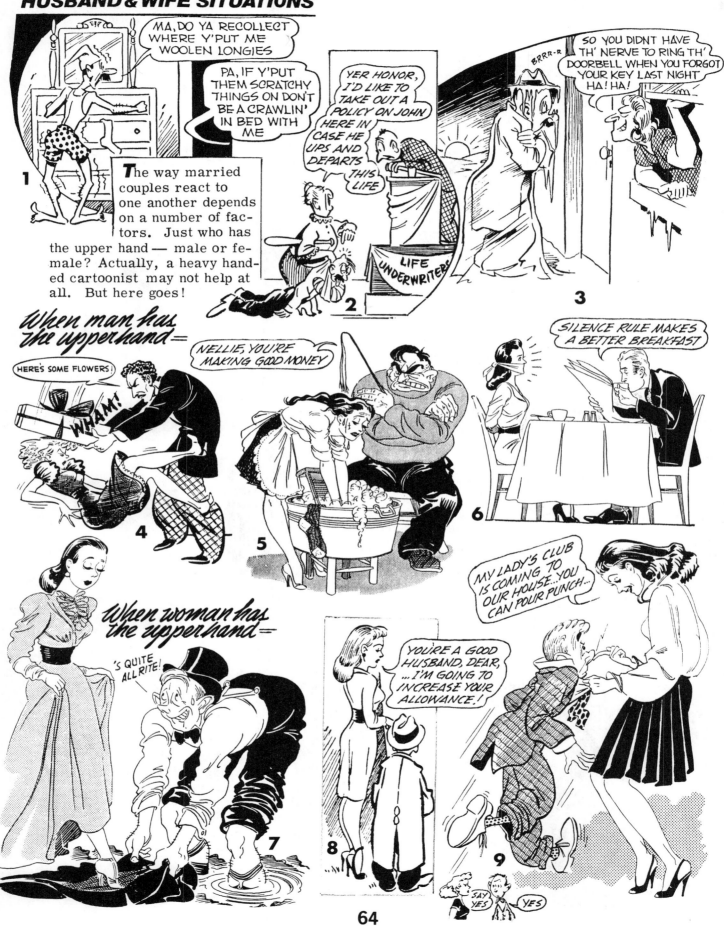

CARTOONING CRAZY COIFFURES

(These were improvised impromtu before a televison audience...)

PLEASE SELECT MY HAIRDO

"I'M NOT TOO FOND OF THIS ONE"

Herewith are some unique and attention-getting hairdos. Oftentimes expert hairstylists go to great lengths to be creative. **1** Instead of a curler a small bone is twisted so that the strands of hair are brought upward. One has to be careful when petting dogs — especially big dogs. **2** This daring hairdo is made to look like a bird's nest. Real birds will be attracted during nesting season. If the lady will remain more or less upright the eggs will not roll out. **3** The inflight hair style. The above portion resembles wings. In the summer the hair waves just enough to automatically cool the head on hot days. **4** This hairdo shows promise of sweeping the country. It is made of real hair which has selected broom straws to give it body. After tall women have swept the floor, they can quickly brush the ceiling by spinning around the room. **5** This hair can appear exotically teased in very little time. In fact, it's ready the moment she gets out of bed. If she is frightened by an intruder, one look and the intruder leaves immediately. **6** This style of grooming is a delightful coiffure. The hair needs to be brushed and combed upward. The top resembles a grass fire under control. The hair growing from the back of the neck should be trained and bunched. **7** This informal wind-blown hair has a weather vane affixed to the scalp which informs people of the wind's velocity.

THE ART OF KISSING

"A little nonsense now and then
is relished by the wisest men."
— no one knows who said it
but 'twas said nonetheless.

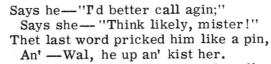

Says he—"I'd better call agin;"
Says she—"Think likely, mister!"
Thet last word pricked him like a pin,
An' —Wal, he up an' kist her.
 — Lowell.

Apparently kissing has been going on since the beginning of time. On these two pages, ways of doing it and the resultant sounds that attend it, are thoughtfully discussed. No one likes to be licked by or kissed on the lips by a hound dog — usually they'd prefer a human kiss over that of a hound. Yet fewer germs are dispersed, some doctors say, by the friendly dog.

Let's go immediately to fig. 6 where the husband puts on his hat to go to work in the morning; then he remembers he hasn't kissed his wife goodbye. He bends down and gives her a sterile top-of-the-head kiss. The sound made is something like a small whisk broom barely brushing a dry blanket.

The husband in fig. 7 is much more attentive. Make no mistake about it, this is a passionate kiss. He is ardently affectionate. He messes up her hair with one hand and pulls her towards him with the other. To say that sparks fly is inadequate — the meeting is a bit electric. The ensuing sound is something like a cow's foot in a bog hole.

Do you hear a quaintly peculiar peck coming from a little chicken on the next page? We leave the pretty blond below who has bathed a receptive face with lipstick.

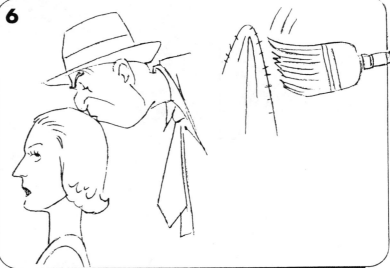

66

Fig. 10 at right illustrates the four stages of the meeting of the minds, and hearts, and lips. In the middle of the ridiculous, a bit of the sublime. The question — does one or the other or both close their eyes at stage four?

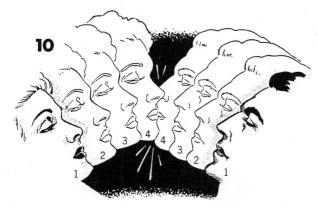

At left in fig. 8 is the pecking kiss. Could be the peckee is a little disappointed. This quick momentary contact is about as affectionate as the quick peck on the empty tomato can by the chicken. The poor guy involved may have a faint touch of red above his left eyebrow. Show and tell? — not much to show — not much to tell.

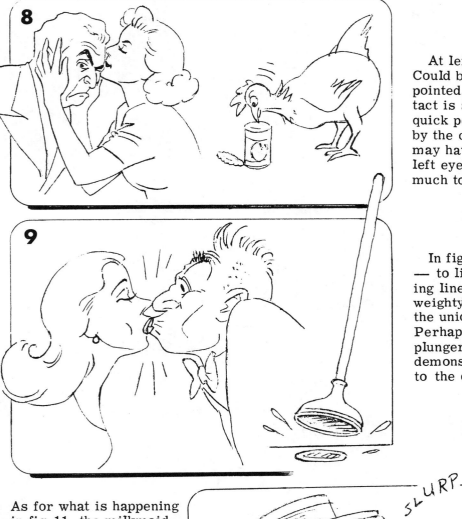

In fig. 9 we have "a little nonsense" — to lift a word or two from the opening lines at the very beginning of this weighty discussion. No question about the union or junction of surfaces here. Perhaps the best sound would be a plunger on and off a wet drain. This demonstration is the exact antithesis to the couple's performance in fig. 8.

As for what is happening in fig. 11, the milkmaid told him to keep his eyes closed for a kiss — he did — and he got it. She ran in a substitute. The timing could not be better. Our hero never had such a kiss in all his borned days. There were two sounds here—"slurp" and off frame and out of view a "tee-hee." Who knows? This poor guy may have kept his eyes closed hoping for a follow-up! And the milkmaid? She may have stepped in quickly and gotten credit for the kiss.

COMMERCIAL CARTOONING

Studies show that a touch of the zany will not only capture attention in advertising, but will produce results in the cash register. A number of these spots were in color.

69

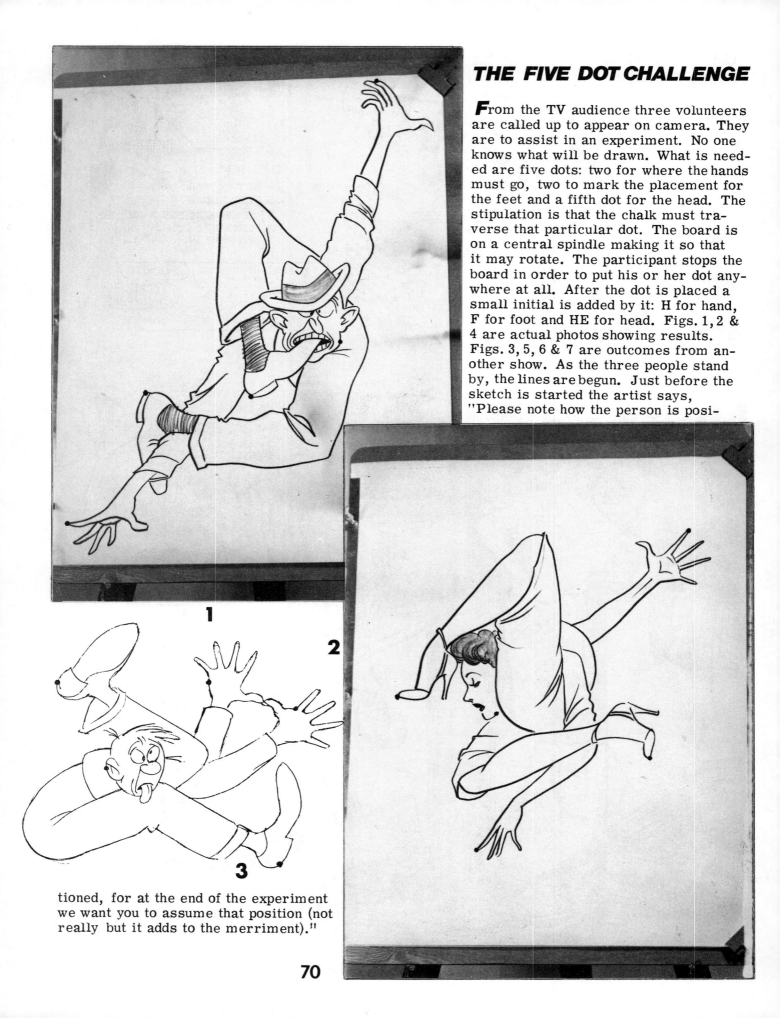

THE FIVE DOT CHALLENGE

From the TV audience three volunteers are called up to appear on camera. They are to assist in an experiment. No one knows what will be drawn. What is needed are five dots: two for where the hands must go, two to mark the placement for the feet and a fifth dot for the head. The stipulation is that the chalk must traverse that particular dot. The board is on a central spindle making it so that it may rotate. The participant stops the board in order to put his or her dot anywhere at all. After the dot is placed a small initial is added by it: H for hand, F for foot and HE for head. Figs. 1, 2 & 4 are actual photos showing results. Figs. 3, 5, 6 & 7 are outcomes from another show. As the three people stand by, the lines are begun. Just before the sketch is started the artist says, "Please note how the person is posi-

1

2

3

tioned, for at the end of the experiment we want you to assume that position (not really but it adds to the merriment)."

70

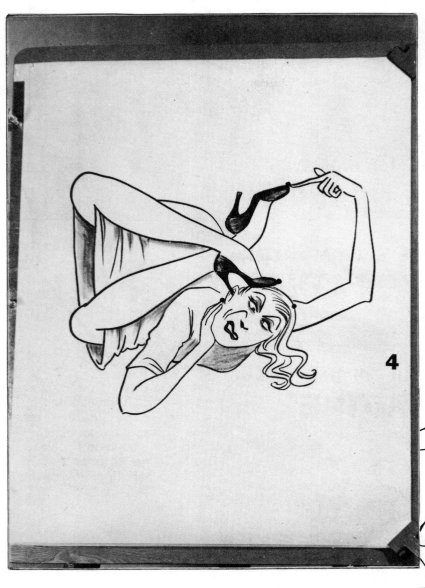

Now for the reader who would like to know the best procedure: draw the hands first, the feet next and the head last. Always place these anatomy parts so the wrists and arms point in toward the center of the board; otherwise the whole person cannot be assembled. The same applies to the ankle. When the head is drawn only the outline appears — the facial features are added last for an interesting climax to the experiment. After the hands and feet are on the board, the artist steps back and asks, "Would anyone here like to finish the job?" No one responds for it looks like an impossible mess. Anything drawn before a TV camera must be done quickly as possible. The success of the show depends partly on speed and execution. These examples are really too detailed. Since viewing screens are miles away and usually smaller than the instudio screen, the reduction in size makes the final result look better. Lots of practice in preparation helps the artist anticipate what to do.

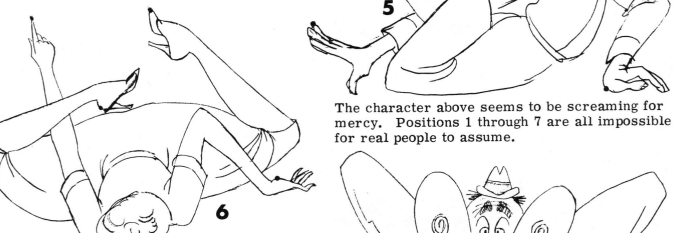

The character above seems to be screaming for mercy. Positions 1 through 7 are all impossible for real people to assume.

Sometimes a joker suggests the dots be arranged in a small group like in fig. 7. There is a way out and this smiling idiot has found it. Notice the holes in his shoes.

71

This "W" begins our question: The problem has to do with combining two halves of different people's heads making one whole head. The two individuals selected do not have to be in the same family. They may be boyfriend and girlfriend, or two friends of the same sex. In a way it's easier to caricature the individual features than to try for portrait exactness. If we go the caricature route it's well to select parts of the face which may be exaggerated — it's funnier that way. Also, profiles work out better than front views. It's a good idea to experiment on

What would happen if ...

THE TOP HALF WAS **SON**

THE BOTTOM HALF WAS **FATHER** ?

OR THE TOP HALF WAS **MOTHER**

and

THE BOTTOM HALF WAS **BABY DAUGHTER?**

someone in your own household. They'll understand it's a practice session. Just use pencil, and have an eraser handy. If you wish to ink it later, it's wise to go lightly with the pencil underdrawing.

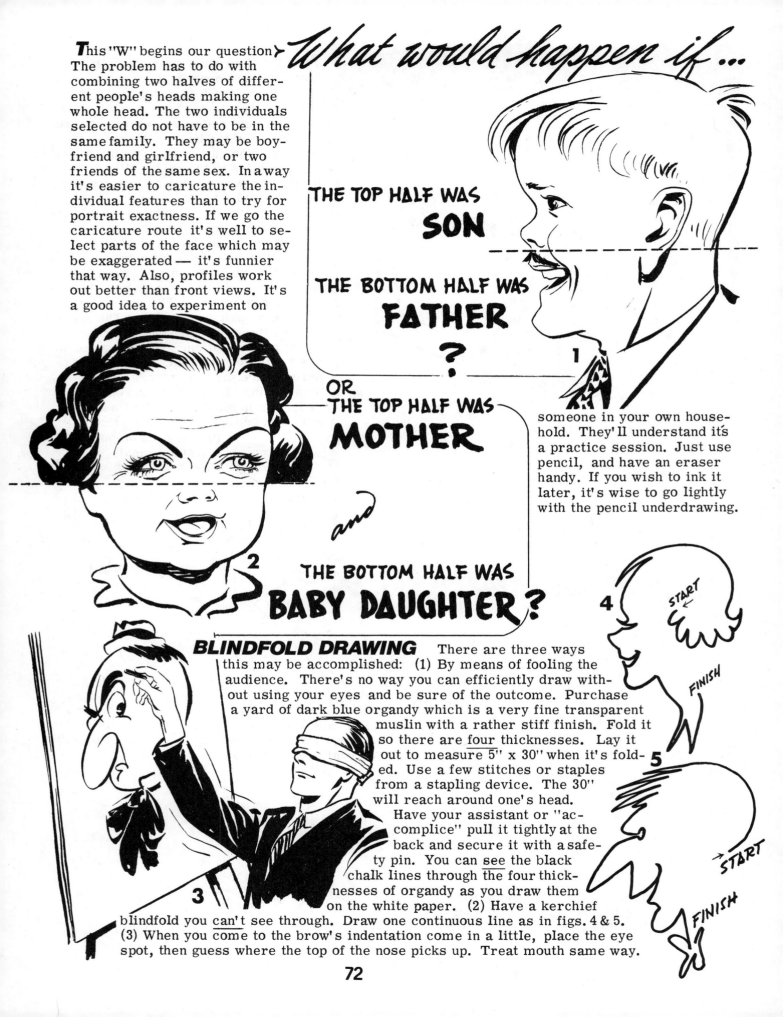

BLINDFOLD DRAWING There are three ways this may be accomplished: (1) By means of fooling the audience. There's no way you can efficiently draw without using your eyes and be sure of the outcome. Purchase a yard of dark blue organdy which is a very fine transparent muslin with a rather stiff finish. Fold it so there are four thicknesses. Lay it out to measure 5" x 30" when it's folded. Use a few stitches or staples from a stapling device. The 30" will reach around one's head. Have your assistant or "accomplice" pull it tightly at the back and secure it with a safety pin. You can see the black chalk lines through the four thicknesses of organdy as you draw them on the white paper. (2) Have a kerchief blindfold you can't see through. Draw one continuous line as in figs. 4 & 5. (3) When you come to the brow's indentation come in a little, place the eye spot, then guess where the top of the nose picks up. Treat mouth same way.

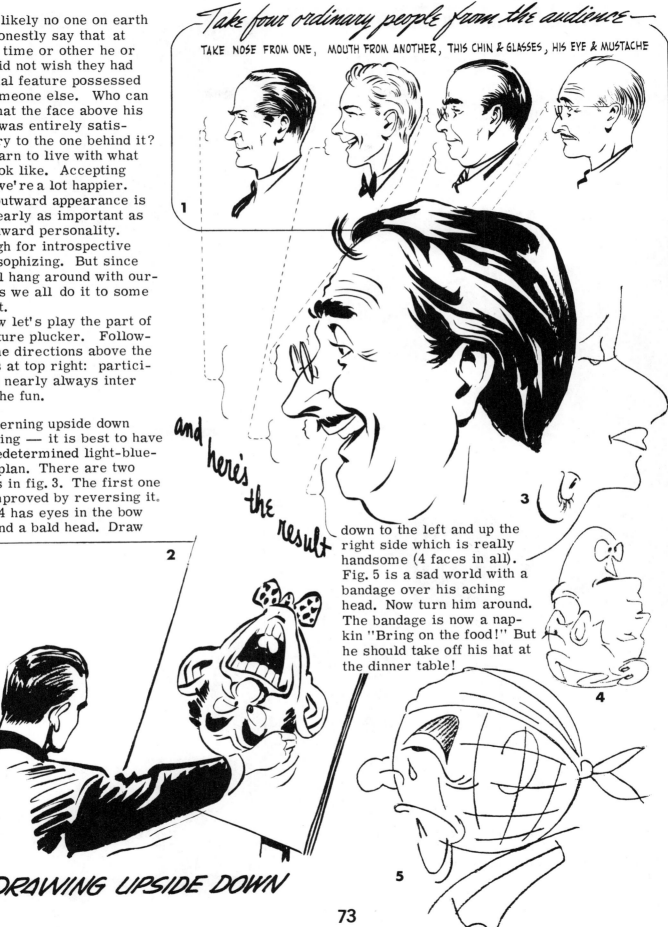

Very likely no one on earth can honestly say that at some time or other he or she did not wish they had a facial feature possessed by someone else. Who can say that the face above his neck was entirely satisfactory to the one behind it? We learn to live with what we look like. Accepting that, we're a lot happier. The outward appearance is not nearly as important as the inward personality. Enough for introspective philosophizing. But since we all hang around with ourselves we all do it to some extent.

Now let's play the part of a feature plucker. Following the directions above the heads at top right: participants nearly always inter into the fun.

Concerning upside down drawing — it is best to have a predetermined light-blue-line plan. There are two faces in fig. 3. The first one is improved by reversing it. Fig. 4 has eyes in the bow tie and a bald head. Draw

Take four ordinary people from the audience—

TAKE NOSE FROM ONE, MOUTH FROM ANOTHER, THIS CHIN & GLASSES, HIS EYE & MUSTACHE

1

and here's the result

3

2

down to the left and up the right side which is really handsome (4 faces in all). Fig. 5 is a sad world with a bandage over his aching head. Now turn him around. The bandage is now a napkin "Bring on the food!" But he should take off his hat at the dinner table!

4

DRAWING UPSIDE DOWN

5

73

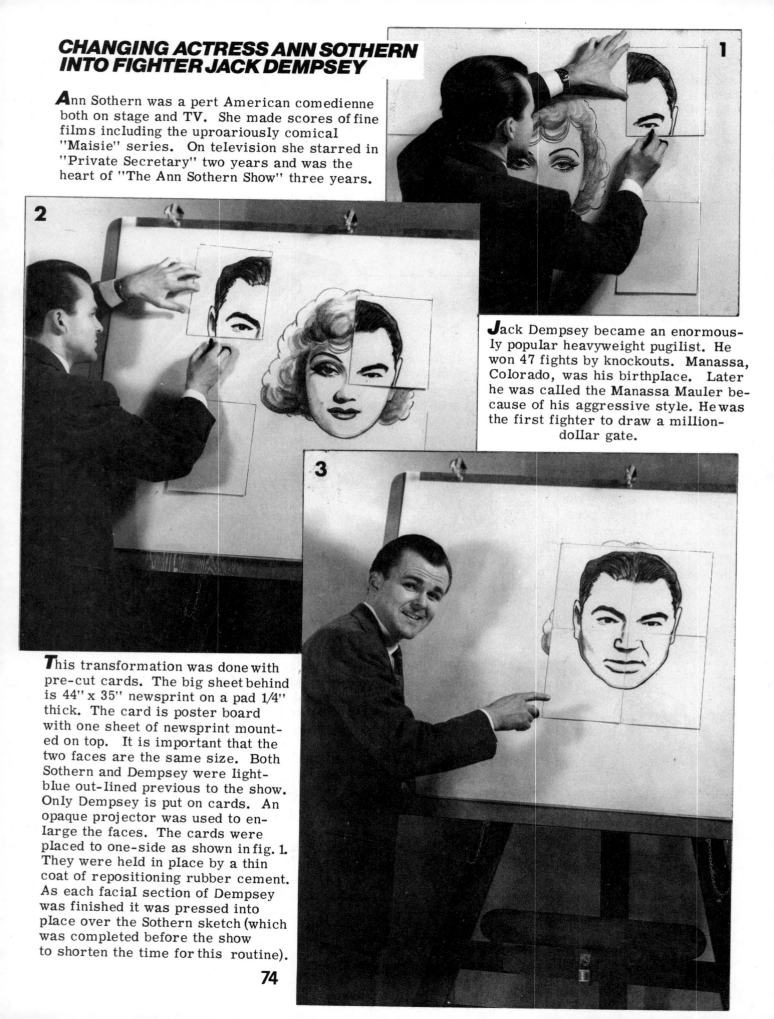

CHANGING ACTRESS ANN SOTHERN INTO FIGHTER JACK DEMPSEY

Ann Sothern was a pert American comedienne both on stage and TV. She made scores of fine films including the uproariously comical "Maisie" series. On television she starred in "Private Secretary" two years and was the heart of "The Ann Sothern Show" three years.

1

Jack Dempsey became an enormously popular heavyweight pugilist. He won 47 fights by knockouts. Manassa, Colorado, was his birthplace. Later he was called the Manassa Mauler because of his aggressive style. He was the first fighter to draw a million-dollar gate.

2

3

This transformation was done with pre-cut cards. The big sheet behind is 44" x 35" newsprint on a pad 1/4" thick. The card is poster board with one sheet of newsprint mounted on top. It is important that the two faces are the same size. Both Sothern and Dempsey were light-blue out-lined previous to the show. Only Dempsey is put on cards. An opaque projector was used to enlarge the faces. The cards were placed to one-side as shown in fig. 1. They were held in place by a thin coat of repositioning rubber cement. As each facial section of Dempsey was finished it was pressed into place over the Sothern sketch (which was completed before the show to shorten the time for this routine).

74

THE HISTORY OF THE MALE MIND

1 There are six phases of this routine on a re-volving board. It is necessary to light-blue-line fig. 6 on your paper. Phase No.1: The young-ster begins with his mind completely blank (point at paper); No.2: He learns that $2+2=4$ (this is an unchanging fundamental truth); No.3: He learns that C-A-T spells cat (the board is moved slightly to accommodate letters' heavy chalk tracing with the C being on the chin; No.4: He is told that 13 is an unlucky number (the 3 is the back of the head & hair; the 1 is the eyebrow turned on its side.) Much can be made of this for until now the child is not superstitious; No.5: He soon catches on that S-H-E is more important than he (the pa-per is turned to accommodate the E's being traced as it appears in No.6. Board is then uprighted so audience can see beautiful girl. Lastly the chalk artist tears off the drawing with "so he marries the girl and the poor lad's mind returns to its former state (blank)."

3

5

(The positioning
of the E is optional.
It may be a comb
and remain horizontal.
Thus the entire board
can be stationary.)

Phase No. 6 may be enlarged to lifesize or more by an opaque projector then light-blue-lined so that only chalk artist may see developing picture.

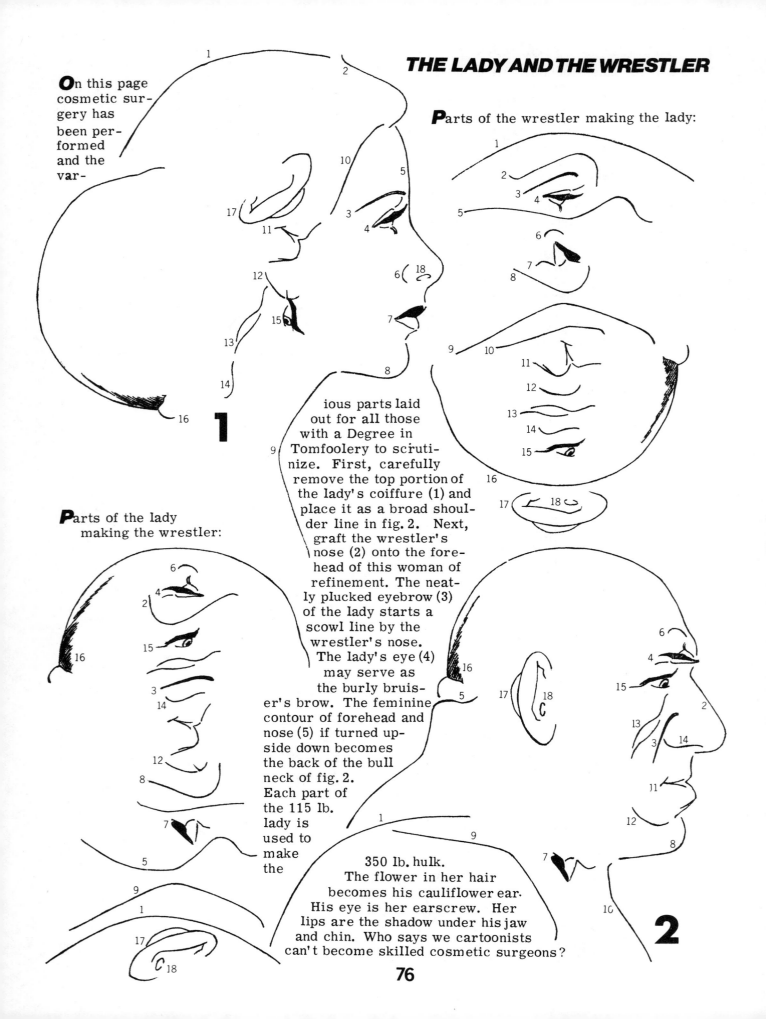

THE LADY AND THE WRESTLER

On this page cosmetic surgery has been performed and the var-

Parts of the wrestler making the lady:

ious parts laid out for all those with a Degree in Tomfoolery to scrutinize. First, carefully remove the top portion of the lady's coiffure (1) and place it as a broad shoulder line in fig. 2. Next, graft the wrestler's nose (2) onto the forehead of this woman of refinement. The neatly plucked eyebrow (3) of the lady starts a scowl line by the wrestler's nose. The lady's eye (4) may serve as the burly bruiser's brow. The feminine contour of forehead and nose (5) if turned upside down becomes the back of the bull neck of fig. 2. Each part of the 115 lb. lady is used to make the

Parts of the lady making the wrestler:

350 lb. hulk. The flower in her hair becomes his cauliflower ear. His eye is her earscrew. Her lips are the shadow under his jaw and chin. Who says we cartoonists can't become skilled cosmetic surgeons?

THE LADY AND THE GENTLEMAN

The handsome man in fig. 2 is wearing a beautiful boutonniere likeness of the lady who has caught his eye. What he doesn't realize is that every line of his profile can be duplicated in every line of his lady love. Starting with No. 1 at the top of his head we find a line exactly like it somewhere in the lady's figure — sometimes in a place where you'd least expect it. For example, his eye (6) and his upper lip and mouth (10) are at the very bottom of the lady's formal attire. All the lines numbered in fig. 2 have matching lines in fig. 1.

INTERLOCKING HEADS

In fig. 2 we have an upside down slapstick face incorporated in the hairdo of an attractive miss. This and all the sketches on this page take pre-planning. They may be simplified and practiced if part of a program before and audience.

Fig. 4 is a clownish character whose profile is woven together with a pretty girl (who as you can see is upside down).

Fig. 5 has a common line running through the composition. Her shoe heel is half his smile.

Fig. 6 could be the farmer's daughter with her dad out front.

Is there any set rule in developing this sort of interplay of lines? Begin with a simple understructure which looks right. With a see-through tissue lay it over first one and then the other until a particular line serves both drawings. For example, the two 14's, the two 22's, the two 20's, etc.

The line which is an essential part of both big head and small body we call the master line. See this in figs. 4, 5 & 6. Fig. 3 has separate heads — no master line, but an overall tie-in line going completely around the double drawing. Small sketches may be enlarged with an opaque projector, then light-blue lined where they can be traced later with black or colored chalk. A 1/4'' pad of plain newsprint paper is best on your show board.

77

COMBINING COMEDIANS WITH ANIMAL FACES

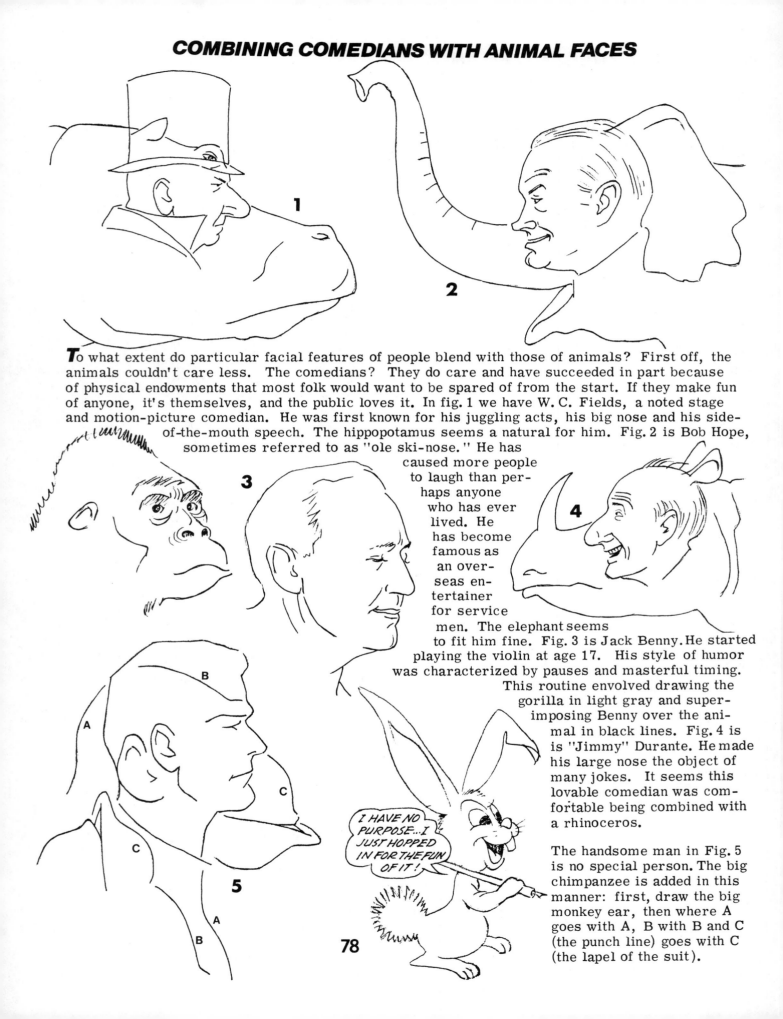

1

2

To what extent do particular facial features of people blend with those of animals? First off, the animals couldn't care less. The comedians? They do care and have succeeded in part because of physical endowments that most folk would want to be spared of from the start. If they make fun of anyone, it's themselves, and the public loves it. In fig. 1 we have W. C. Fields, a noted stage and motion-picture comedian. He was first known for his juggling acts, his big nose and his side-of-the-mouth speech. The hippopotamus seems a natural for him. Fig. 2 is Bob Hope, sometimes referred to as "ole ski-nose." He has caused more people to laugh than perhaps anyone who has ever lived. He has become famous as an over-seas entertainer for service men. The elephant seems to fit him fine. Fig. 3 is Jack Benny. He started playing the violin at age 17. His style of humor was characterized by pauses and masterful timing. This routine envolved drawing the gorilla in light gray and super-imposing Benny over the animal in black lines. Fig. 4 is is "Jimmy" Durante. He made his large nose the object of many jokes. It seems this lovable comedian was comfortable being combined with a rhinoceros.

3

4

The handsome man in Fig. 5 is no special person. The big chimpanzee is added in this manner: first, draw the big monkey ear, then where A goes with A, B with B and C (the punch line) goes with C (the lapel of the suit).

5

A
B
C
C
A
B

I HAVE NO PURPOSE...I JUST HOPPED IN FOR THE FUN OF IT!

78

LAUGHABLE ANIMALS

This chimpanzee ranks way up in high society. She is wearing a brief mini-skirt. She has painted toenails. She holds her little fingers out when sipping tea or handling her slim cigarette. Fig. 2 is a tiger on a football team by that name. Fig. 3 concerns itself with an actual dry spell.

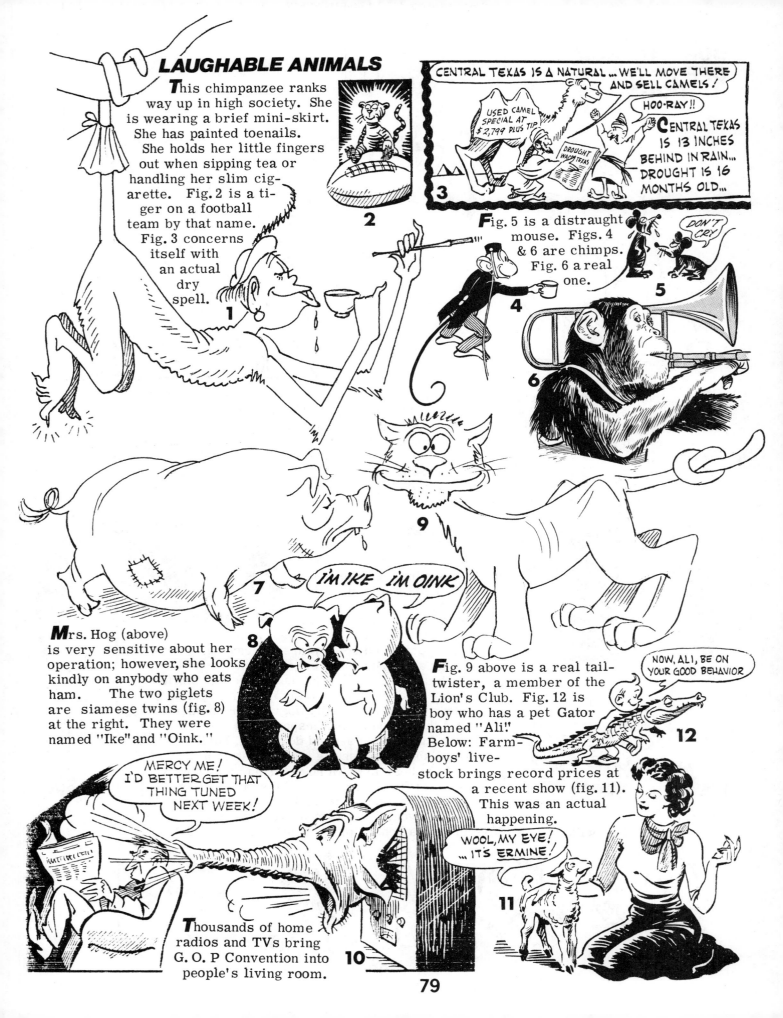

3 CENTRAL TEXAS IS A NATURAL ... WE'LL MOVE THERE AND SELL CAMELS!

USED CAMEL SPECIAL AT $2,799 PLUS TIP

DROUGHT WACO TEXAS

HOO-RAY!!

CENTRAL TEXAS IS 13 INCHES BEHIND IN RAIN ... DROUGHT IS 16 MONTHS OLD ...

Fig. 5 is a distraught mouse. Figs. 4 & 6 are chimps. Fig. 6 a real one.

DON'T CRY

Mrs. Hog (above) is very sensitive about her operation; however, she looks kindly on anybody who eats ham. The two piglets are siamese twins (fig. 8) at the right. They were named "Ike" and "Oink."

I'M IKE I'M OINK

Fig. 9 above is a real tail-twister, a member of the Lion's Club. Fig. 12 is boy who has a pet Gator named "Ali!" Below: Farmboys' livestock brings record prices at a recent show (fig. 11). This was an actual happening.

NOW, ALI, BE ON YOUR GOOD BEHAVIOR

12

MERCY ME! I'D BETTER GET THAT THING TUNED NEXT WEEK!

WOOL, MY EYE! ... ITS ERMINE!

11

Thousands of home radios and TVs bring G.O.P Convention into people's living room.

10

79

OUR HATS ARE OFF TO THE DOGS

The above dog duet was performed on television. Because it was done in the least possible amount of time it was kept simple. One of the secrets of effective TV drawing is to save the best till last. In this case it is the comic faces of the canine singers. Since it is first developed on paper with light non-reproducing blue lines, the chalk artist can skip around. This keeps the viewing audience in suspense as to the outcome. For example, the two tails could be heavy-lined first, the two noses sticking up in the air second, the body sections of the dogs next, etc. Last of all the faces, the "yipes" and "arroo's" after that. Musical background could be used or some pre-thoughtout patter by the chalk artist.

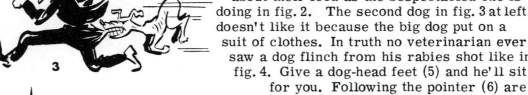

Dogs are probably the most non-complaining and amusingly condescending of God's whole animal kingdom. Nearly every comic page has two, sometimes more, dogs entertaining readers. Figs. 2 through 11 are simply spots lifted from years of drawing. Pure-bred dogs are wonderful, but the dogs themselves couldn't care less. If we as human beings smiled as often as dogs wagged their tails it would be a better world. In reality dogs never complain about their food as the bespectacled one is doing in fig. 2. The second dog in fig. 3 at left doesn't like it because the big dog put on a suit of clothes. In truth no veterinarian ever saw a dog flinch from his rabies shot like in fig. 4. Give a dog-head feet (5) and he'll sit for you. Following the pointer (6) are little dogs with smiles. Give them the benefit of the doubt — it's the backend that smiles.

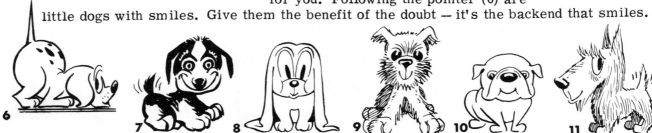

80

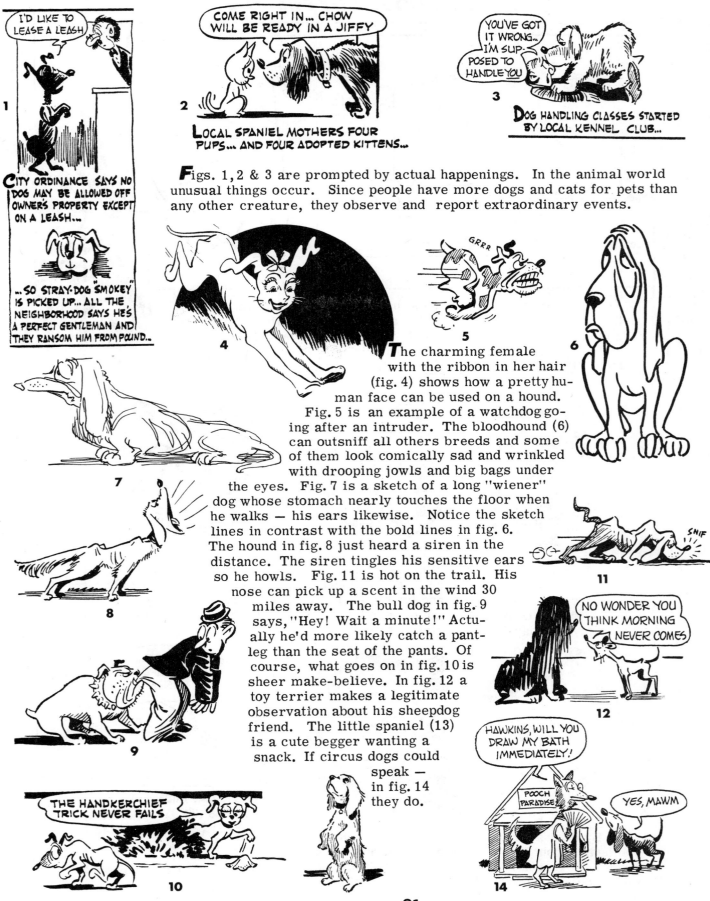

Figs. 1, 2 & 3 are prompted by actual happenings. In the animal world unusual things occur. Since people have more dogs and cats for pets than any other creature, they observe and report extraordinary events.

The charming female with the ribbon in her hair (fig. 4) shows how a pretty human face can be used on a hound. Fig. 5 is an example of a watchdog going after an intruder. The bloodhound (6) can outsniff all others breeds and some of them look comically sad and wrinkled with drooping jowls and big bags under the eyes. Fig. 7 is a sketch of a long "wiener" dog whose stomach nearly touches the floor when he walks — his ears likewise. Notice the sketch lines in contrast with the bold lines in fig. 6. The hound in fig. 8 just heard a siren in the distance. The siren tingles his sensitive ears so he howls. Fig. 11 is hot on the trail. His nose can pick up a scent in the wind 30 miles away. The bull dog in fig. 9 says, "Hey! Wait a minute!" Actually he'd more likely catch a pant-leg than the seat of the pants. Of course, what goes on in fig. 10 is sheer make-believe. In fig. 12 a toy terrier makes a legitimate observation about his sheepdog friend. The little spaniel (13) is a cute begger wanting a snack. If circus dogs could speak — in fig. 14 they do.

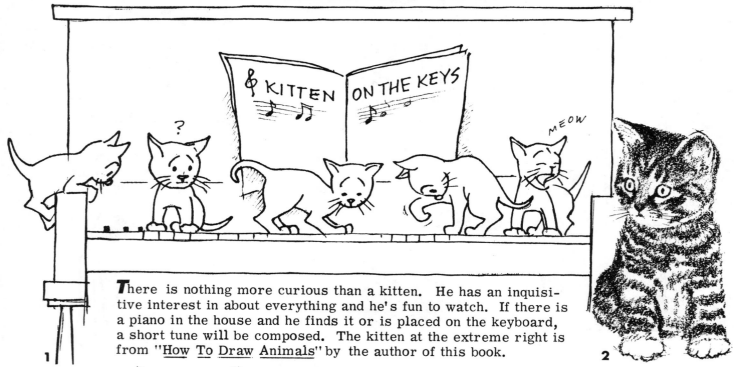

There is nothing more curious than a kitten. He has an inquisitive interest in about everything and he's fun to watch. If there is a piano in the house and he finds it or is placed on the keyboard, a short tune will be composed. The kitten at the extreme right is from "How To Draw Animals" by the author of this book.

3

"Me-aah! dis silk piller stuff wid ribbons is sissy — gimme da back alleys anyday."

4

"Purr-r-r! I do not care for the rough and tumble — I prefer tea parties and girl talk."

5

"I know, we cats don't usually make expressions like this — I got the idea from human TV comedians."

6

"Oh! By the way, have you heard about Mrs. Jones? Now, don't tell a soul—SSSp-ssp-ssssp!"

7

"Mercy! You don't say! Well, what do you know about that! Tsk Tsk—" (with apologies to cats)

COULD BE... YOUR PAPA HAD A BUSHY TAIL

8 A CAT, "MRS. MIDNIGHT," MOTHERS TWO BABY SQUIRRELS AFTER LITTER OF KITTENS DIE...

The above actually happened.

82

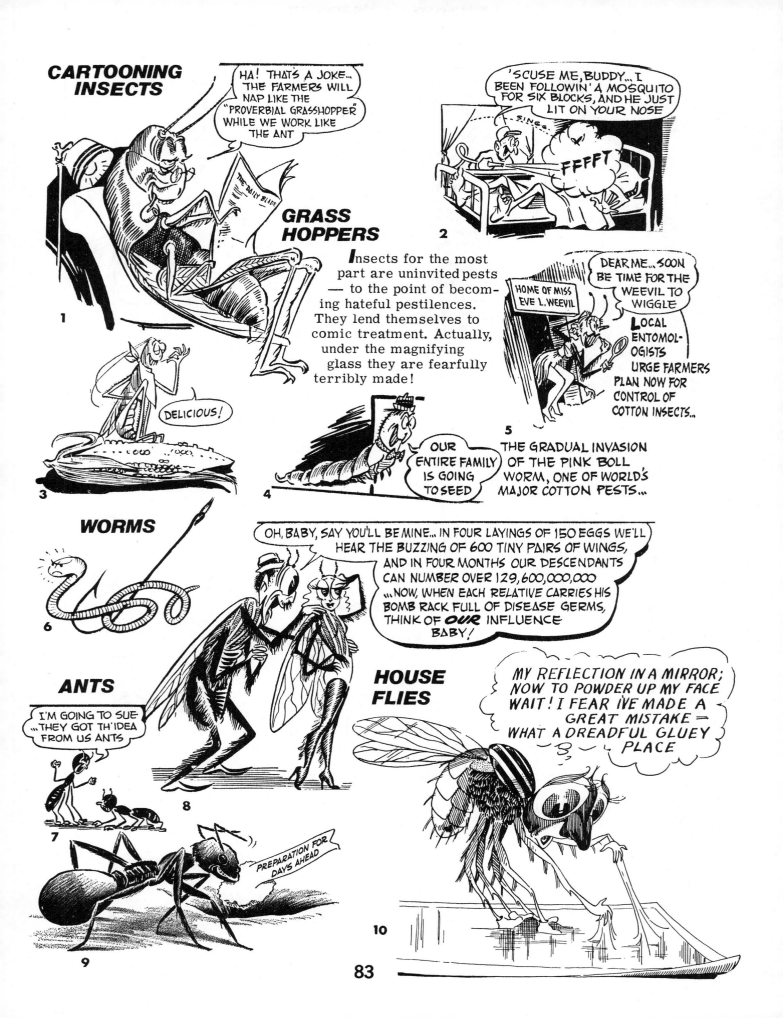

CARTOONING INSECTS

GRASS HOPPERS

Insects for the most part are uninvited pests — to the point of becoming hateful pestilences. They lend themselves to comic treatment. Actually, under the magnifying glass they are fearfully terribly made!

THE GRADUAL INVASION OF THE PINK BOLL WORM, ONE OF WORLD'S MAJOR COTTON PESTS...

WORMS

ANTS

HOUSE FLIES

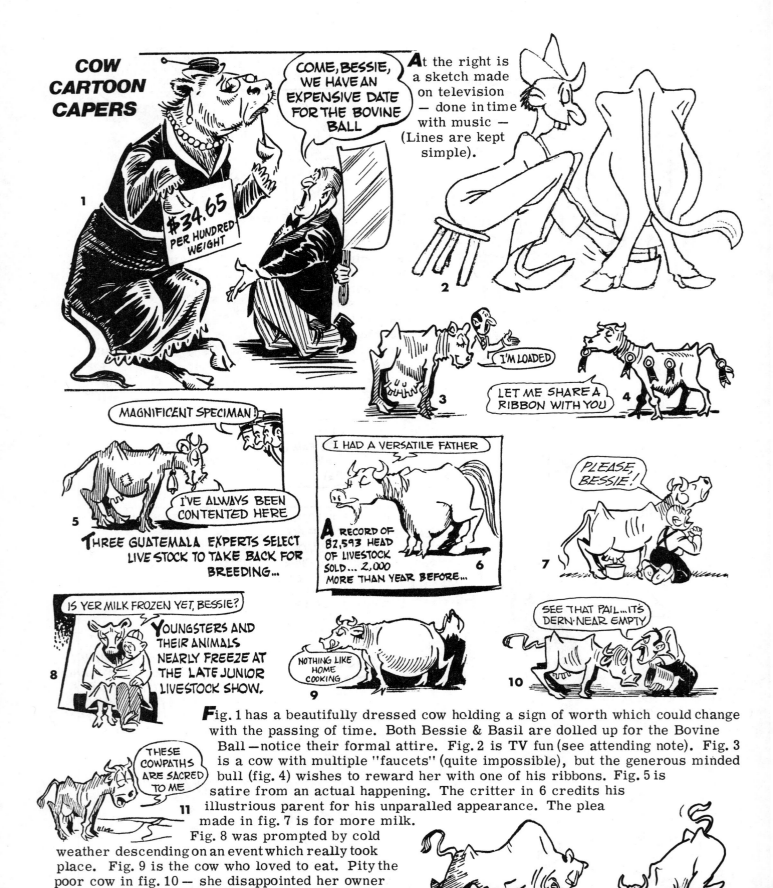

COW CARTOON CAPERS

Fig. 1 has a beautifully dressed cow holding a sign of worth which could change with the passing of time. Both Bessie & Basil are dolled up for the Bovine Ball—notice their formal attire. Fig. 2 is TV fun (see attending note). Fig. 3 is a cow with multiple "faucets" (quite impossible), but the generous minded bull (fig. 4) wishes to reward her with one of his ribbons. Fig. 5 is satire from an actual happening. The critter in 6 credits his illustrious parent for his unparalled appearance. The plea made in fig. 7 is for more milk.

Fig. 8 was prompted by cold weather descending on an event which really took place. Fig. 9 is the cow who loved to eat. Pity the poor cow in fig. 10 — she disappointed her owner in giving very little milk. Many of our streets were once called "cowpaths"— fig. 11 features a senti-mental cow. The brahman bull of fig. 12 causes the cow in 13 to act coy thinking the bull will go away.

84

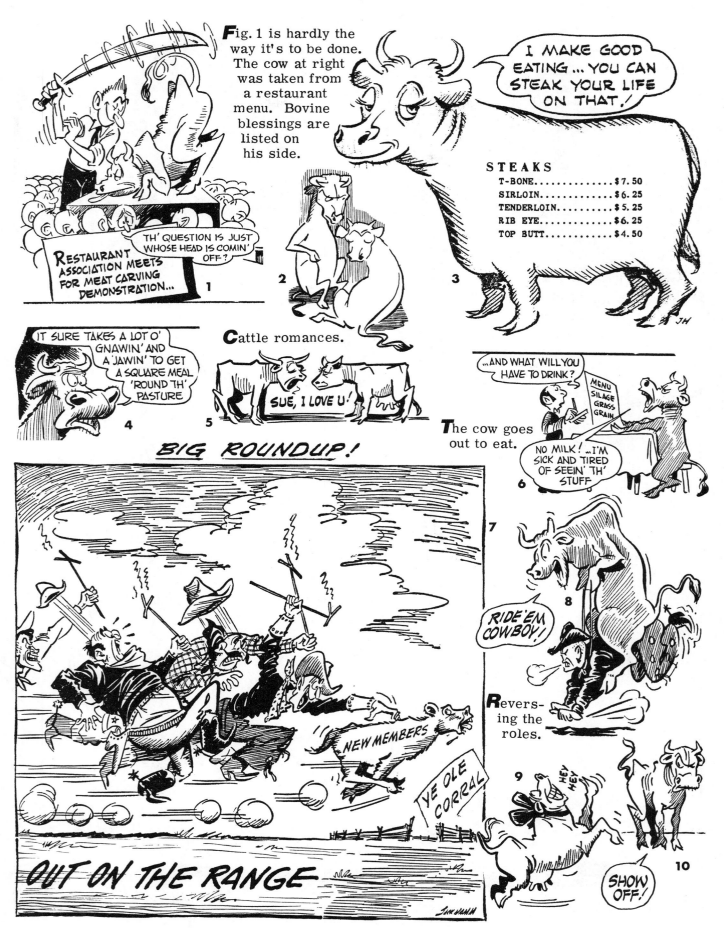

85

DISCUSSING BEAR HUMOR

The laughing eyes and broad smile on this bear are not natural.

What's wrong with the big bear at the right? There's a lot right about it: the ears, the nose, the shaggy fur. But a smile? Not only can't bears smile, actually in real life they can't even look pleasant or friendly. A dog can't smile either, but he can look friendly. Zoo experts can read the minds of many animals, but the bear never discloses his thoughts. He may be affable but he remains impassive and unpredictable. That's why "dancing" bears with carnivals and circuses wear muzzles. Even a confined bear possesses the strength of up to ten men — especially the Alaskan brown bear. Human beings emit something intangible through their eyes. It's hard to keep this from happening. This is not true of bears. It is interesting to note there are more toy bears on the market than any other animal. Teddy bears by the thousands have been sold. Soft, cuddly bears are big sellers. Greeting cards featuring comic bears move well. Even little cookies shaped like bears are on the grocery shelves. You'd never dream that it's an easy matter for even a medium-sized bear to break the neck of an ox with a single blow. Just the swat of one front leg of an an angry bear has the smash of a sledge hammer.

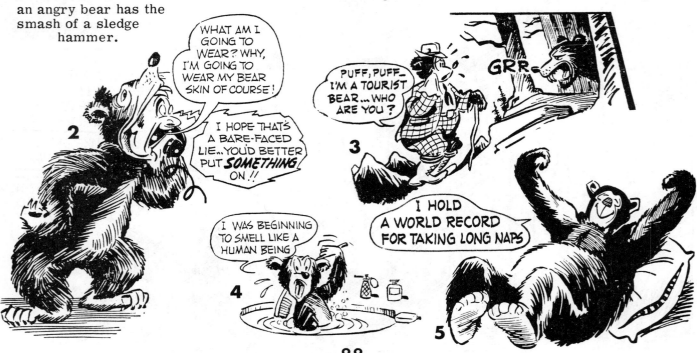

WHAT AM I GOING TO WEAR? WHY, I'M GOING TO WEAR MY BEAR SKIN OF COURSE!

I HOPE THAT'S A BARE-FACED LIE... YOU'D BETTER PUT *SOMETHING* ON !!

PUFF, PUFF— I'M A TOURIST BEAR... WHO ARE YOU?

GRR

I WAS BEGINNING TO SMELL LIKE A HUMAN BEING

I HOLD A WORLD RECORD FOR TAKING LONG NAPS

THE WORLD OF THE BEAR CUB

Though big bears can be rough and tough, the cubs can be the opposite. Very little bears are cute and cuddly. Like many animals the underdrawing can be a couple of circles (fig. 1A). The steps from A through E are simple enough.

Fig. 2, A, B & C are the same little bear in various positions. The twin cubs in fig. 3 are definitely on the comic side. The thick-lined technique, the double-ringed eyes, big feet, checkered pants — all contribute to making them funny. The telephone conversation going on in fig. 4 has been used by hundreds of different churches — both teacher and pupil are dressed in their Sunday best. The frilly costume, baby shoes and sox of the cub and the checkered suit, bow tie and jaunty hat of the adult bear attest to the "human" qualities which have been given to this intriguing pair. In fig. 5 we have a switch in bear types. Here is a white polar bear cub engaging in a little reading. By way of contrast the black (fig.6) cub with the big eyes and button nose smiles at us as he sets out on his morning walk. In fig. 7 a single flower has caught the attention of the baby bear. In fig. 8 a happy cub sits on top of a basket ball. His team just won a championship title. The next page takes up mascot possibilities in the bear world.

WHO ITH THITH?

THIS IS YOUR SUNDAY SCHOOL TEACHER...WE'RE BEARING DOWN ON EVERBODY TO COME SUNDAY

Nearly every state in the union has a junior high, high school, college or professional team called the BEARS.

Coaches and athletic directors feed players and fans alike with footballs to cure what ails them.

At some time during the the year there comes a warning: take your shots early to ward off the flu and other maladies.

No sooner is football season over than basketballs start bouncing.

The fans back up the team win or lose.

Freshman players are brought in, and injured players are given the best of medical attention.

A loss or two are embarrassing, but the team goes ahead with practice sessions.

A new season begins.

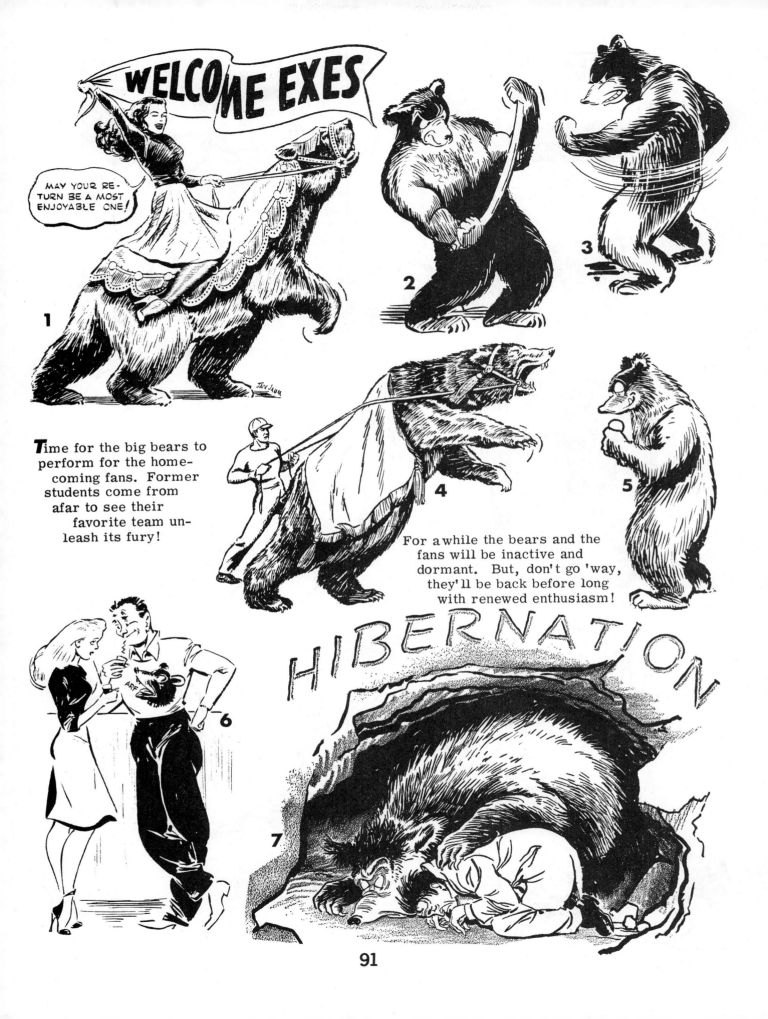

WELCOME EXES

MAY YOUR RE-TURN BE A MOST ENJOYABLE ONE!

1

2

3

Time for the big bears to perform for the home-coming fans. Former students come from afar to see their favorite team un-leash its fury!

4

5

For a while the bears and the fans will be inactive and dormant. But, don't go 'way, they'll be back before long with renewed enthusiasm!

HIBERNATION

6

7

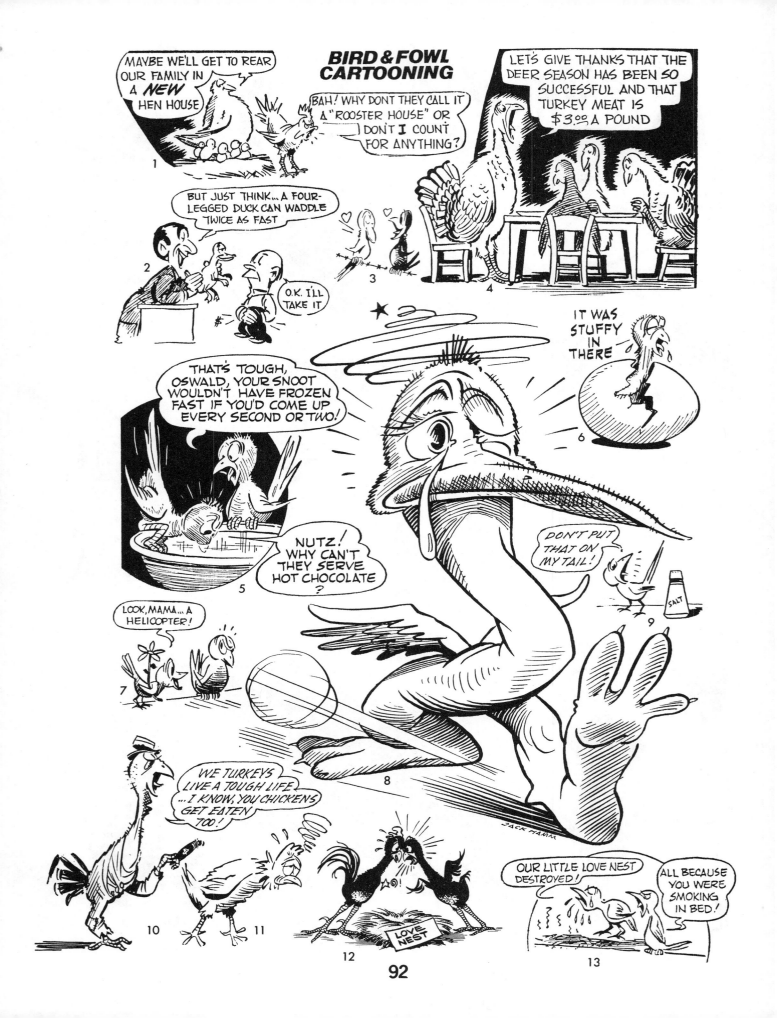

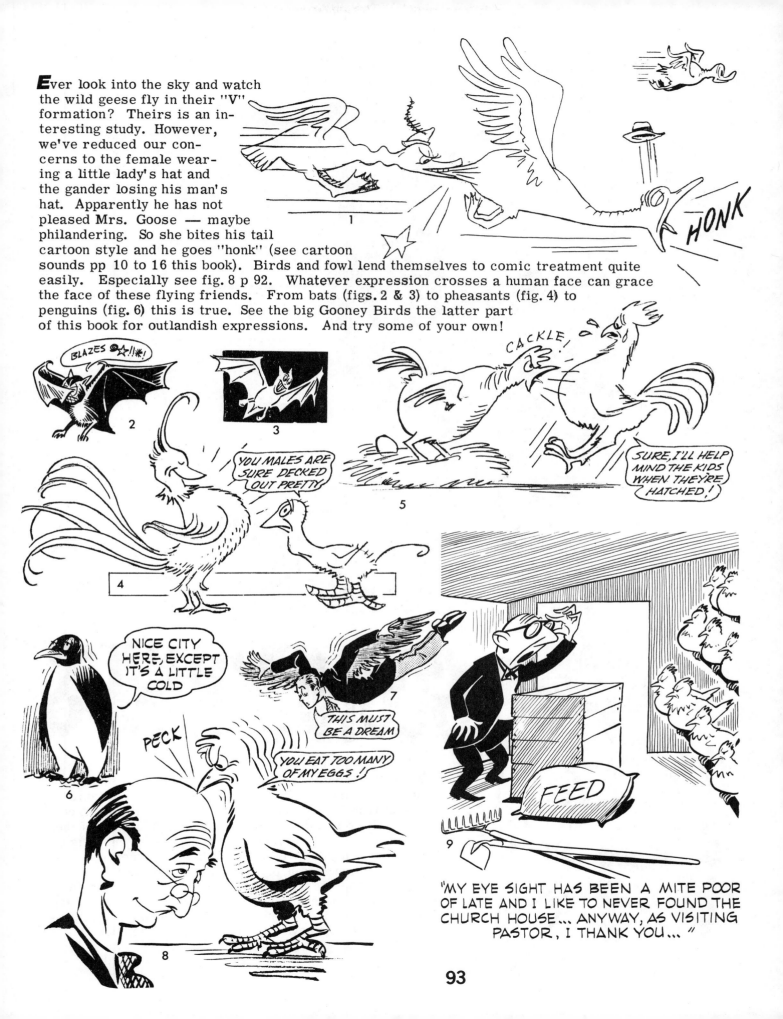

Ever look into the sky and watch the wild geese fly in their "V" formation? Theirs is an interesting study. However, we've reduced our concerns to the female wearing a little lady's hat and the gander losing his man's hat. Apparently he has not pleased Mrs. Goose — maybe philandering. So she bites his tail cartoon style and he goes "honk" (see cartoon sounds pp 10 to 16 this book). Birds and fowl lend themselves to comic treatment quite easily. Especially see fig. 8 p 92. Whatever expression crosses a human face can grace the face of these flying friends. From bats (figs. 2 & 3) to pheasants (fig. 4) to penguins (fig. 6) this is true. See the big Gooney Birds the latter part of this book for outlandish expressions. And try some of your own!

1

HONK

BLAZES ⊙☆!!☀!

2

3

CACKLE!

YOU MALES ARE SURE DECKED OUT PRETTY

4

SURE, I'LL HELP MIND THE KIDS WHEN THEY'RE HATCHED!

5

NICE CITY HERE, EXCEPT IT'S A LITTLE COLD

6

THIS MUST BE A DREAM

7

PECK

YOU EAT TOO MANY OF MY EGGS!

8

FEED

9

"MY EYE SIGHT HAS BEEN A MITE POOR OF LATE AND I LIKE TO NEVER FOUND THE CHURCH HOUSE... ANYWAY, AS VISITING PASTOR, I THANK YOU..."

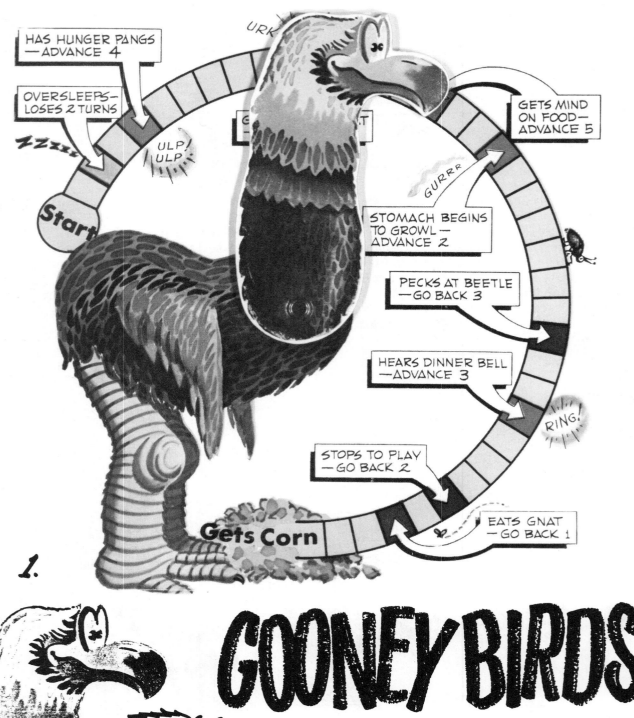

HAS HUNGER PANGS —ADVANCE 4

OVERSLEEPS— LOSES 2 TURNS

ZZZZ

ULP! ULP!

URK

GETS MIND ON FOOD— ADVANCE 5

GURRR

STOMACH BEGINS TO GROWL — ADVANCE 2

PECKS AT BEETLE —GO BACK 3

HEARS DINNER BELL —ADVANCE 3

RING!

STOPS TO PLAY —GO BACK 2

EATS GNAT —GO BACK 1

Start

Gets Corn

1.

GOONEY BIRDS

Of all the creatures God put on the earth, no single species has more colorful variety than the bird family. This is true from the tiny hummingbird to the giant condor. There are birds all over the earth. Many of them are unusual if not clownishly crazy looking, but none of them seem to mind. Likewise, other birds possess positively brilliant plumage. Our interest at the moment is laughable aspects with which the bird may be endowed. These qualities may be used in drawing a human (?) face. Alongside the bird's expression is a similar one in cartoon. The ramifications in this respect are endless.

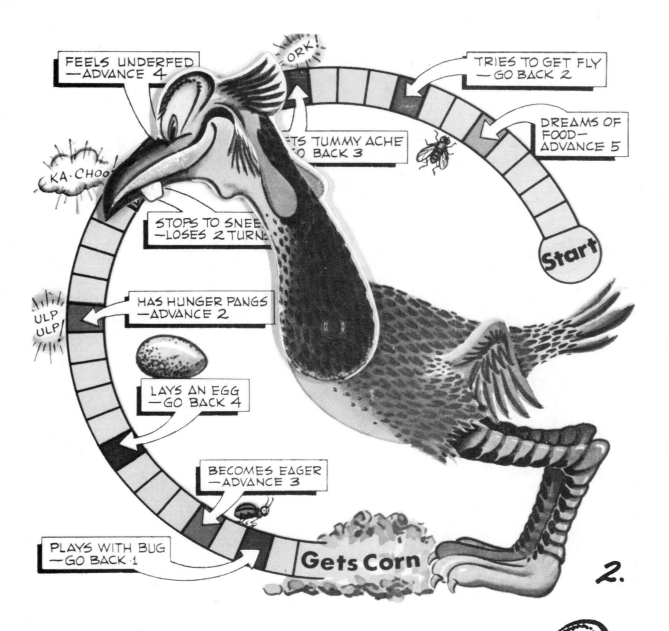

FEELS UNDERFED
—ADVANCE 4

TRIES TO GET FLY
— GO BACK 2

DREAMS OF
FOOD—
ADVANCE 5

ORK!

...TS TUMMY ACHE
..GO BACK 3

KA-CHOO

STOPS TO SNEE...
—LOSES 2 TURN...

Start

HAS HUNGER PANGS
—ADVANCE 2

ULP
ULP!

LAYS AN EGG
—GO BACK 4

BECOMES EAGER
—ADVANCE 3

PLAYS WITH BUG
—GO BACK 1

Gets Corn

2.

The treatment given these facial features fulfills the two great principles dealt with in the early pages of this book: (1) Exaggeration and (2) Distortion. First, it is obvious that the object of the GOONEY BIRD game for children is to set the bird's beak on "Start." Then the player who goes first flicks the spinner which stops on 1, 2, 3 or 4. The beak advances on that number of squares. If on that particular square directions are indicated then the bird must follow those directions. The first one reaching "Gets Corn" wins. Now, turn the page for our application in this chapter.

I'M PROUD TO SAY
MY HIGH I.Q. IS
IN EVIDENCE!

95

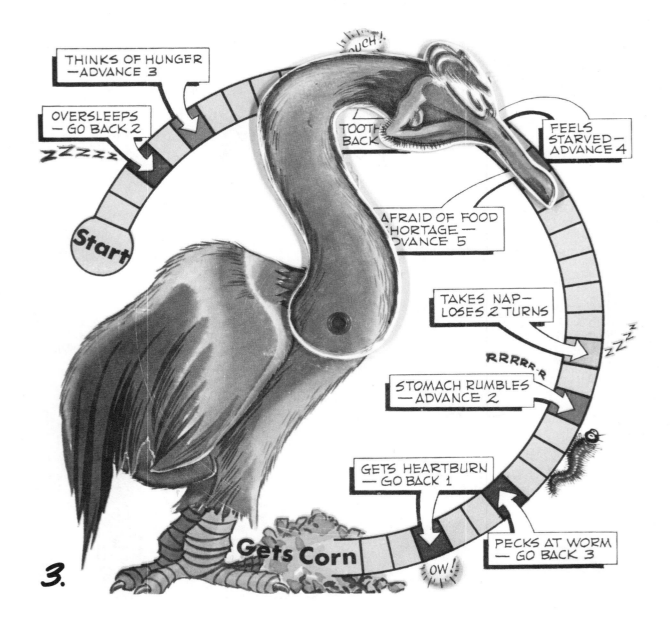

THINKS OF HUNGER
—ADVANCE 3

OVERSLEEPS
— GO BACK 2

ZZZZZ

Start

OUCH!

TOOTH
BACK

FEELS
STARVED—
ADVANCE 4

AFRAID OF FOOD
SHORTAGE —
ADVANCE 5

TAKES NAP—
LOSES 2 TURNS

ZZZZ

RRRRR-R

STOMACH RUMBLES
—ADVANCE 2

GETS HEARTBURN
— GO BACK 1

PECKS AT WORM
— GO BACK 3

3.

Gets Corn

OW!

As a reader of these pages you at once admit to being interested in laughter. Most people who read the comics drawn by cartoonists laugh inwardly rather than outwardly — some do both. Though anyone who tells a joke or draws a joke or invents a punchline to a joke is strangely rewarded if the hearer or reader laughs out loud. If there is laughter in a circle of friends the host or hostess feels good about it. Our whole body functions better when we're happy. Medical science attests to this.

I HAVE A LOT OF
RELATIVES IN THE
COMICS WHO ARE
SLIGHTLY ZANY

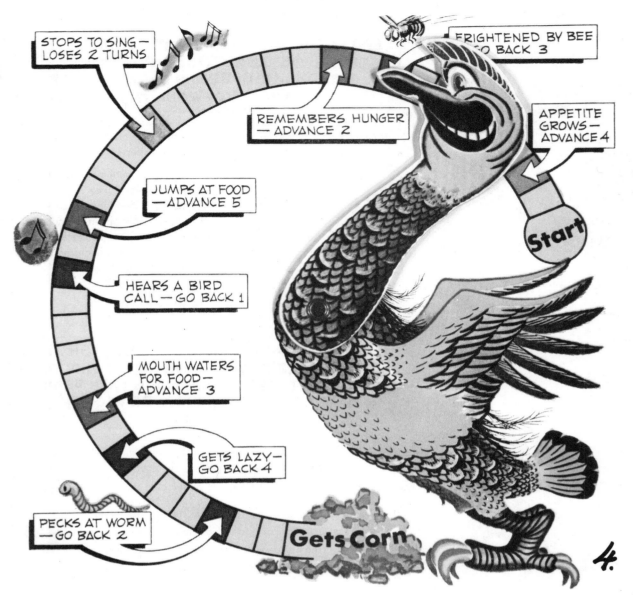

STOPS TO SING—
LOSES 2 TURNS

FRIGHTENED BY BEE
GO BACK 3

REMEMBERS HUNGER
—ADVANCE 2

APPETITE
GROWS—
ADVANCE 4

JUMPS AT FOOD
—ADVANCE 5

Start

HEARS A BIRD
CALL—GO BACK 1

MOUTH WATERS
FOR FOOD—
ADVANCE 3

GETS LAZY—
GO BACK 4

PECKS AT WORM
—GO BACK 2

Gets Corn

4.

Our fourth Gooney Bird is grinning which means he is well fed even if he doesn't get to the corn first. The human (?) being who is his counterpart is experiencing the same emotion. The bird's crest on top of his head grows that way naturally. The fellow's hair to the right just hasn't been combed since he got out of bed this morning. Most comic characters are not too well-groomed. We invite them into our homes as special guests despite this fact. What self-respecting newspaper doesn't have one or more comic pages?

BIRDS OF A FEATHER FLOCK TOGETHER

97

Poor old sad-faced Jerry is getting told—but it's better to be _told_ than to have to learn through bitter experience.

Many broom manufacturers all over the country will tell you that they always get exactly what they expect when they buy their material from John L. Denning & Company. Conscientious service; honest descriptions; grading based on U. S. Government Standards; proper storage and the John L. Denning & Company assurance of complete satisfaction on every deal protect each manufacturer against need for weathering any storms of disappointment and loss.

You're always safe, so

B. A. CUSTOMER

There's a world of satisfaction in knowing when you order a car of broom corn that it will arrive exactly as described—and that shipment has been made promptly on the date promised.

Every member of the John L. Denning & Company organization is aware of the importance of prompt and complete service . . . and years of honest dealing have established an iron clad practice that John L. Denning & Company customers must always be satisfied.

B. A. CUSTOMER

Evidently Jennie didn't get the grade she had expected and now, after a bad time of it, she's howling.

It's so much wiser, and cheaper, to avoid disappointment rather than to "take a chance" and then regret it.

Customers of John L. Denning & Company never need to take chances. They know that every member of the John L. Denning organization is always alert to meet the needs of every manufacturer in material and service—and they know, too, that they can depend on Denning grading and descriptions.

B. A. CUSTOMER

WECOME HOME, SON!

I'VE RETURNED AGAIN FOR DENNING'S BEST; I'VE FLOWN THE EARTH AROUND — BUT NO WHERE IS THERE SUCH A GRADE OF BROOM CORN TO BE FOUND —

Jerry Wren is telling Jenny just what the many Denning customers tell others—and us.

For years many of our customers have depended on John L. Denning & Company for material and service which they know is always honest, dependable and considerate.

With definite knowledge of the broom corn business and intimate acquaintance with the manufacturer's requirements, is it any wonder that Denning customers continue through the years?

B. A. CUSTOMER

The saga from figs. 1 to 4 recounts the travels of the Jerry & Jennie Wren family. These fascinating little birds were used to advertise broom corn. The messages were carried on long postcards. This illustrates how laughable birds can do a selling job.

Fig. 5 may contain the world's shortest poem: "Whoooo? Moooo!" The comic owl perched on the steer's horn asks the question and gets a forthright answer.

The quip in fig. 6 tells the story of many fine chicken diners eaten over the years. After the sermon he may be invited to yet another one.

The loquacious parrot in fig. 7 is none too happy about his assignment. The people in the pews have settled down to listen out the half-hour. Maybe they'll all pitch in and at least buy some bird seed.

WHOOOO?

MOOOO!

5

Bird experts tell us that there are about 9,000 different species, or kinds, of birds living throughout the world.

"IN FACT AS A YOUNG COUNTRY PREACHER I ATE SO MUCH OF IT FRIED, FOR AWHILE I THOUGHT I MIGHT TURN INTO ONE"

"OFF THE CUFF LET ME SAY THE SWAB IS PAYING ME EXACTLY NOTHING AS HIS PULPIT SUPPLY"

1

2

3

4

Which of the facial features reveal the most intense of our emotions and fiery feelings? The nose does nothing at all except perhaps during hay fever season. Though we may get emotional about sneezes and sniffles, the topic of extreme emotions hardly enters into the picture. The chin may quiver a little when we get upset. But the mouth and the eyes convey the extreme emotions in a very direct manner.

Study shows that the intangible goings on in the mind are revealed through both the eyes and the mouth. What is said by the eyes is more subtle than what is said by the mouth.

First, let's consider the mouth. Some portrait artists maintain that the corners of the mouth communicate thoughts quickly. The birth of a smile or the start of a laugh begins in the corners of the mouth. When one is petrified with fear what does the mouth do. It usually just hangs open. The eyes are like open windows when fear is felt in the extreme. They don't crack open as portrayed in fig. 1. But they seem to bulge as they grow wider.

With anger — savage uncontrollable anger — the teeth may clamp together. Do they crack each other? Probably not. But elements of the ultimate in each of these emotions can help the comic artist. On page 103 at the top are four rows of faces depicting comic versions of Fear, Anger, Pain and "Insanity" in that order. These were taken from the book Cartooning the Head & Figure by this author. By exaggerating and distorting these big somewhat ugly faces in a comic way the comic cartoonist comes up with the comical. If we may ride herd on a word.

Emotions expressed on the simple faces of the characters in the funny papers are forever amusing and entertaining to the readers of these strips. We all fall in love with these fictitious people and they come alive for us. The rich and the famous, the educated and uneducated, the poor and hardworking wage earner — they all admit to liking particular comics.

Hence, for in-depth study, we present enlargements and cross-sections of Fear, Anger, Pain and 'way out "Insanity."

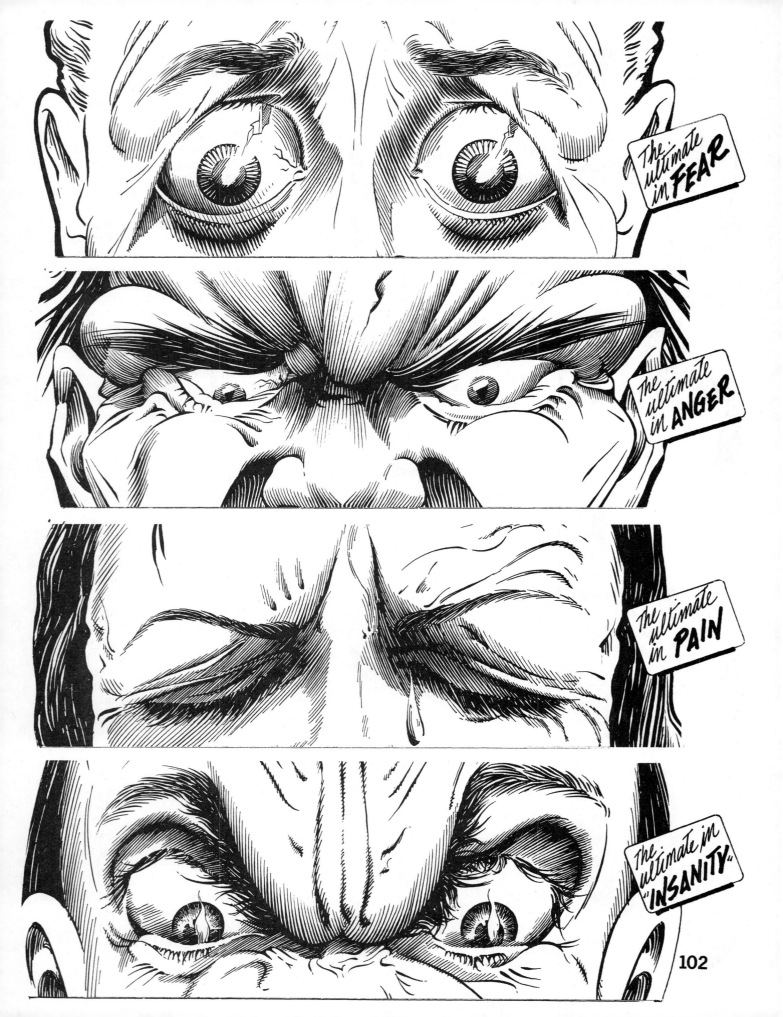

102

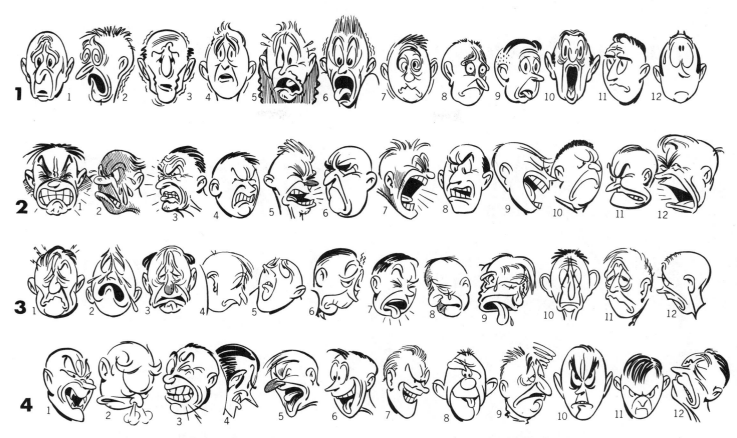

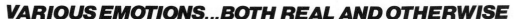

VARIOUS EMOTIONS...BOTH REAL AND OTHERWISE

THE PLAGUE FAMILY

1. The father plagued with sleeping sickness...

2. The mother plagued with the vanity of her own beauty...

3. The son plagued with the desire to become an embryo once again...

4. The daughter plagued with year 'round hay fever...

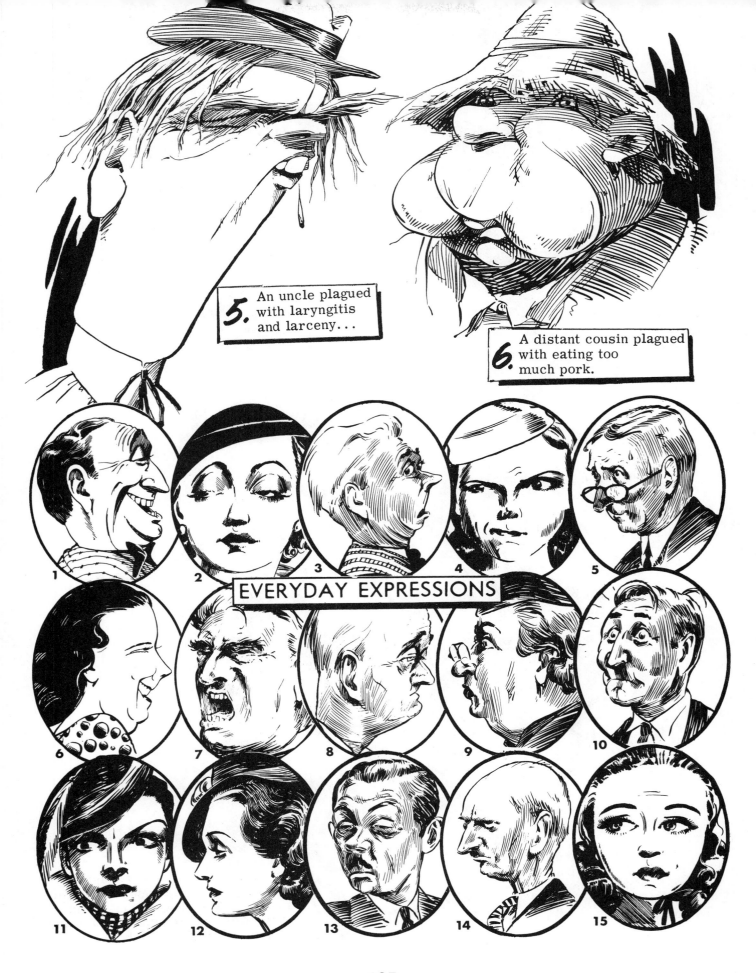

5. An uncle plagued with laryngitis and larceny...

6. A distant cousin plagued with eating too much pork.

EVERYDAY EXPRESSIONS

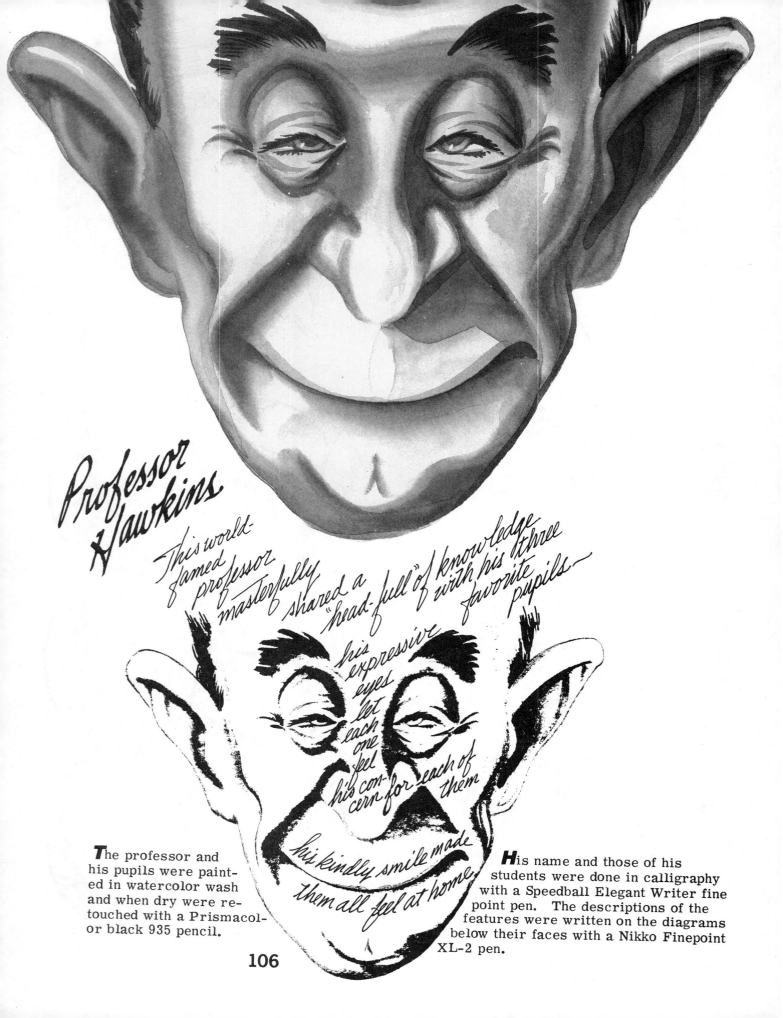

Professor Hawkins

This world-famed professor masterfully shared a "head-full of knowledge" with his three favorite pupils— his expressive eyes let each one feel his con-cern for each of them his kindly smile made them all feel at home.

The professor and his pupils were painted in watercolor wash and when dry were retouched with a Prismacolor black 935 pencil.

His name and those of his students were done in calligraphy with a Speedball Elegant Writer fine point pen. The descriptions of the features were written on the diagrams below their faces with a Nikko Finepoint XL-2 pen.

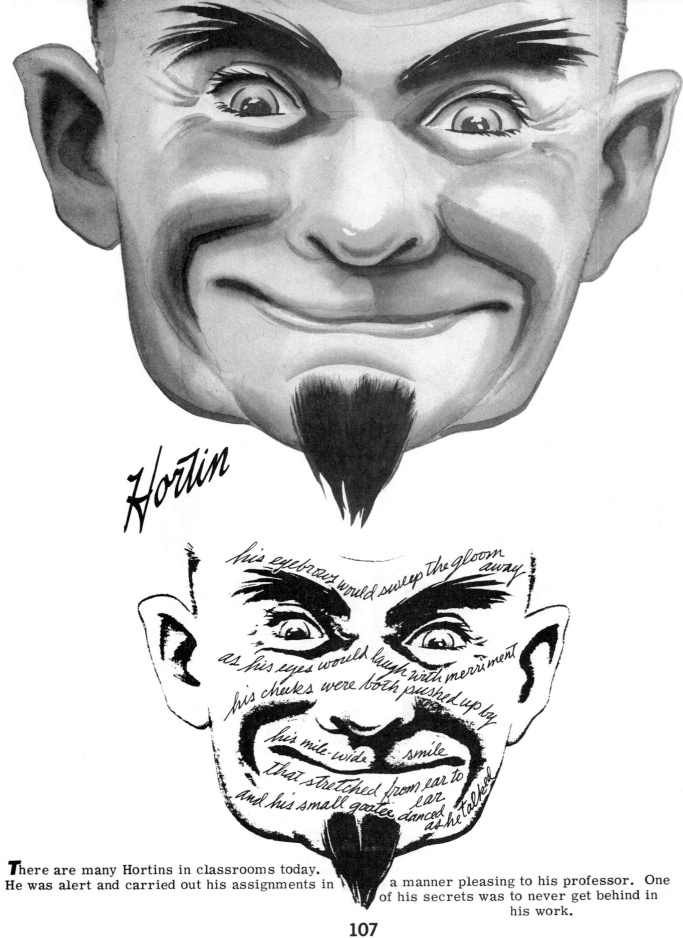

Hortin

his eyebrows would sweep the gloom away

as his eyes would laugh with merriment

his cheeks were both pushed up by

his mile-wide smile

that stretched from ear to ear

and his small goatee danced as he talked

There are many Hortins in classrooms today. He was alert and carried out his assignments in a manner pleasing to his professor. One of his secrets was to never get behind in his work.

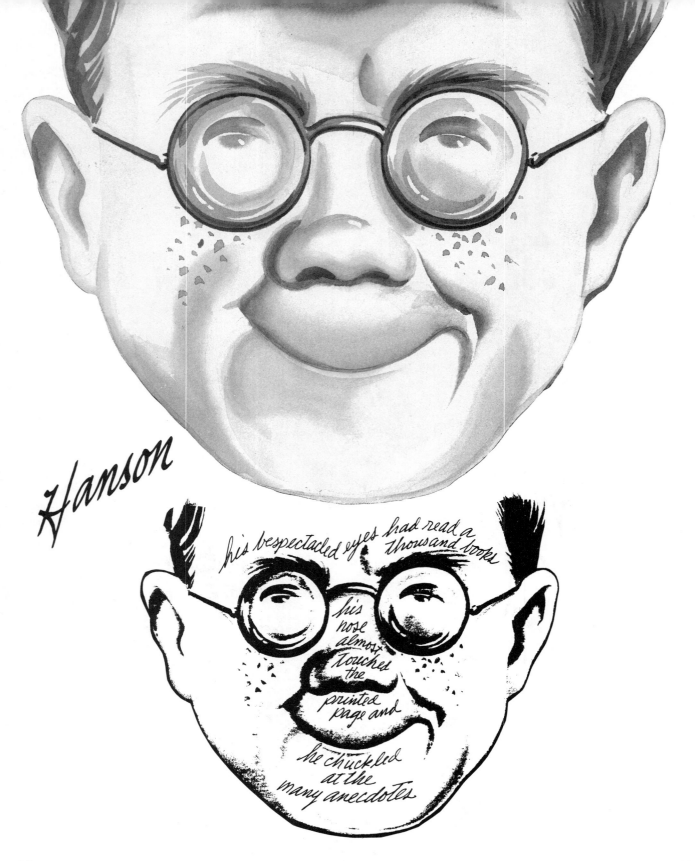

Hanson

his bespectacled eyes had read a thousand books

his nose almost touched the printed page and

he chuckled at the many anecdotes

Most classes have a Hanson kind of student. He loved books and was an avid reader. He was chess champion. To the surprise of many he could play the game and read a book between moves.

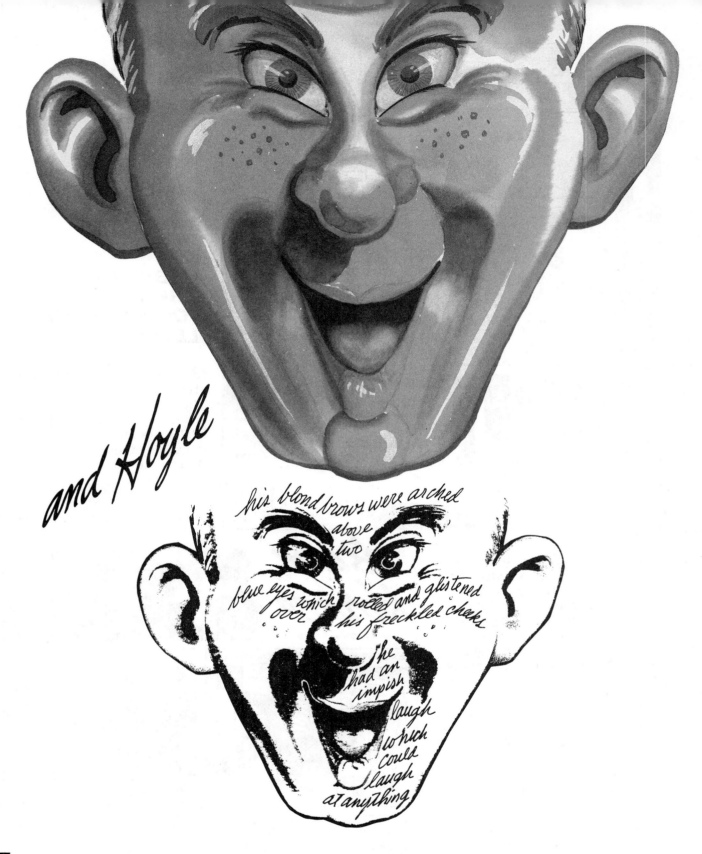

and Hoyle

his blond brows were arched above two blue eyes which rolled and glistened over his freckled cheeks he had an impish laugh which could laugh at anything

The Hoyles in classes brighten up each day. His grades might have been better; he got a little behind in his studies. But he was a delight to have around — made friends easily.

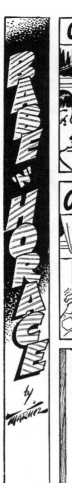

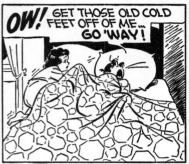
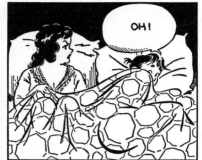

A TRIBUTE TO EDGAR "ABE" MARTIN, CARTOONIST PAR EXCELLENCE...

On this page are two Sunday strips entitled "Babe 'n' Horace." The author of this book was an understudy of Martin who created "Boots and Her Buddies"... Recognized as the Best Dressed Girl in the Comics. The author

was privileged to write and draw "Babe 'n' Horace" — also the brain child of Martin — when Martin suffered a crippling attack of arthritis. The two strips shown here were drawn by the author who then signed Martin's name to them. Many readers got a weekend laugh from their antics.

110

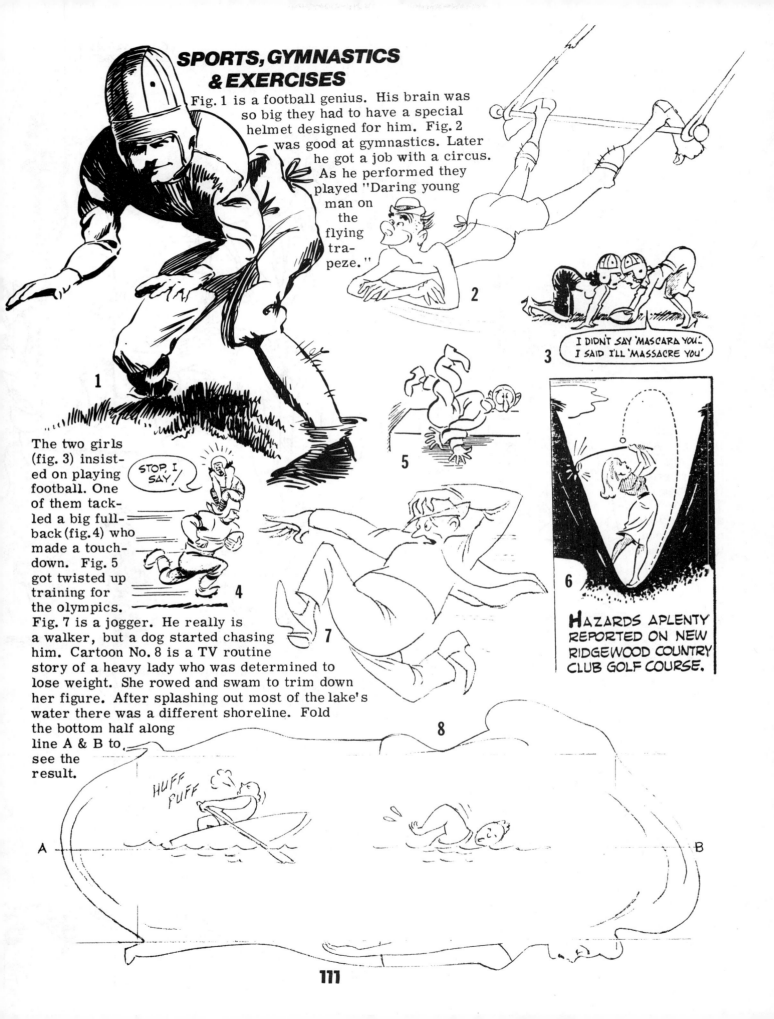

SPORTS, GYMNASTICS & EXERCISES

Fig. 1 is a football genius. His brain was so big they had to have a special helmet designed for him. Fig. 2 was good at gymnastics. Later he got a job with a circus. As he performed they played "Daring young man on the flying trapeze."

The two girls (fig. 3) insisted on playing football. One of them tackled a big fullback (fig. 4) who made a touchdown. Fig. 5 got twisted up training for the olympics. Fig. 7 is a jogger. He really is a walker, but a dog started chasing him. Cartoon No. 8 is a TV routine story of a heavy lady who was determined to lose weight. She rowed and swam to trim down her figure. After splashing out most of the lake's water there was a different shoreline. Fold the bottom half along line A & B to see the result.

I DIDN'T SAY 'MASCARA YOU.' I SAID I'LL 'MASSACRE YOU'

STOP, I SAY!

HAZARDS APLENTY REPORTED ON NEW RIDGEWOOD COUNTRY CLUB GOLF COURSE.

HUFF PUFF

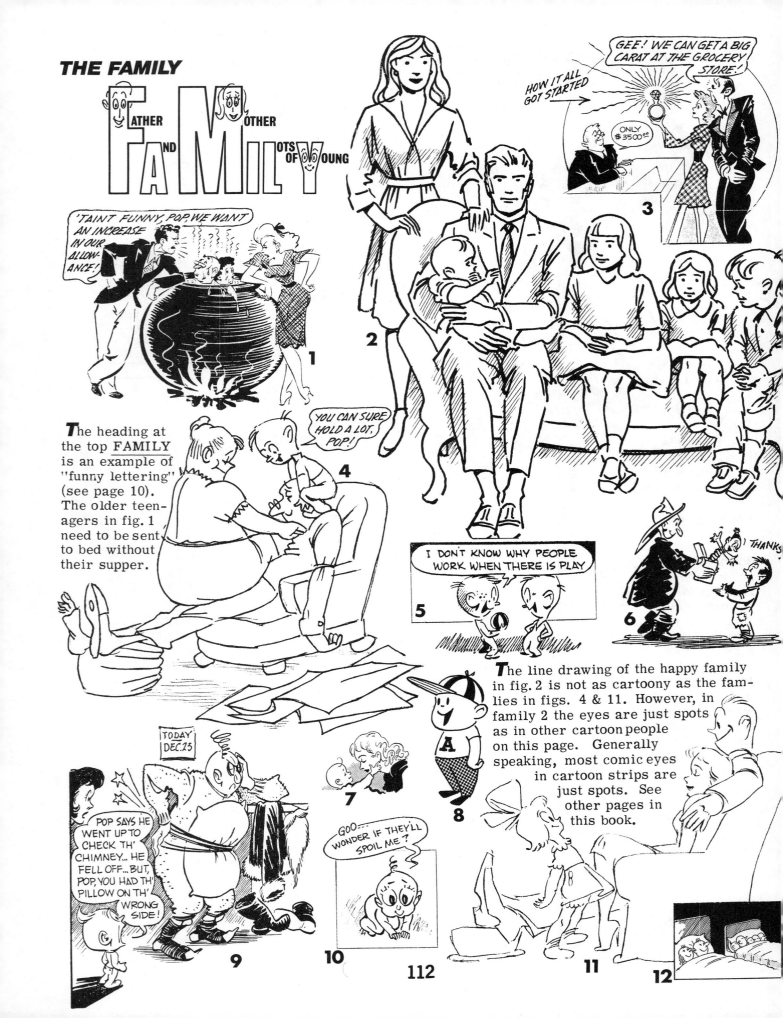

THE FAMILY

FAMILY — **F**ather **A**nd **M**other **L**ots **O**f **Y**oung

'TAINT FUNNY, POP, WE WANT AN INCREASE IN OUR ALLOW- ANCE!

GEE! WE CAN GET A BIG CARAT AT THE GROCERY STORE!

HOW IT ALL GOT STARTED

ONLY #3500⁰⁰

The heading at the top FAMILY is an example of "funny lettering" (see page 10). The older teen- agers in fig. 1 need to be sent to bed without their supper.

YOU CAN SURE HOLD A LOT, POP!

I DON'T KNOW WHY PEOPLE WORK WHEN THERE IS PLAY

THANKS

The line drawing of the happy family in fig. 2 is not as cartoony as the fam- lies in figs. 4 & 11. However, in family 2 the eyes are just spots as in other cartoon people on this page. Generally speaking, most comic eyes in cartoon strips are just spots. See other pages in this book.

TODAY DEC. 25

POP SAYS HE WENT UP TO CHECK TH' CHIMNEY... HE FELL OFF... BUT, POP, YOU HAD TH' PILLOW ON TH' WRONG SIDE!

GOO— WONDER IF THEY'LL SPOIL ME?

A TRIBUTE TO MINISTERS & PASTORS EVERYWHERE

On the next several pages are cartoons involving various church situations. A special tribute is here paid to these preachers of the Gospel. In the opinion of this author these men possess a 'built-in sense of humor' — this, despite the fact that they are not in one of the highest paid of 'professions.'

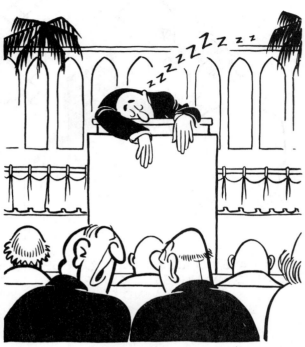

"THAT'S THE BEST 'PEACE OF MIND' SERMON
I'VE HEARD IN A LONG TIME"

"THE COTTON ? OH, HE NEVER LIKES TO
HEAR HIS REPEAT SERMONS A SECOND
TIME "

"I RECOGNIZE YOU, McDUFF, THE SERVICE
STARTS IN TWENTY MINUTES"

"WHILE I THINK OF IT, JENKINS, PLEASE TIGHTEN
THE LIGHT BULBS OVER THE CHOIR LOFT"

113

"THE CREATOR MUST HAVE HAD A SENSE OF
HUMOR WHEN HE MADE ALL THOSE ODD-BALL
LOOKING HUMANS"

"YOU HAVE NO IDEA WHAT YOUR SERMONS
MEAN TO MY HUSBAND SINCE HE'S LOST
HIS MIND"

"NOT SO REVERENT, BUT IT SURE
REGAINS THEIR ATTENTION"

"THE DOG? DON'T WORRY ABOUT HIM,
PARSON...NEVER BITES ANYONE UNLESS
HE'S A SCOUNDREL."

"I'VE COMPLETELY FORGOTTEN THE NAME, BUT THE SNORE WAS FAMILIAR"

"THIS EXPLAINS THE MISPLACED HIGH NOTE WE HEARD IN LAST SUNDAY'S HYMN...THESE TWO BOARDS PINCH WHERE THEY COME TOGETHER"

"OH DEAR ... I ACCIDENTALLY SENT THE BUTCHER'S $12.00 DOG FOOD CHECK IN PLACE OF OUR $2.00 CHURCH PLEDGE"

"ALL RIGHT! WHO WAS THE WISE GUY THAT CHANGED 'COUNT YOUR BLESSINGS' TO 'COUNT YOUR CALORIES'?"

"I CAN'T UNDERSTAND IT...THIS IS THE FIRST
TIME PATRICIA HAS GONE TO THE NURSERY
WITHOUT CRYING"

"SPEND MONEY ON THE OLD BELFRY? BAH!
WHAT WAS GOOD ENOUGH FOR MY FATHER
IS GOOD ENOUGH FOR ME...."

"IT'S NOT THE SPIRIT OF THE GIFT I WISH
TO QUESTION, IT'S... WELL, REGARDING
YOUR BUSINESS OF COUNTERFEITING"

"OH STOP CARVING A NOTCH EVERY TIME
HE SAYS 'IN CONCLUSION'!"

STUPE THE STUDENT

One this page are some examples of an inexpensive way to make multiple prints of cartoons cut into linoleum blocks. The character was named "Stupe the Student." He was none too bright. The drawing was first made on thin paper and traced on the linoleum surface in reverse. The lino cutters and pre-mounted blocks can be obtained from your art store. The blocks were locked into place for a tabloid-size press run.

With each drawing was a paragraph or two written by Stupe -- in this case the author of this book. Most school papers have more modern methods of printing.

A man never knows how well off he is until he breaks a shoestring. This is one of the items on man's list of inconsequential catastrophies which causes him to suddenly sink into a state of defeatism. Snap—and the whole world is against you. The full import of the mishap cannot be overestimated for your plans for an entire day, a week, a lifetime are brought to a bitter halt. There is little use to go on living. You are a black-balled pedestrian. It is as if your spine were snapped—it is really worse than that for no one will sympathize. No nurse will stroke the brow. No doctor will stand by with a splint and discuss the healing properties of the broken member—yet the terminal part of the leg is useless.

You are usually alone when it happens and the loneliness is only intensified. The rest of the world is foot-loose and fancy-free; they walk about as they please with nimble step, but you—you are stranded, as if on a desert isle, holding a there-to-fore vital segment of the walking apparatus dangling, limp, and lifeless—the broken string. And there at the end of the limb a couple of holes from the top of the shoe is the scrawnchie stub where the break occurred.

Completely baffled you sit for a moment in meditative silence apart from the passing parade. The stub—how short it is. You twiddle it a time or two which doesn't help at all. You try to catch hold of it, but it's far too short for that. Finally you succeed in backing it up a hole or so and trying a single bow knot which looks worse than the flop-ears of a poodle. That won't do so you remove the shoe for a closer inspection. There you sit unshod and dejected with the empty shoe much too close to your nose. You begin to see why God made the nose at the opposite end of the anatomy. You reclaim the broken piece and tie it to the stub in a healthy knot, then lace it back in the shoe. You stuff your foot back in and tie a stinted bow which suffers greatly from the used up portion. The first step is taken as if you expected the limb to give way or the floor to cave in. You regret saying "Oh fudge" and start for your already late appointment. The big repair knot which you tried to hid burrows into the top of your foot with each step. A man never knows how well off he is until he breaks a shoestring.

1

(On page 61, fig. 16, is another example of a cartoon cut in linoleum.)

If a poll were taken it might be possible to confirm the belief that the reason some students sleep in class is that it was just twenty-four hours from the time that they had their last sleep. Noon to some students is an illuminated midnight. They point out to you that daily slumber is much safer than the nightly kind with all its prowling wickedness. The time to be awake is when you need protection—that's at night; in the day time you have lots of light, no chance for foul play or burglary. Besides, you have in the class room some thirty or forty body guards at their posts and a teacher standing vigil—such protection affords unusual security.

2

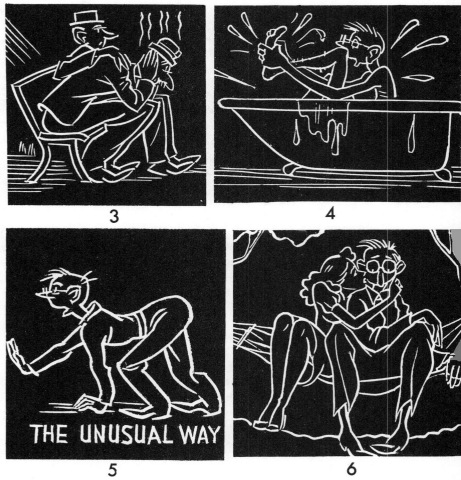

3

4

THE UNUSUAL WAY

5

6

IMPROVEMENTS IN FACIAL DESIGN

Let's say you were called upon to design the human face. You had never seen one before. You wanted to do the best job possible, for the pattern you put down would be used for all human-kind forever. Let's begin with the nose, the very center of this new concept.

"I would do it this way — not the way we're wearing ours today. And I believe it would be a real improvement.

▶ 1. I would place the nostrils at the top. Say you're ever trapped in rising water... you'd just live that much longer if your nostrils were higher on your head.

▶ 2. Another thing: your nose wouldn't be so inclined to run if it were upside down. If you sneezed, you wouldn't be so likely to mess up your vest.

▶ 3. Still another advantage — especially for the ladies — if the nose were reversed, it would be in shadow. You know how many of them worry about a shiny nose!

"Where would you put the mouth? I would not put it below the nose like we're wearing ours today.

▶ 1. It would be more sanitary above the nose.

▶ 2. We'd taste our food longer for the mouth would be farther away from the stomach.

▶ 3. It would be better for people who talk through their hat; it would be more convenient if the mouth were high on the head.

"Where would you place the eyes? I would place them below the mouth and nose; not above as we are wearing ours today. This way they would be closer to the ground, and we'd better see where we were going.

▶ 1. We would not be so likely to stumble. Our footing would be more sure.

▶ 2. If there happened to be an obstruction we could kick it away.

▶ 3. We could better enjoy the beauty of the flowers with our eyes nearer to them.

▶ 4. It would be a big help in tying these fangdangled bow ties — our eyes would be closer to our work.

▶ 5. If your hat is too big, it wouldn't be nearly so likely to cover up your eyes if they were low on the face.

"Where would you put the eyebrows? Above the eyes as we have them today? No. I'd put them below the eyes.

▶ 1. This way they could serve as tear catchers should one need to cry.

▶ 2. It would give a person more time to reach for a handkerchief.

▶ 3. Also, the rouge on the ladies' cheeks wouldn't get streaked up.

"Where would you put the chin?
At the bottom of the face? No!

▶ 1. If the chin were on top of the
head, you could get a shave
and a haircut at the same time.
▶ 2. For a bald-headed man, he
could just let his beard be his
hair. It would do away with
baldness!

"Where would you place the ears? On each
side of the head? To be sure — but make
them upside down! The reason for that is
simple.

▶ 1. The women would be pleased. They would
have a lot more room for wearing earrings
and earscrews. Instead of just one, they could
wear two, three, four or more.
▶ 2. Then say you sometimes slipped through a
hole. If your ears were upside down, they'd
serve as a safety catch and break your fall.

"Where would you put the neck?
Not below, but on top of the
head. This is logical because:

▶ 1. An aspirin or two could be
taken for both sorethroat and
headache.
▶ 2. You wouldn't need a scarf
— just put your hat on and
you'd have protection from the
cold.

"Where would you wear neckties?
On the topside instead of hidden
underneath your chin.

▶ 1. Male birds have their decora-
tive and ornamental plumage on
top to attract the females.
▶ 2. Also, when on a hunting expedi-
tion, an approaching hunter would
not shoot you — especially if the
tie were bright orange.

▶ 3. Whether the tie is a bow tie or a long necktie makes
little difference. The long tie in the wind would pleas-
antly announce your arrival to friends awaiting you at
airports or at sports events at stadiums.

The conclusion to this whole proposal is undoubtedly a
positive one. It's a bit late now, however, for there are
some 5,320,000,000 people on the earth.

VERY IMPORTANT: If you wish you may light-blue-line (by
means of an opaque projector) the face and head of a friend,
an official or a well-known personality. The paper should be
upside down to the audience. The remarks that attend each
heavy-lined traced feature may be either memorized or writ-
ten in light blue beside the particular feature itself to be read
aloud in the drawing process. When all is completed, turn
the board around with "Hello, Mr. So-and-so!"

INDEX

Learning to Draw Is Easy with
Illustrated Art Instruction Books from Perigee!

Especially for beginners...

Now you can learn to draw with two user-friendly drawing guides from among the very best of the Putnam Art Instruction books, bestsellers for over thirty years. Profuse illustrations and step-by-step instructions designed specifically for the beginner cover all facets of drawing, from the best materials to anatomy, perspective, shading, and composition.

Drawing People
by Victor Perard and Rune Hagman

Concentrates on the myriad expressions of the human face and how to capture them in a drawing.

Drawing Animals
by Victor Perard, Gladys Emerson Cook, and Joy Postle

A veritable Noah's ark of animals to draw, each accompanied by a description of its habits and habitat.

Detailed how-to guides for beginners and practicing artists from noted illustrator Jack Hamm...

Drawing the Head and Figure

Here at last is a how-to handbook that makes drawing the human figure easy and fun. Step-by-step procedures and hundreds of illustrations explain the fundamentals of figure drawing, with tips on foreshortening, depicting youth and age, and rendering clothing. Beginners will value the simplified approach while experienced artists will appreciate the scores of helpful hints.

How to Draw Animals

Over a thousand illustrations accompany clear, simple instructions for drawing animals in the detailed manual that includes fundamentals for the beginner and more advanced techniques for the professional. The author begins with a section on guide lines, methods, and comparisons of related body parts, then goes on to specific animals, from dogs and cats to elephants and camels.

Drawing Scenery
Landscapes and Seascapes

Step-by-step processes for drawing complete, successful landscapes and seascapes are illustrated with over 900 diagrams, pictorial explanations, and pictures. Beginning with the fundamentals of good composition, this guide ranges from the simplest scenery sketching to the most complex renderings to give every artist, beginner or professional, essential scenery-drawing techniques.

First Lessons in Drawing and Painting

From basic skills to advanced techniques, this handbook presents the underlying principles and basic tenets that a still-life artist needs to be successful. Over 800 illustrations and diagrams and clear explanations provide working methods and approaches to all kinds of media including pencil, charcoal, pastels, pen-and-ink, watercolors, oils, acrylics, and more.

Ordering is easy and convenient. Just call **1-800-631-8571** or send your order to:

The Putnam Publishing Group
390 Murray Hill Parkway, Dept. B
East Rutherford, NJ 07073

These books are also available at your local bookstore or wherever paperbacks are sold.

			PRICE	
			U.S.	**CANADA**
_____	Drawing People	399-51385	$7.95	$10.50
_____	Drawing Animals	399-51390	7.95	10.50
_____	Drawing the Head and Figure	399-50791	6.95	9.75
_____	How to Draw Animals	399-50802	6.95	9.25
_____	Drawing Scenery	399-50806	8.95	11.75
_____	First Lessons in Drawing and Painting	399-51478	7.95	10.50
_____	Drawing and Cartooning for Laughs	399-51634	8.95	11.75

Subtotal $ _____

*Postage & handling $ _____

Sales Tax $ _____
(CA, NJ, NY, PA)

Total Amount Due $ _____
Payable in U.S. Funds
(No cash orders accepted)

Please send me the titles I've checked above. Enclosed is my
☐ check ☐ money order Please charge my ☐ Visa ☐ MasterCard
Card # _____ Expiration Date _____
Signature as on charge card _____
Name _____
Address _____
City _____ State _____ Zip _____

Please allow six weeks for delivery. Prices subject to change without notice.

*Postage & handling: $1.00 for 1 book, 25¢ for each additional book up to a maximum of $3.50